# FATIMID ART

at the Victoria and Albert Museum

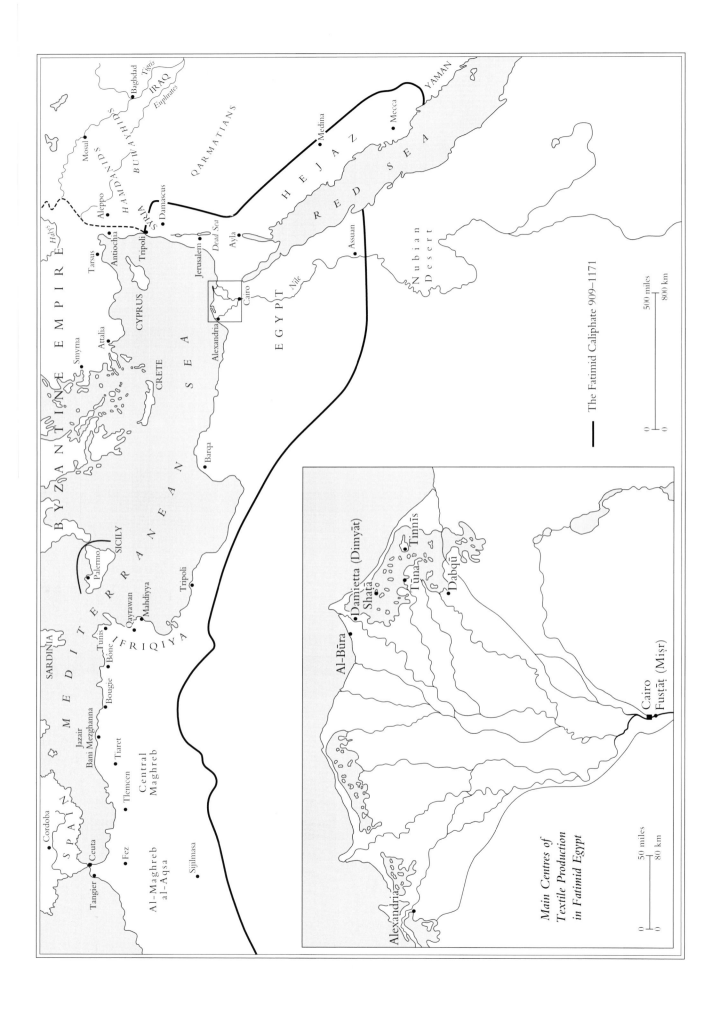

BAGHDAD

IRAQ

Tigris

Euphrates

Mosul

MOSUL

BUWAYHIDS

HAMDANIDS

Aleppo

Tarsus

Antioch

SYRIA

Tripoli

Damascus

Jerusalem

Dead Sea

QARMATIANS

Medina

Mecca

HEJAZ

YAMAN

RED SEA

Ayla

Cairo

EGYPT

Nile

Assuan

Nubian Desert

BYZANTINE EMPIRE

Halys

CYPRUS

Smyrna

Attalia

CRETE

Alexandria

MEDITERRANEAN SEA

Barqa

SARDINIA

SICILY

Palermo

Qayrawan

Mahdiyya

Tripoli

IFRIQIYA

Tunis

Bône

Bougie

Jazair

Bani Mezghanna

Tiaret

Tlemcen

Central Maghreb

SPAIN

Cordoba

Ceuta

Tangier

Fez

Sijilmasa

Al-Maghreb al-Aqsa

The Fatimid Caliphate 909–1171

500 miles

800 km

## Main Centres of Textile Production in Fatimid Egypt

Damietta (Dimyāt)

Shatā

Tinnis

Tuna

Dabqū

Al-Būra

Alexandria

Cairo

Fusṭāṭ (Miṣr)

50 miles

80 km

# FATIMID ART

## at the Victoria and Albert Museum

## ANNA CONTADINI

V&A Publications

Note: Historical dates are given with the Christian date first, followed by the Hijra (Muslim calendar) date

Unless otherwise stated, the images and objects featured in this book come from the collections of the V&A

## JACKET ILLUSTRATIONS

*Front*: Jar, earthenware painted in lustre on a white slip and transparent glaze. Fatimid Egypt, eleventh century. C. 48-1952

*Back*: Ivory plaque carved in relief. Fatimid Egypt, eleventh century. A. 53-1921

# CONTENTS

The colour plates fall between pages 58 and 59

# ACKNOWLEDGEMENTS

My research for this book began in the Research Department of the Museum, and I should like to thank Charles Samaurez-Smith, then Head of the Research Department, for the enthusiasm with which he greeted my project and for his unfailing encouragment. Other colleagues in the Department were also helpful: Clive Wainwright, Paul Greenhalgh (present Head of Research) and the then secretaries Richenda Binney and Ghislaine Wood. I should also like to thank various colleagues in the different Collections of the Museum for help and assistance with various practical aspects of the study of the objects in their care: Paul Williamson and Fiona Leslie in Sculpture Collection; Richard Cook in Sculpture Conservation; Linda Woolley in Textile and Dress Collection; Oliver Watson, Reino Liefkes and Judith Crouch in Ceramic and Glass Collection; Christopher Wilk and Jane Rick in Furniture and Woodwork Collection; Philippa Glanville and Anthony North in Metalwork Collection; Rowan Watson, Susannah Robson and David Wright in the National Art Library; James Stevenson and Ken Jackson in the Photographic Studio.

Colleagues in other institutions have also provided valuable assistance: Marthe Bernus-Taylor, Musée du Louvre; Vivianne Huchard, Musée du Cluny; James Allan, Ashmolean Museum, Oxford; Sheila Canby and Rachel Ward, British Museum; Stefano Carboni, Metropolitan Museum, New York; Ettore Vio, Treasury of San Marco, Venice; Giovanni Curatola, Udine University; Mina Moraitou, Benaki Museum, Athens.

I should also like to thank Linda Woolley for providing the technical analyses of the textiles, Alexander Morton for providing the text on the glass weights, Claire Thorn for the drawings of the ceramic and glass objects, Anne Searight for the drawings of the inscriptions on the textiles and John Banks, my editor. Colleagues and friends who have kindly given time to discuss particular points include Oliver Watson, Geoffrey Khan, Sarah Clackson, Venetia Porter and Derek Kennet. I am grateful to all of them.

I should especially like to thank Michael Rogers and Ralph Pinder-Wilson for reading chapters of the book, providing invaluable comments, and generously spending further time in discussion. Owen Wright has provided most generous support both professionally and emotionally.

Last but not least, I should like to thank Mary Butler, Head of V&A Publications, and Miranda Harrison, Managing Editor, for being so gracious and patient with a difficult and complicated book.

# INTRODUCTION

This book has been prompted by the research on the Islamic collection of the V&A carried out between 1992 and 1994, when I was the Baring Research Fellow in Islamic Studies. There were two main reasons for choosing the specific topic of Islamic art during the Fatimid period, which means art from North Africa, Egypt and Syria between the tenth and the twelfth centuries, based on the Collection of the Museum. One is that Fatimid art in general is still insufficiently studied; the other is that the V&A collection of materials from this period is one of the most important in the world outside the Middle East: it is representative across the media and the quality of the material is exceptionally high.

Attempts have been made during the last twenty years to identify unifying elements in Islamic art, but without notable success, and it would be wiser to recognize that the term is, in essence, little more than a convenient label: in fact, the art of many Islamic cultures has been thoroughly eclectic, in both style and content, and probably to a greater degree than in many other cultures. Terms such as Fatimid art (or Timurid art or Abbasid art) are equally no more than useful conventions: they define time and place, but it would be misleading to seek to relate them to the character of the political dynasty from which they take their name, even when, as with the Fatimids, that dynasty stood in ideological as well as political opposition to its neighbours. Consequently, the numerous and varied Fatimid holdings of the V&A need to be studied not only in relation to each other and the society that produced them, but also in a wider art-historical context.

In many cases the choice of the material has had to be selective: the V&A collection of Fatimid pottery fragments, for example, is far too large to include in its entirety, as is its collection of Fatimid textiles. Setting aside problems of attribution and date, which, in the case of Fatimid art, as of medieval Islamic art in general, are often acute, the choice, as also in the case of glass, has been dictated by the importance of a particular piece in the context of a historical and art-historical discussion. In the case of rock crystals, on the other hand, all ten Islamic pieces have been included, even if a few of them may be considered pre-Fatimid: they serve the broader discussion of cut relief objects in rock crystal and glass. For similar reasons, a few pre-Fatimid textiles have been included. In the case of ivory, woodwork and metalwork, however, only those pieces which are securely attributable to the Fatimid period have been included.

## HISTORICAL SURVEY

The Fatimids were a branch of the Ismāʿīlī movement,[1] a Shīʿīte splinter group whose origin goes back to the eighth century. Shīʿīs owe allegiance to the line of ʿAlī, the cousin of the Prophet Muḥammad, and the Fatimids take their name from Fāṭima, daughter of the Prophet and wife of ʿAlī, from whom they claim descent.[2] Unlike the Sunni majority of the Muslim population, the Shīʿīs espoused a religious–social hierachical structure with at its head a hereditary Imām (or guide) who was in the direct line of descent from ʿAlī. As guide of the community, the Imām had authority to define doctrine in both its "explicit" meaning, open to the world, and its hidden, esoteric meaning, to which only a small group of initiates had access. These in their turn would disseminate the Imām's teaching and serve as guides for all good Muslims.

According to Fatimid belief history was divided into eras, each one marked by a Prophet after whom a number of Imāms followed, charged with preserving his legacy. Muḥammad had been the Prophet of the sixth era, and the following line of Imāms began with ʿAlī and continued with the dynasty of the Fatimid caliphs.[3] The imminent end of the world would be announced by the beginning of the glorious seventh era, that of the Mahdī (messiah), who would also, according to Ismāʿīlī belief, be of ʿAlid descent, and specifically of the line of Ismāʿīl, son of Jaʿfar al-Ṣādiq, the sixth Imām after ʿAlī.[4]

By the Sunni Abbasids in Baghdad the Fatimids were inevitably seen as sectarian dissidents, and the doctrinal threat they posed was also felt by the equally Sunni Umayyad emirate of Spain.[5] Indeed, it was partly as a reaction to growing Fatimid power in North Africa that the Umayyads of al-Andalus adopted for themselves the title caliph, with the result that in 972/362, when the Fatimid al-Muʿizz triumphantly entered Cairo, there were three sovereigns claiming the title of "caliph": al-Muʿizz, the Abbasid Caliph al-Muṭīʿ in Baghdad, and the Umayyad Caliph al-Ḥakam II in Spain. But whereas the Abbasid caliphate was already at that time merely nominal, with provincial governors effectively the independent rulers of vast territories, and the Spanish caliphate was entering a crisis which would lead to its fall in 1031/423, the Fatimid caliphate was just beginning to consolidate its power in Egypt.

From a historical and cultural point of view, the Fatimids represented one of the major powers of the Mediterranean and Near East, especially during the first half of the eleventh century when they were probably the most powerful and rich of all, able to dominate not only the Mediterranean trade routes but also those leading to India. When the Fatimids conquered Egypt the needs of dynastic legitimacy made them adopt a complex ceremonial derived from the Byzantine one,[6] and such public displays, which were allied to the splendour of new mosques, palaces and other public and private buildings, resulted in Cairo being transformed into one of the richest and most glittering cities of the age, eclipsing both Byzantium and Baghdad.[7]

The dynasty dates from 909/297, when the first sovereign, ʿUbayd Allāh al-

Mahdī (r. 909–34/297–322), conquered Ifrīqiya (present Tunisia) from the Aghlabids and founded a new capital, Mahdiyya.[8] The way had been prepared for him by the *dāʿīs*, Ismāʿīlī missionaries, and when, for reasons that are not entirely clear, ʿUbayd Allāh decided to leave his native Salamiyya in Syria,[9] itself a centre of Ismāʿīlī propaganda, North Africa was a suitable haven where the missionaries had been working successfully among the Berbers since the late ninth century.

Once established in Tunisia, Fatimid power was soon extended to Sicily, which had also been under Aghlabid control.[10] However, their attempts to expand westwards met with only limited success, and the conquest of Egypt was to be their major goal. It was under the fourth Fatimid Caliph, al-Muʿizz, that this was achieved, the architect of victory being his general Jawhar. Carefully planned in its practical aspects, and prepared psychologically by deft political propaganda in a country suffering internal chaos and ravaged by famine, the conquest was finally achieved without much difficulty, and Jawhar entered Fusṭāṭ in 969/358.[11] A skilful leader who tried to win the population over by concentrating at first on taking measures against the famine and on restoring order, Jawhar acted with considerable generosity. He had the name of the Abbasid caliph suppressed in the Friday sermon (*khuṭba*), but introduced Shīʿī formulae only very gradually. To house his troops he built a new town – Cairo, al-Qāhira (the Victorious) – and laid the foundation stone of the al-Azhar mosque in 970/359.

The Fatimids used, and were supported by, Ismāʿīlī ideology which was propagated by a transnational organization, the *daʿwa*. This functioned as both a propaganda and a "missionary" organization transcending political boundaries and as an ideological organ within the state.[12] The idea was of a centre, Egypt, successfully won to the cause and directly governed by the Imāms or caliphs, surrounded by territories under different rulers which would soon pass to the cause of the Egyptian caliphs. These areas were constantly visited by the missionaries (*dāʿīs*) who had the job of spreading the message to prepare for imminent conquest from Egypt. Before being sent out these missionaries were indoctrinated in the Ismāʿīlī creed at the al-Azhar mosque, and they mantained continuous contact through a network of emissaries.

But ultimately such an expansionist policy required the backing of a powerful military structure. The Fatimid army was composed of two main groups. Initially it depended on Berbers recruited from North Africa. Called *maghāriba* (Westerners), they played a major part in the conquest of Egypt. Subsequently Turkish elements, called *mashāriqa* (Easterners), came to the fore, although footsoldiers were also levied from the Sudan.[13]

The Fatimids had some success in expanding further east, and it is under the Caliph al-ʿAzīz in the late tenth century that we see Fatimid territory at its maximum extent. They had gained control of the two holy cities of Mecca and Medina, and also of the Yemen, but they found it more difficult to establish their presence in Palestine and Syria,[14] and, though they had intermittent control of

Jerusalem, Damascus and Aleppo (and even, for a time, Mosul), it is possible to say that Syria was never a solidly Fatimid possession.

The strong ideological component of the Fatimid movement was cleverly manipulated to justify the claim to political domination during its period of expansion. Thereafter, however, the message carried by the network of missionaries, intended as a preparation for an expansion of political control, was not crowned by further successes.[15] As was only to be expected, the resulting tensions were to lead to schismatic divisions within the Ismāʿīlī community.

*The Druze*

The first schism occurred immediately after the death of the Caliph al-Ḥākim (996–1021/386–412). The twenty-five years of his controversial reign[16] are marked by apparently inexplicable events, the interpretation of which is rendered more difficult by the fact that we do not have reliable sources: most accounts are by later Sunni historians unlikely to be dispassionate and impartial. But it seems at least clear that certain segments of the population suffered from restrictive measures or even persecution at different times during his reign. The Sunni majority of the population was affected; but it was the Christians and Jews who were more at risk. Their inferior status was emphasised by the enforcement of the often neglected requirement that they wear a differentiated type of clothing; they suffered from the prohibition of religious festivals, and, especially damaging, from the physical destruction of places of worship. This culminated in 1010/401 in the order to demolish a particularly important monument for Christianity, the Church of the Holy Sepulchre in Jerusalem. This policy was maintained until 1013/404, when a more tolerant period began, marked by unusual measures such as that allowing Christians who had converted to Islam to revert to their original faith.

The sources emphasize the eccentric behaviour of the caliph to the extent that he has been regarded in much of the historiographical literature as mad. However, most scholars now dismiss this as a partial, distorted and generally hostile picture and see in al-Ḥākim a Fatimid caliph who took very seriously his role of Imām and attempted to restore the messianic element within the Ismāʿīlī movement.[17] This interpretation takes account of the fact that during his reign the idea began to circulate that al-Ḥākim was God incarnate. This seems to have been first propounded by certain extremist *dāʿīs*, who deplored the religious laxity that had affected the state. Its main propagator was the missionary Muḥammad ibn Ismāʿīl al-Darazī, and when al-Ḥākim disappeared without trace in 1021/412 the followers of al-Darazī, the Druze, proclaimed that he was not dead but hidden, and would appear again at the end of time.[18] For al-Ẓāhir (r. 1021–36/412–28), al-Ḥākim's successor, such views were heretical, and the Druze were forced to flee to Syria and Palestine, where the main communities are still found today.

*The Assassins*

Just over half a century later a second schism was to occur. But if the first resulted from tension between ideological expectation and political reality, the second was, rather, the product of a much messier period of internal factionalism and economic difficulty, and had its immediate roots in rivalries between various army factions. These culminated in 1062/454 in open conflict between the Turkish, Berber and Sudanese contingents, the destructive consequences of which were exacerbated between 1066/459 and 1074/467 by repeated failures of the annual flooding of the Nile, so essential for agriculture.[19] As a result of the ensuing economic disruption[20] the Caliph al-Mustanṣir found himself unable to pay the Turkish troops garrisoned in the capital, who reacted by sacking the city and the palace treasury in 1067/460. This is one of the most lamented tragedies related by later historians such as al-Maqrīzī, who, in the late fourteenth century, as we will see in the following chapters, tells us about the thousands of objects which came out of the treasury[21] and were dispersed and sold on the market.

There followed a period of general anarchy and confusion which brought the Fatimid kingdom to the brink of collapse. Order was gradually restored when al-Mustanṣir brought in Badr al-Jamālī al-Juyūshī, an Armenian commander of the Fatimid troops in Syria,[22] who succeeded in crushing one by one the groups of rebellious soldiery. Badr al-Jamālī secured thereby the continuation of the dynasty and established important military and administrative reforms[23] but, appointed vizier with almost absolute power, he also claimed control of the ideological basis of the caliphate and had himself appointed by the Caliph al-Mustanṣir as Chief of the Missionaries (*dāʿī al-duʿāt*), an appointment that, apparently, was not very well received. Discontent was felt most keenly by a group of adepts led by Ḥasan-i Ṣabbāḥ, and when the Caliph al-Mustanṣir died they maintained their allegiance to Nizār, al-Mustanṣir's eldest son and rightful successor, who had been ousted and probably killed when attempting to regain the imāmate. For Ḥasan-i Ṣabbāḥ and his followers he was not dead, but had mysteriously disappeared, and remained the true Imām, now hidden.

With this schism the Assassins were born.[24] Agents from this faction became consummate masters in the art of infiltrating themselves among the intimates of high personages, only to murder them after a while. The unpredictability and perfect planning of these attacks made them feared political adversaries during the twelfth century, when they started to be known as al-Ḥashīshiyya, the Arabic word from which the word assassin comes.

After the crisis over the succession to al-Mustanṣir the Fatimid kingdom would never regain the splendour it had experienced during its golden age of the tenth and early eleventh centuries. By 1071/464 the Normans had completed the conquest of an already quasi-independent Sicily, and in subsequent conflicts with the Byzantines,[25] Seljuqs and Crusaders[26] the Fatimid grip on the cities of Syria and Palestine gradually weakened, with the last redoubt, Ashkelon, falling to the Crusaders[27] in 1153/548. Soon after, the Fatimid kingdom began to crumble

internally in Egypt itself, and it was not difficult for Saladin, the first Ayyubid ruler, to destroy it finally in 1171/567.[28]

*Trade*

The Fatimid period in Egypt, especially from the late tenth to the mid-eleventh century, coincides with an unusual increase in Mediterranean trade, with Egypt itself one of the major centres of activity,[29] so much so that for the late tenth-century geographer al-Muqaddasī the towns of Fusṭāṭ and Cairo were metropolitan centres of the world's commerce.[30] Among the main reasons for this development was Fatimid control over crucial trade routes. Apart from black slaves, trans-Saharan trade brought in gold mined in Sudan.[31] At the same time the Red Sea route to India[32] was being developed at the expenses of both the Persian Gulf route, affected by political instability, and the land route through Central Asia, affected by Turkish invasions. The importance of commercial activity along the Red Sea brought about a close alliance between the Fatimids and the Sulayhids of Yemen.[33] In the Mediterranean itself the Fatimids developed links with Italian cities such as Amalfi, Pisa, Genoa and Venice, whose merchants began to be assiduous visitors to Damietta and Alexandria, as well as to the ports of Syria.[34] Apart from precious spices from India, the goods traded with the Mediterranean ports included textiles.

Information about such trade is mainly found in documents from the eleventh century on recording the activities of Jewish merchants. The reason that these have been preserved is not commercial but religious: anything with the name of God written on it was not to be destroyed; rather it was disposed of in a Geniza , a storeroom of a synagogue. Most of this material has disappeared, but one synagogue in Cairo preserved its Geniza practically intact until this century, when its contents began to be unearthed and studied.[35] The importance of these documents cannot be stressed enough: they have shed light on several aspects of commercial life in the eleventh and twelfth centuries, and they will be referred to repeatedly in the following chapters.

# ARCHITECTURE

Economic prosperity provided an opportunity for artistic production and building on a large scale. But even if little now remains, there is evidence that impressive buildings had been constructed already during the early North African years of the dynasty.[36] Of the capital al-Mahdiyya the sources tell us that there were many palaces, houses, fine baths and khans (caravanserai),[37] but the archaeological evidence is scanty, and only the Great Mosque (fig.1), rebuilt on the model of its original Fatimid plan in the 1960s, provides some clue as to type.[38] Its plan was clearly inspired by the Great Mosque at Qayrawān, a hypostyle, T plan, but with projecting corner bastions flanking a central projecting portal, a construction

which might have been inspired by Roman triumphal arches[39] and by royal palace architecture of the Umayyad period.[40] In 947/336 al-Manṣūr, the third caliph reigning in North Africa, founded a new capital: Ṣabra Manṣūriyya,[41] at a short distance south-west of Qayrawān. It was to remain the Fatimids' capital until 972/362, when al-Muʿizz moved to Egypt. The site has only partially been excavated and only a few objects have been published,[42] so that in order to have an idea of the town we have again to resort to sources such as al-Muqaddasī who tells us that the plan of the city was circular, with the sultan's palace at its centre, as in Baghdad.[43]

Two further monuments in central Algeria from this period deserve mention, both produced by minor dynasties under Fatimid control: the palace of Ashīr, built around 947/336 when the Zirids founded their capital,[44] and the Qalʿa (citadel) of the Banū Ḥammād,[45] a town with a huge royal complex, founded by a Berber dynasty around 1010/401. The chronology of the Qalʿa is not clear, but, given certain similarities with buildings like the Cuba and especially the Zisa in Palermo,[46] it seems that its architecture influenced that of twelfth-century Sicily under the Normans. Noteworthy among the finds from the Qalʿa of the Banū Ḥammād are the ceramic tiles painted in lustre.[47]

After their conquest of Egypt the Fatimids embarked on a grandiose programme of building, some of which survives, while much more has been recorded by historians and geographers.[48] Writing in 985/375 al-Muqaddasī tells us that Cairo "is large and well-built, and has a handsome mosque. The royal palace stands in its centre. The town is fortified and has iron plated gates. It is on the highway to Syria, and no one can enter Fusṭāṭ without passing through it, as both the one and the other are hedged in between the mountain (al-Muqattam)

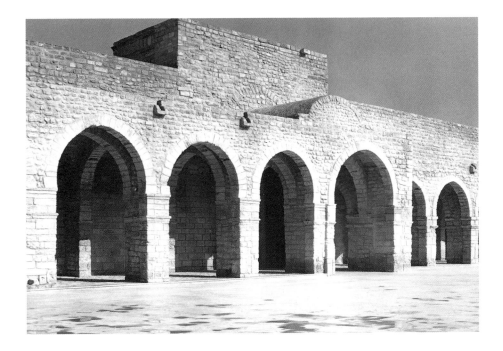

*1.* Mahdiyya, founded in 912/300: Great Mosque, entrance façade. Photograph courtesy of Josephine Powell

and the river."[49] Of the royal palace (the so-called Eastern, or Greater Fatimid, palace)[50] Nāṣir-i Khusraw in 1047/439 tells us that it rose in the middle of the walled enclosure of Cairo and was free-standing; that it consisted of twelve pavilions with ten gates; and that the various parts of the complex, which also included the kitchens and beautiful reception rooms, were connected by underground passages.[51] He also talks of another palace outside the city (possibly the Western, or Lesser Fatimid, palace) connected to it by an underground passage. Two Crusader envoys who were received in audience by the last Fatimid Caliph al-ʿĀḍid in 1167/563 relate that they were taken through many courts until they finally arrived at the throne room where the Caliph was seated behind a heavy curtain, and that when this was drawn the Caliph was revealed sitting on a golden throne.[52] Unfortunately, nothing survives of the two palaces: they were destroyed by the Ayyubids, the dynasty that succeeded the Fatimids. In fact, almost no architectural evidence remains of the palaces described in such abundant detail. The sole available clue is provided by the late tenth-century palace of Sayyidat al-Mulk,[53] the sister of the Caliph al-Ḥākim, and a similar structure, perhaps the Dār al-Quṭbiyya, which has recently been uncovered in the courtyard of the Qalāʿūn *madrasa* (religious school).[54] The palace featured a courtyard with four *īwāns* (vaulted or flat-roofed halls open at one end), three of them provided with a water channel at the rear, which presumably met at a fountain in the centre of the courtyard. A colonnaded portico to the north gave access to a deep narrow hall.

Of religious architecture rather more survives, enough indeed to demonstrate an interesting but not yet fully understood difference between earlier and later types. Typical of the early mosques are that of al-Ḥākim (fig.2), with its monumental portal,[55] and the al-Azhar mosque.[56] Their decoration continues earlier styles as seen in Samarra,[57] and consists of stucco, stone and wooden reliefs with geometrical, vegetal and epigraphical motifs. Fortunately, some of the splendidly carved wooden decoration of al-Ḥākim has been preserved, little *in situ*.[58] Both al-Azhar and al-Ḥākim mosques conform in plan to the typically hypostile, large congregational mosque, whereas in the later Fatimid period the plan of the mosques changes quite dramatically: like the mosque of al-Aqmar (1125/519; fig.3)[59] they become small sanctuaries which seem connected more to the cult of saints. However, certain continuities remain, and it has been suggested that the design of the portal of the al-Aqmar mosque may be related to the monumental portal of the mosque of al-Mahdiyya.[60]

In addition to mosques a number of important funerary and commemorative Fatimid monuments survive also in Egypt. Groups of small and simple mausoleums with a square plan, crowned by a cupola supported by simple squinches and octagonal drum, are found south of Cairo and around Aswān, in Upper Egypt.[61] Mausoleums of bigger dimensions, with the same plan but usually crowned by a ribbed cupola, are those of Sayyida Nafīsa (1089/482),[62] Muḥammad al-Jaʿfarī and Sayyida ʿĀtika (ca. 1100/494), Shaykh Yūnus (1100–25/494–519),[63] and Yaḥyā al-Shabīh (ca. 1150/545).[64] In these mausoleums

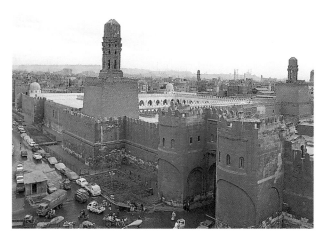

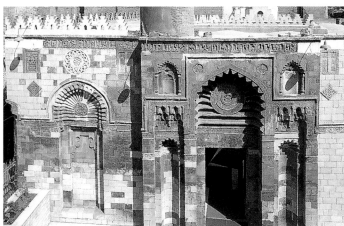

*2.* Cairo: al-Ḥākim mosque, 990–1013/384–403. General view with city walls and Bāb al-Futūḥ, 1087/480. Photograph courtesy of Bernard O'Kane

*3.* Cairo: al-Aqmar mosque, 1125/519. Façade. Photograph courtesy of Bernard O'Kane

we also find the use of the *muqarnas* (stalactite) instead of the squinch to provide a transition from the wall to the cupola. Of particular interest are the sanctuaries called *mashhad* (places for prayer, pilgrimage and religious piety). The most important are those of the cemetery of Aswān (1100–10/494–504), Umm Kulthūm (1122/516), Sayyida Ruqayya (1133/527)[65] and al-Juyūshī (1085/478).[66] This last, situated on top of the al-Muqattam hills outside Cairo, has usually been considered a mosque, but is referred to as a *zāwiya* (chapel) in a contemporary inscription and was probably erected to commemorate the victories of the vizier Badr al-Jamālī al-Juyūshī after the crisis of the 1060s discussed above. The *mashhads* have a complex entrance (with a cupola at Aswān, dominated by a minaret at al-Juyūshī) which leads to a courtyard, while the inner sanctuary has an ample cupola over the *miḥrāb* (niche that marks the direction to Mecca), in the case of al-Juyūshī splendidly decorated with stucco work.

Perhaps the most spectacular constructions of the whole Fatimid era were ordered by the same vizier Badr al-Jamālī al-Juyūshī. They are neither mosques nor sanctuaries but the massive city walls, partially preserved, especially the three main, fortified city gates: the Bāb al-Naṣr (fig.4), Bāb al-Futūḥ and the Bāb al-Zuwayla, all in solid stone with bastions and towers.[67]

THE ARTS

Among the decorative arts of the African period, the sources tell us of the production of textiles,[68] obviously continuing an Umayyad and Abbasid tradition, as represented by a textile with an inscription mentioning al-Marwān (plate 12). One mentioning al-Muʿizz (dated 965/354) has been identified as the earliest

dated Fatimid textile.[69] Also mentioning al-Muʿizz in its dedicatory inscription, and made in Manṣūriyya, is an ivory rectangular box (fig.5).[70] It can therefore be dated to between 952/341 and 972/362. Its inscription contains a Shīʿī formula,[71] which we will see repeated in some of the inscriptions considered in the chapter on textiles.

Rather more survives of ceramic production from Fatimid North Africa, and in addition to the tiles of the Qaʿla of the Banū Ḥammād mentioned above we have several examples of a glazed, polychrome pottery of remarkable variety,[72] where manganese, yellow and green are the preferred colours. The decorative repertoire varies from human beings occupied in different activities (especially hunting or warfare) to animals and to epigraphical bands (fig.6). Such wares continued to be produced after the Fatimid conquest of Egypt where, however, a totally different range of pottery started to be made.[73]

A further area that needs to be taken into consideration is the arts of the book. But, together with the Palaces, the great Fatimid library, one of the richest of the medieval world, containing books (including illustrated ones) in many languages and covering all scientific and literary subjects, was dispersed when the dynasty fell in the twelfth century.[74] Even examples of illuminated Qurʾāns from the period are extremely rare. However, we are fortunate that one complete example has survived, dated 1037/428, now in the Chester Beatty Library in Dublin (figs 7 and 8).[75] This can be attributed to Fatimid Egypt on the basis of the correspondence between its decoration and calligraphic style and those seen on Egyptian metalwork, architecture and wooden panels of the eleventh century. But perhaps the most striking example is the so-called Blue Qurʾān, written in

*4.* Cairo: city walls and Bāb al-Naṣr, 1087/480. Photograph courtesy of Bernard O'Kane

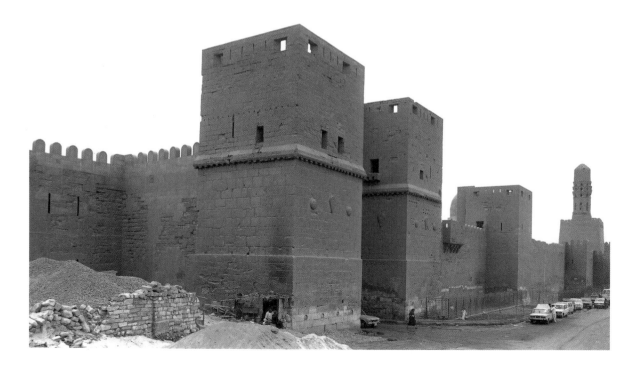

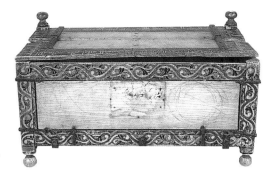

*5.* Casket of wood with ivory inlays (L. 42 cm; W. 24 cm; H. 20 cm) made for the Fatimid Caliph al-Muʿizz, second half of the 10th century.
Archivo Fotográfico, Museo Arqueológico Nacional, Madrid: 887

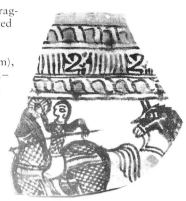

*6.* Ceramic fragment decorated in coloured glazes (max. Diam. 12.5 cm), Tunisia, 10th–11th century.
Benaki Museum, Athens: 11762

*7.* Fatimid Qurʾān (H. 9.3 cm x W. 7.7 cm), dated 1037/428. Fols 150v–151r.
Reproduced by kind permission of the Trustees of the Chester Beatty Library, Dublin: Is 1430

*8.* Fatimid Qurʾān, dated 1037/428. Detail of illuminated chapter heading on fol. 151r.
Reproduced by kind permission of the Trustees of the Chester Beatty Library, Dublin: Is 1430

gold letters on indigo-dyed parchment, which can be ascribed, on the basis of documentary evidence, to tenth-century Fatimid North Africa.[76] Various other pages from Qurʾāns can be attributed to the Fatimid period, including one in the V&A (Ms.L.31-1985; fig. 9), but of the secular manuscript production little survives. One complete work is an interesting eleventh-century compendium by a Fatimid court musician, Ibn al-Ṭaḥḥān,[77] who flourished under the Caliph al-Ẓāhir (1021–36/411–27).

As far as painting is concerned, it is only from the fragments on paper with sketches, drawings and paintings that have been found at Fusṭāṭ, most of which are now in the Keir collection in London,[78] that we can gain some idea of the style of the Fatimid period.[79] Some are simple sketches in black ink (fig.10), others are coloured with light colours (fig.11), while others remind us of the impressionistic painting style of classical wall paintings.[80] A page in the Metropolitan Museum of Art in New York[81] is of particular interest as it may be the earliest evidence to have survived of an Islamic illustrated bestiary (figs 12 and 13). Datable to the early twelfth century, it contains two miniatures, one of a hare, the other of a lion, and if the hypothesis that it comes from a bestiary is correct it may mark the earliest stage of what was to become a flourishing

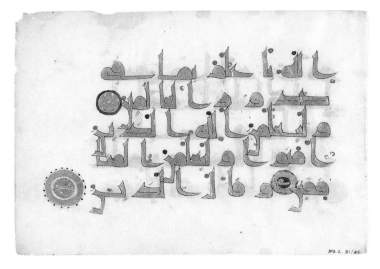

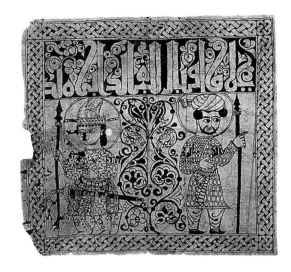

9. Vellum page from a Qur'ān (H. 15 cm x W. 21 cm), Fatimid period, 10th century. Ms.L.31-1985

10. Drawing on paper (H. 14 cm x W. 14 cm) of two warriors, found at Fusṭāṭ, Fatimid period, 11th century. Museum of Islamic Art, Cairo: 13703-15601

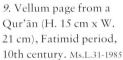

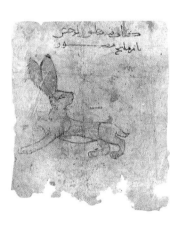

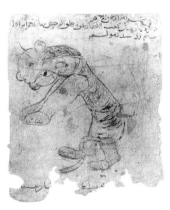

12 and 13. Drawings of a hare and a lion on a paper page (max. H. 15.7 cm; max. W. 12.1 cm) from a bestiary, found at Fusṭāṭ, Fatimid period, 11th century. Metropolitan Museum of Art (Rogers Fund 1954), New York: 54.108.3

11. Paper fragment of a painting, (H. 23.2 x W. 14.7 cm), found at Fusṭāṭ, Fatimid period, 11th century. Keir Collection, Richmond, England: I.11

tradition of illustrated bestiaries.[82] Another interesting piece, now in the British Museum, is a fragment of a rather large composition showing, according to Basil Gray, a battle between Arabs and Knights (fig.14).[83] The Knights are distinguished by their helmets with nose guards, their coats of mail, and kite-like shields, whereas the Arabs are bare-headed, do not have a coat of mail and have the typical Middle Eastern buckler. Found in Fusṭāṭ, the fragment nevertheless presents strong parallels with contemporary glazed pottery from Mahdiyya and Ṣabra Manṣūriyya both in the style of the figures and in the palette employed (fig.6).[84]

It is impossible to establish a coherent development of book illustration of the period on the basis of the little that remains, but it is possible to sketch an idea of styles of painting on the basis of this and material in other media[85] such

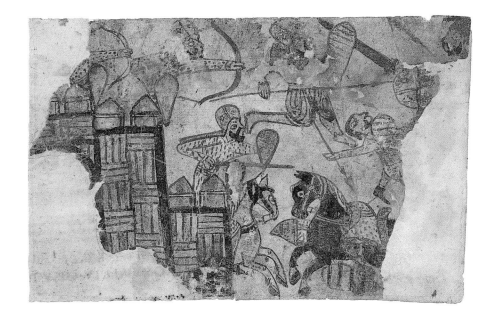

*14.* Paper fragment (max H. 21 cm; max W. 31.5 cm) with a battle between Arabs and Knights, found at Fusṭāṭ, Fatimid period, 12th century. © The British Museum, London: 1938.3-12.01

as pottery, and wall and wood painting. A major cycle of presumably Fatimid paintings survives in Norman Sicily, in the wooden ceiling of the Cappella Palatina of the palace of Roger II, of ca. 1140,[86] and other examples, perhaps by artists from Egypt or North Africa, are preserved in the Cefalù cathedral.[87] The hypothesis that the artists either came from the Fatimid kingdom or were working in a well-established Fatimid tradition is reinforced by the recent discovery of a carved, wooden ceiling in Cairo, datable to the late tenth century, painted with flowers and animals.[88]

On the basis of the paper fragments and the pottery material, Fatimid painting may be situated within what has been called a "classical style",[89] a term which in this context is used to embrace extensions not only of the Greco-Roman tradition but also of the very similar stylistic traits, as exhibited, for example, in the human faces of the third-century Central Asian paintings of Miran.[90] Thus, just as the other Fatimid arts to be considered in the following chapters can best be understood in a wider art-historical context, the study of Fatimid painting needs to take account of both its links to "classical" antecedents and its own prolongations beyond Fatimid Egypt itself: to the twelfth-century paintings of the Cappella Palatina in Sicily and also to the early thirteenth-century North African or even Andalusian miniatures of the *Ḥadīth Bayāḍ wa Riyāḍ*.[91]

## NOTES

1. For Ismāʿīlism see Madelung "Ismāʿīliyya"; Dodge 1959; Ivanow 1942; Stern 1983; Daftary 1990; Brett 1994.

2. For the history and interpretation of the Fatimid dynasty see Canard "Fatimids"; Wüstenfeld 1881; Lane-Poole 1901; O'Leary 1923; Wiet 1937; Levy 1957; Ḥasan 1958; Lewis 1972; Lombard 1975; Brett 1980; Lev 1991; Halm 1991; Sayyid 1992; and Brett 1996, which is a critical survey of the main scholarship on the subject.

3. Dodge 1960.

4. For the messianic expectation of a Mahdī see Halm 1978.

5. See Mekky 1972; also Contadini 1993, especially p. 108.

6. For the Fatimid ceremonial and its connections with that of the Byzantines see Canard 1951 and 1973a.

7. Al-Muqaddasī 1994, p. 181.

8. For the Fatimids in North Africa see Marçais 1946; Dachraoui 1961; Idris 1962; Talbi 1966; Dachraoui 1981; Brett 1987.

9. Either to escape Abbasid investigations, or to escape a conspiracy against him within the Ismāʿīlī movement, that of the so-called "three Karmati brothers": Ivanow 1942, pp. 75 ff.

10. For the Fatimids and Sicily see Amari 1933–8; Canard 1956; Canard 1973b; Johns 1995; for the Arab dominion in Sicily in general see Gabrieli and Scerrato 1985, pp. 35–105.

11. For the Fatimid conquest of Egypt see al-Maqrīzī 1895; Guest 1912; Wiet 1937; Bianquis 1972; Sato 1972; Canard 1973b; Lev 1979; Morimoto 1981; Brett 1984.

12. For the Ismāʿīlī and Fatimid *da'wa* see Ivanow 1939; Vatikiotis 1954 and 1957a; Hamdānī 1956a and 1956b; Dodge 1960; Canard 1973b; Madelung 1977 and 1985; May 1975; Stern 1972; Stern 1983.

13. For Fatimid military organization see Parry and Yapp 1975; Beshir 1978; Lev 1980; Lev 1984.

14. For the Fatimids in Syria and Palestine see Zakkar 1971; Salibi 1977; Lev 1981; Yusuf 1985; Bianquis 1986–9. On Karmati/Fatimid relationship see De Goeje 1886; also al-Maqrīzī 1967–73, I, pp. 248 ff.

15. For the failed Fatimid attempt to combine political power with religious authority see Crone and Hinds 1986.

16. For the reign of al-Ḥakim see Van Ess 1977; Vatikiotis 1955.

17. Assad 1974; for the *da'wa* during the reign of the Caliph al-Ḥakim see Walker 1993.

18. For the Druze see Bryer 1975–6.

19. For agricultural policy under the Fatimids see Guest 1912; Sato 1972; Morimoto 1981; Brett 1984.

20. For the economy of Egypt and North Africa during the Middle Ages see Vanacker 1973; Daghfous 1977; Udovitch 1981.

21. For the Fatimid treasury and the account of al-Maqrīzī see Kahle-Bonn 1935.

22. Canard 1955.

23. For these reforms and the establishment of feudalism during the Fatimid period see Poliak 1936; Cahen 1953; Cahen 1972b; Rabie 1972.

24. For the Assassins see Hodgson 1955; Vatikiotis 1957b; Lewis 1967.

25. The members of the sect were dispersed after the Mongol invasion of 1256, but have not disappeared: they are found today in the Indian subcontinent, especially around Bombay.

26. For Fatimid/Byzantine relationships see Stern 1950; Ostrogorsky 1956; Hamdānī 1974; Forsyth 1977; Lev 1984.

27. For the Fatimids and the Crusades see Setton 1955; Runciman 1951–4; Smail 1956; Elisséeff 1967; Holt 1986.

28. For Saladin and the end of the Fatimid empire see Cahen 1947; Ehrenkreutz 1972; Lyons and Jackson 1981.

29. Mann 1920–2; Goitein 1950; Lewis 1951; Ashtor 1978; Lombard 1978.

30. Al-Muqaddasī 1994, pp. 181–3. For the town of Fusṭāṭ see Kubiak 1987.

31. For trans-Saharan trades see Brett 1969 and 1983.

32. Lewis 1949–50; Goitein 1963; see also Barnes 1990.

33. Hamdānī 1931.

34. Cahen 1972a.

35. These documents have been first studied by Goitein 1967–88.

36. For the origins of Fatimid art see Bloom 1985.

37. Al-Maqrīzī 1967–73, I, p. 79; Ibn Ḥawqal 1938, I, p. 71.

38. Creswell 1952, pp. 5–9. For Fatimid architecture in North Africa see Marçais 1954; Lézine 1965, pp. 65 ff. for the mosque at Mahdiyya.

39. Marçais 1954, pp. 106 ff.

40. Ettinghausen and Grabar 1987, p. 169.

41. Marçais 1954, pp. 79–81; Idris 1962, pp. 425–7.

42. Marçais and Poinssot 1952, II, pp. 271–406; Zbiss 1956.

43. Al-Muqaddasī 1994, p. 203; see also Bloom 1985, p. 29.

44. Golvin 1957, pp. 180 ff.; Hillenbrand 1994, p. 438, plan 7.172.

45. Golvin 1965; Hillenbrand 1994, pp. 439–41, plans 7.173, 7.176–7, 7.179.

46. Bellafiori 1978; Hillenbrand 1994, pp. 440–2.

47. See Chapter 3, note 37.

48. Including later historians such as al-Maqrīzī 1853.

49. Al-Muqaddasī 1994, p. 184.

50. Creswell 1952, pp. 33–4; Hillenbrand 1994, p. 435.

51. Nāṣir-i Khusraw 1881, p. 128.

52. Creswell 1952, p. 33.

53. Hillenbrand 1994, p. 435, plan 7.160.

54. Hillenbrand 1994, p. 435.

55. For the mosque of al-Ḥakim see Creswell 1952, pp. 65–106. Also Bloom 1983 for an interpretation of the minarets.

56. For the al-Azhar mosque see Creswell 1952, pp. 36–64.

57. Ettinghausen 1952, pl. X, no. 3.

58. Especially in the Museum of Islamic Art in Cairo and in the Musée du Louvre. For an illustration of beams *in situ* see Ettinghausen and Grabar 1987, fig. 169.

59. For the al-Aqmar mosque see Creswell 1952, pp. 241–6. For inscriptions on architecture of Fatimid Cairo see Bierman 1997.

60. Williams 1983 and Bloom 1985, p. 23.

61. Monneret de Villard 1930; Creswell 1952, pp. 131–45.

62. Creswell 1952, pp. 257–8.

63. Creswell 1952, pp. 227–38.

64. Creswell 1952, pp. 264–9.

65. Creswell 1952, pp. 239–53.

66. Creswell 1952, pp. 155–60; Hillenbrand 1994, pp. 314–15; Raghib 1987.

67. For these see Creswell 1952, pp. 166–217.

68. Al-Jawdharī 1954, pp. 52–3.

69. Cairo, Museum of Islamic Art, acc no. 13165. The textile in question, of embroidered cotton, was attributed by Lamm to Khurāsān (Lamm 1937, pl. XVI–c), but it has later been interpreted by Marzouk as the earliest dated Fatimid textiles: Marzouk 1957. For the inscription see *Répertoire*, V, no. 1622.

70. The box was found at Carrion de los Condes in Palencia, and is now in the Museo Arqueológico Nacional in Madrid, inv. no. 887: Ferrandis 1935–40, no. 9; Kühnel 1971, no. 20, pl. VIII; Hayward 1976, p. 151, no. 145.

71. *Répertoire*, V, p. 89, no. 1811.

72. For North African pottery see Ventrone 1974, pp. 85–102; for the rich material recovered in Italy see Berti and Tongiorgi 1981; for other material see Philon 1980, figs 124–30.

73. See Chapter 3.

74. See Wiet 1963.

75. Is 1430: see Arberry 1967, no. 42, p. 15.

76. The Qur'ān is dispersed in various public and private collections. For a Fatimid attribution see Bloom 1989 and, more recently, to Islamic Spain: Stanley 1996, pp. 7–15.

77. *Ḥāwī al-funūn wa-salwat al-maḥzūn*, now in the Dār al-Kutub in Cairo, Ms funūn jamīla 539: see Ibn al-Ṭaḥḥān 1990 (facsimile edition with critical notes by E. Neubauer).

78. Grube 1976 and 1987.

79. Some 158 fragments have been listed by Grube 1985 with their present location.

80. As in the case of the page representing a cockerel, now in the Metropolitan Museum of Art in New York, acc. no. 54.108.1: Grube 1963.

81. Acc. no. 54.108.3: Grube 1963.

82. See Contadini 1988–9 and 1994.

83. British Museum, Department of Prints and Drawings, inv. no. 1938.3-12.01: Gray 1938.

84. This consists of yellow, green, brown and red colours, characteristics also shown by a comparable fragment in the Benaki Museum in Athens: see fig. 6.

85. Ettinghausen 1942.

86. For these paintings see Monneret de Villard 1950 and for some colour reproductions Gabrieli and Scerrato 1985. See also Grube 1994.

87. Gelfer-Jørgensen 1986.

88. Meinecke-Berg 1991.

89. Grube 1968, especially pp. 11–15.

90. Bussagli 1963, especially illustrations on pp. 18 and 25.

91. Rome, Biblioteca Vaticana, Ms. Ar. 368: Monneret de Villard 1941.

# 1: ROCK CRYSTAL

## SUBSTANCE

Rock crystal is the purest kind of quartz. It is found all over the world and is, in fact, one of the most common minerals in the Earth's crust, occurring in hexagonal crystals, some only tiny specks, others as long as a metre. The largest crystals, some of which may have a circumference of several metres, have been found in Madagascar, but some of the best specimens have come from cavities known as crystal caves in the schists of the Swiss Alps. It is theoretically possible to tell the provenance of rock crystal by examining the composition of the impurities within it, which vary according to locality.[1] But as the pieces to be discussed here all have a very low occurrence of impurities it would in fact be very difficult to pinpoint the sources of supply.

On the Mohs scale,[2] the standard measure for hardness, which goes from 1 for talc up to a maximum of 10 for diamond, it stands at 7 (as compared with 6 for glass). As glass does not polarize light, a polariscope may be used to distinguish it from rock crystal, which does.[3]

According to Aristotle rock crystal was a kind of glass, but harder and more compact, while for other classical authorities the combination of crystalline structure and translucency suggested an analogy with ice. Although Solinus in the third century BC observed that rock crystals are also found in warm climates, the frozen ice concept continued to hold sway. Pliny the Elder (first century AD) wrote that a violently contracting coldness forms the rock crystal in the same way as ice, and the medieval authority known as Theophilus believed that rock crystal was ice frozen so hard that it could not melt again. For the great polymath al-Bīrūnī (973–1048/363–440), who wrote a work on minerals, rock crystal is a compound of air and water, and he refers to an earlier Book of Stones according to which it is a type of mineral glass, whereas glass is a type of artificial rock crystal.[4]

Rock crystal is a poor heat conductor and consequently feels warmer than glass. Because of the frozen ice theory, however, a cooling effect was ascribed to rock crystal in antiquity. Solinus thought that crystal vessels could not tolerate heat, and Pliny likewise wrote that because rock crystal is formed from rainwater and pure snow it could not stand extreme heat. Although their arguments

bear no sign of being derived from observation, it is in fact correct to say that rock crystal can react to heat. As it is a poor heat conductor, if only part of a crystal object is heated, the other part remains relatively cool, thus creating tension. In extreme circumstances explosion can result, and accidental cases have been recorded associated with both natural sources (the sun) and artificial ones (photographic lamps).[5]

In addition to theorizing about the origin of rock crystal, early authorities also pronounced upon its properties, ascribing to it magical powers. It was claimed, for example, that those who enter a temple with a crystal in their hands will have their prayers heard. Its curative powers included healing sick kidneys, and ground with honey it could increase a mother's milk. In the Middle Ages it was believed that it healed dropsy and toothache and, when worn as an amulet, protected against haemorrhage and thirst.[6]

## SUPPLY

According to Pliny,[7] crystal was imported from the Orient, that from India being particularly prized. It was also found in Asia Minor and in Cyprus, where, however, it was not much in demand; on the other hand, crystal from the Alps in Europe was in great esteem. Another source was an island called Necron, which he situates in the Red Sea, in front of Arabia, but which may possibly be Madagascar. He also says that the biggest rock crystal piece that he has ever seen is one that the Empress Livia had in the Capitol, weighing 50 *libra* (about 17 kg).[8] Among Islamic authorities, al-Tīfāshī (d. 1253/651)[9] says that at thirteen days' journey from Kashgar there are two mountains the interiors of which consists entirely of beautiful rock crystal; it is worked at night, as the reflection of the sun's rays renders work by day impossible. Al-Akfānī (d. 1348/749)[10] gives the fullest account of the places in which it is found: according to him it comes from East Africa (Zanj), Badakhshan, Armenia, Sri Lanka, the land of the Franks and Morocco. Al-Bīrūnī tells us that rock crystal "is the most precious of stones. Its worth lies in its clarity, and in being like a combination of two of the four elements: air and water" and that in fact "it unites the fineness of air with the clarity of water". He speaks of rock crystal being imported from the "Isles of Zanj" (East Africa) and from "al-Dībājāt" (the Laccadive and Maldive Islands) to Baṣra, where it was worked by local craftsmen. Further, he says that pieces of cut or uncut rock crystal are imported from Kashmir and made into various objects: vases, beakers, chess and backgammon pieces and beads as big as hazelnuts. However, rock crystal from this source remains inferior to that from Zanj in quality (translucency and purity), and its workmanship is not as skilful as that of the Baṣra craftsmen. According to him, it is also found in al-Jibāl (part of Iraq, or, according to Le Strange, "Lands of the eastern Caliphate", north-west Persia/Azerbaijan) and, in large quantities, in Wakhkhān (Pamir and Hindukush) and Badakhshān (Balkh), but nobody bothers

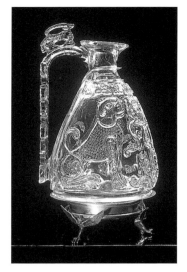

*15.* Rock crystal ewer (H. 23 cm, including mount; Diam. ca. 12.5 cm) of the Fatimid Caliph al-'Azīz, 975–96/365–86. Treasury of San Marco, Venice: 80

*16.* Rock crystal ewer (H. 15.6 cm; Diam. of base 7.7 cm), Fatimid Egypt, 1000–8/391–9. Museo degli Argenti e delle Porcellane di Palazzo Pitti, Florence: 1917

to import it. Al-Bīrūnī also quotes earlier Arab authorities, including al-Kindī (d. ca. 866/256), for whom the best rock crystal is the Arabian one found among the pebbles of the desert, some crystals weighing two *raṭl*.[11] Other claims are that rock crystal from Sri Lanka is good but not as clear, and similarly with that found underground; that pieces may weigh as much as 200 *raṭl*; and that rock crystal is found in Armenia and Bidlis. Another authority he quotes, Naṣr, says much the same as al-Kindī, apart from finding the Sri Lankan crystal to be better than the Arabian. Finally, al-Bīrūnī mentions impurities and how these are disguised by decoration or by inscriptions, although if the impurities are too many the piece is termed dirty crystal.

Nāṣir-i Khusraw,[12] writing in the mid-eleventh century, tells us that unworked crystal from the Maghreb was being replaced by finer quality material from Qulzūm on the Red Sea; and he also gives an eye-witness account of the working of pieces in Fatimid Cairo.

We are thus offered information on a wide range of sources of supply in the Islamic period, decided opinions about variations in quality and references to two widely separated centres, Baṣra and Cairo, for the working of rock crystal in the tenth and eleventh centuries.

If one thinks of the size of the Fatimid crystal ewers, where the handle is integral with the body, it is clear that crystals of huge size must on occasion have been found. But the challenge they presented was by no means novel. Because of its purity, beauty and permanence, rock crystal had been fashioned into objects of particular rarity since classical times, and in the central lands of the Islamic world – Persia, Iraq, Syria and Egypt – it was carved most probably from the very beginning, in the seventh century, up to the eleventh century, when production ceased abruptly, eventually to be revived in the sixteenth century, under Mughal patronage in India and Ottoman in Turkey. Indeed, at the time of the Great Mughal in Aurangpur, near Delhi, there were mines that provided rock crystal, and although these are now exhausted the workings are still visible.

## IDENTITY AND PROVENANCE

Just under 180 carved rock crystals of the early Islamic period have survived,[13] a large number of them from the period between the ninth and the eleventh centuries. Many are preserved in royal and church treasuries of Western Europe, where a few arrived as early as the tenth century; others are in public and private collections, a few having been found in archaeological excavations, notably those at Fusṭāṭ, the earliest Islamic settlement of Cairo.[14] The majority were

fashioned as containers such as ewers and flasks of various forms and cups and dishes. But we also find examples of maceheads and, possibly, sword or dagger pommels. Other objects include a lamp and a number of chess pieces,[15] while smaller pieces were worked as small animals (sometimes transformed into chess pieces),[16] pendants and beads, amulets and seals.

These items were for a long time all attributed to Fatimid Egypt. But references in literature, as we have seen, indicate that rock crystal was also worked elsewhere in the Islamic world; and objects of this kind were known in Syria and Mesopotamia in the Umayyad and Abbasid periods. When talking about Islamic rock crystal, problems of provenance, attribution and date are often acute; and the most basic question is how a piece can be identified as Islamic at all, rather than Byzantine, European or pre-Islamic.

In fact, with so many rock crystal pieces being held in European collections, churches and family treasuries, objects now acknowledged as of Islamic origin have in the past been treated very largely as a form of European medieval art. Of the V&A collection a rock crystal flask (plate 6), a chess piece (plate 10) and a ewer (plate 7) were bought by the Museum between 1862 and 1883 as Byzantine objects. Later the opinion of scholars was reversed, and in the 1910 "Exhibition of Mohammedan Art" in Munich fourteenth-century crystal vessels now known to be Burgundian were regarded as Fatimid, even if reservations about their not very close stylistic connections were expressed.[17] Already in 1907 Migeon[18] had discreetly separated the Burgundian ones from the Fatimid group (by not mentioning them), but in 1912 Schmidt still considered both groups together,[19] as did Kühnel in 1925, followed by Longhurst in 1926.[20] The arguments adduced related primarily to morphology, a common origin being claimed on the basis of the angled handles of all these vessels. But the right angle of the handle probably derives ultimately from a classical source, as Roman rock crystal jugs have that characteristic, as shown by one in the V&A (A.74-1952), and in a crisply argued article published in 1930 von Falke was able to establish that the two groups are sufficiently different in shape and style to exclude any possibility of a common origin.[21]

But if the Burgundian group can now be distinguished as separate, the Fatimid identity of the other one still needs to be established. In fact there are cogent reasons for an attribution to Fatimid Egypt of several of the rock crystal vessels that have survived, the most fundamental being that for three pieces the evidence is incontrovertible: they have inscriptions which relate them to known personages, and hence fix them in both time and place. One of the ewers in the treasury of San Marco, Venice (fig.15), bears a dedicatory inscription to the Fatimid Caliph al-'Azīz (975–96/365–86);[22] the ewer in the Pitti Palace Museum in Florence (fig.16) has an inscription which refers to the Fatimid Caliph al-Ḥākim's general Ḥusain ibn Jawhar (*qā'id al-quwwād*), and is therefore datable to 1000–8/391–9;[23] and a crescent-shaped piece in the German Museum at Nuremberg (fig.17) is inscribed with the name of the Fatimid Caliph al-Ẓāhir (1021–36/411–27).[24] The theoretical possibility that all three pieces could have

*17*. Rock crystal crescent-shaped piece (Diam. ca. 19 cm) of the Fatimid Caliph al-Ẓāhir, 1021–36/411–27. Germanisches Nationalmuseum, Nuremberg: KG 695

been commissions executed outside Egypt is too far-fetched to be entertained seriously, and in view of the sherds found at Fusṭāṭ local production must be taken as assured, particularly given that some must be from vessels damaged in the working.[25] We may therefore turn next to stylistic evidence, which not only suggests an Egyptian attribution for other pieces closely related to the above three in terms of design, decoration and technique but also points through them to identification on the basis of elements having evident affinities with Islamic art from Egypt of the ninth and tenth centuries as exhibited, for example, in the calligraphic repertoire of the various formulaic benedictory inscriptions. There is, further, circumstantial evidence: the contemporary accounts of the Persian traveller Nāṣir-i Khusraw, mentioned above, who visited Fatimid Egypt at intervals between 1046 and 1050, tell of the vessels produced and sold in the lamp market in the Cairo bazaar, where he saw "rock crystal of perfect beauty and artistically worked by craftsmen of elegant taste";[26] and the description by the Qāḍī (judge) Ibn al-Zubayr of the palace treasures of the Caliph al-Mustanṣir (1036–94/427–87), as reported by the fourteenth-century historian al-Maqrīzī, speaks of a multitude of rock crystal vessels in the treasury. We thus have conclusive evidence both of Fatimid rock crystal production, of court patronage and collection, and of the existence of commercial workshops producing for the open market.

## CRAFT HISTORY

The ewer in the treasury of San Marco (fig.15), together with the others associated with it, represents a pinnacle of artistic achievement, and the outstanding skills of the Egyptian craftsmen who produced it in the last quarter of the tenth century must have been the result of long experience in a highly developed tradition. Unfortunately, we have no solid information on the way in which that tradition evolved, and its economic (and social) structure during the Fatimid period remains almost as obscure as its origins. Al-Bīrūnī tells us that in Baṣra the rough crystal is first seen by an assessor (*muqaddir*, someone who judges the shape) who decides what to make out of the small and big pieces, and writes this on each of them. Then the pieces are taken to the craftsman who carves them. The biggest fee goes to the assessor, according to the difference between concept and execution.[27] From Nāṣir-i Khusraw's remarks on the carving and sale of rock crystal in the Cairo bazaar we can at least infer that, even if there might have been a royal workshop in which the finer and more expensive pieces were produced, there were certainly commercial workshops producing for the open market, and it is reasonable to suppose that the organization and hierarchy of the trade was similar to that described by al-Bīrūnī. The existence of a commercial market sector may also suggest economic parallels with the production of paper and manuscripts: it certainly stands in contrast to the Fatimid state monopoly on textiles.

# ORIGINS AND DEVELOPMENT

But just as there is no hard and fast evidence here, so also reflections on origins and development proceed, ultimately, by analogy, relying on the repertoire of design and decoration to suggest possible relationships and lines of diffusion, and making assumptions on the basis of what is known about the evolution of related but antecedent crafts. It seems logical, for example, that the origins of the craft of working rock crystal are to be sought in those regions where there already existed a tradition of hardstone carving and glass cutting. This connection was pointed out in the Middle Ages, by Theophilus, who states that glass is cut in the same way as precious and semi-precious stones like onyx, emerald, jasper and rock crystal. In the early centuries of the Roman empire centres for these related crafts existed in both Egypt, where Alexandria was famous for the production of cameos,[28] and Syria, where fine cut-glass vessels were being produced.[29] But these later declined, to be supplanted by those of Constantinople, Italy and other centres in the more northerly regions of the empire,[30] and on present evidence it seems unlikely that the industry still existed in Egypt at the time of the Arab conquest. In Persia, on the other hand, there was a flourishing industry of hollow-cut and relief-cut glass under the Sasanian emperors, and vessels carved in agate have been attributed to Persian workshops.[31] Moreover, there is no disputing the Persian provenance of the so-called "Cup of Solomon" now in the Bibliothèque Nationale in Paris.[32] This famous dish of gold with inset roundels of garnet, green glass and rock crystal carved in the form of rosettes was, according to tradition, given by the Emperor Charles the Bald to the Abbey of Saint-Denis. The large central roundel is of rock crystal, carved in relief with the Sasanian emperor shown seated on a throne supported by winged horses. The emperor has been variously identified as Khusraw I (531–79) and Khusraw II (591–605).

We do not know where in the Sasanian empire the dish was made, but the most likely place would have been Ctesiphon, the capital of the Sasanian empire, in present-day Iraq. Evidence for the survival of a late pre-Islamic tradition of glass carving in Iraq into the early Islamic period is provided by the fragments of vessels in so-called "crystal glass" among the finds from Samarra in the British Museum.[33] These are faceted, and the manner of handling suggests that of crystal carving. Evidence for rock crystal carving in this area is provided by finds at Susa and Wāsiṭ. The Louvre holds a rock crystal dish[34] which was acquired in 1912 from clandestine excavators at Susa. Furthermore, a piece has been excavated at Wāsiṭ (Iraq), under the Great Mosque.[35] In addition to these pieces, the provenance of which is assured, there is a goblet in the British Museum, said to have been found at Qazwīn,[36] and a rock crystal dish sold on the market in 1985, of alleged Persian or Iraqi provenance.[37] Consequently, it is logical to hypothesize that the earliest Islamic rock crystal carvings were made somewhere in Persia or Iraq.

*18.* Detail of plate 7, showing the "line and dot" motif.

*19.* Buckley Ewer, clear cut relief glass (H. 23.8 cm), Persia (?), 10th–11th century. C.126-1936

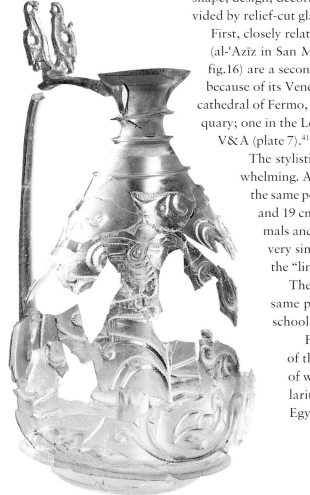

# CHRONOLOGY

More problematic is the dating of these pieces. The possibility of an early Islamic date is confirmed by their common decorative repertoire. This consists of relief cutting on the exterior with a palmette motif, medallions with a square enclosing a circle in between. The rim of the dishes is cross-hatched with a fan palmette at either end, and they can, therefore, be linked more easily to objects of the Islamic than of the Sasanian period.[38] Despite this, the Louvre's rock crystal dish has been variously published as either third or fourth century or seventh century.[39] However, as there are no certain Sasanian objects of comparable shape or decoration, the Sasanian dating remains to be proved, and quite apart from the decoration the historical context raises the possibility of an early Islamic date: in the fourth century Susa was destroyed and only partially reinhabited by the late Sasanian period, whereas in the early Abbasid period it was once again a flourishing city.[40]

We have, then, the likelihood of a centuries-old rock crystal tradition in the East (with a possible prolongation into the eleventh century, at least at Baṣra); and the certainty of Egyptian production in the late tenth and early eleventh centuries. The questions of, first, the extent of that production, second, its duration, and, third, its possible links with the Eastern tradition can be answered, in the present state of our knowledge, only on the basis of stylistic affiliations in shape, design, decoration and technique, and call on the parallel evidence provided by relief-cut glass.

First, closely related to the two Fatimid ewers with identificatory inscriptions (al-'Azīz in San Marco, fig.15, and of al-Ḥākim's general in the Pitti Palace, fig.16) are a second one in the San Marco treasury (called a rock crystal cruet because of its Venetian, probably thirteenth-century, metal mount); one in the cathedral of Fermo, again in Italy, which has a missing handle and is now a reliquary; one in the Louvre, from the Treasury of Saint-Denis; and the one in the V&A (plate 7).[41]

The stylistic evidence for the unity of this group of six ewers is overwhelming. All are of one piece including the angled handle; they all have the same pear-shaped body; the height is very similar, being between 16 and 19 cm; the decorative repertoire is very similar, consisting of animals and foliage; the decorative elements and the way of carving are very similar, consisting of stems, half palmettes, line and disks, and the "line and dot" motif (detailed in fig. 18).

The conclusion is inescapable that they must belong to the same period and must have been worked by the same lineage or school of craftsmen.

Further, various of the above stylistic features characteristic of this group are also found on several other pieces (a number of which, held in the V&A, are discussed below), and the similarities are such that it is safe to conclude that these, too, are of Egyptian provenance.

Second, on the basis of this material Kurt Erdmann proposed in 1951 a tentative chronology in which he assigns the earliest pieces to the middle of the ninth century.[42] What characterizes these early pieces is that they are not carved in sharp relief like the later ones: the cut is bevelled, similar to that of the stuccos from Samarra, Tulinid woodwork, and the rock crystal knops on the San Marco candlesticks;[43] and the chess piece in the V&A (plate 10), which shows this kind of cut, can be therefore assigned to this group. Erdmann's conclusions, although inevitably based only on stylistic grounds, carry conviction. According to these, the extant objects may be assigned to various pre-Fatimid periods: pre-Tulunid (before 868/254),[44] Tulunid (868–905/254–93)[45] and Ikhshidid (935–69/324–59);[46] and within the Fatimid period to early Fatimid (ca. 969–1000/359–91),[47] high Fatimid (ca. 1000–60/391–452),[48] and later Fatimid (ca. 1060–1171/452–567).[49] However, if the general chronology may be accepted, what is questionable in Erdmann's scheme is the implied attribution of all pieces to Egypt. In the light of the discussion above it is clear that the existence of a second centre of rock crystal production in the East (Mesopotamia/Persian area) needs to be taken into account, so that instead of referring to primarily Egyptian dynasties it would be preferable to give only a geographically neutral indication of date. Here one piece may be cited in illustration: a rock crystal flask in the Freer Gallery.[50] Stylistically, in the winged palmettes or split leaves, this provides close parallels with architectural decoration from ninth-century Samarra, and with late ninth- or early tenth-century Tulunid woodwork and stucco; and the winged palmette, as well as the stylized tree, can be seen also on manuscript illuminations and ceramics from the Iraqi area, again of the late ninth or early tenth century. Accordingly, a pre-Fatimid date may be suggested with some confidence for this piece, but not an exact geographical provenance. Further, there are other pieces which are in some respects similar to the Freer piece: flasks in Essen, Quedlinburg, Assisi[51] and a fragmentary cylindrical bottle in the V&A (plate 3), and on the same grounds these may also be considered pre-Fatimid, but not necessarily Egyptian. These multiple stylistic parallels, suggesting

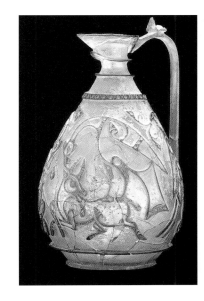

*20.* Corning ewer, clear glass with an overlay of transparent green glass cut in relief, Persia (?), 10th–11th century. Corning Museum of Glass (Clara S. Peck Endowment): 85.1.1

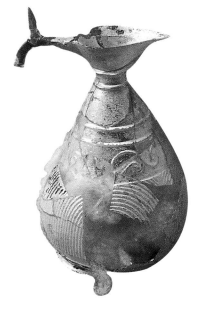

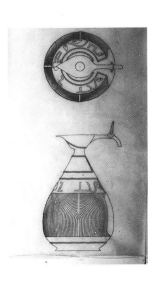

*21.* Ewer, clear cut relief glass (H. 19 cm; max body Diam. 10 cm) , found at Fusṭāṭ, 9th century (?). Museum of Islamic Art, Cairo: 71.6.34

affinities with materials of both Egyptian and Iraqi origin, point towards the next area of enquiry.

Third, Eastern and Fatimid rock crystals have here so far been discussed as separate groups, but given the frequent migration of ideas, objects and people over vast distances in the Islamic world there is an obvious possibility of connections between them, and even if the documentary and archaeological record is inadequate, there are, again, strong stylistic parallels, especially when the evidence of cut-relief glass is taken into consideration.

For example, close analogies to the pear-shaped body of the ewers, with its characteristic handle, are provided by Sasanian bronze objects. As this shape can ultimately be derived from a Roman prototype[52] it could be claimed that there is the theoretical possibility of it having survived in Egypt rather than having been transmitted indirectly through the East. But there is no evidence for direct transmission, and the decline of the related stone and glass cutting industries renders this unlikely. However, there are Sasanian glass ewers of this shape,[53] and evidence for the survival of this shape in the East into the Islamic period is again provided by various glass objects. A fine example (if without decoration) is preserved in the Shosoin of the Todaiji, Japan, where it was deposited in 731/113, suggesting that it may have been made in Persia in the early Islamic period.[54] There are, further, glass ewers of exactly the same shape as the Fatimid rock crystals, a particularly splendid example being the so-called Buckley Ewer (fig.19) in the V&A,[55] unfortunately very fragmentary, which has in addition a low foot characteristic of Sasanian silver vases.

This was found in Persia, and can be related to other glass fragments found in Eastern sites. At the same time it is extremely similar in decoration as well as shape to the Fatimid rock crystals, and therefore points in both directions, suggesting the possibility of contact between the two traditions and hence of the transfer of motifs and techniques which, given the greater continuity of the Eastern tradition, are assumed to have flowed westwards. But if an Eastern provenance is accepted for the Buckley ewer, the level of similarity between it and the Fatimid ewers is such that assigning other related pieces to Egypt rather than Iraq or Persia becomes hazardous. There is, for example, a glass ewer in the Corning Museum (fig.20) which has a decoration practically identical to that of both the Buckley and the V&A rock crystal ewer; but because it was acquired in Persia it has been considered Persian.[56] On the other hand, a ewer of this type has been excavated also at Fustāt (fig.21).[57] The cut-relief decoration is quite unusual, for beneath a floriated Kufic inscription the lower part of the body is decorated with a striking figure consisting of parallel cords densely arranged in a series of ellipses and repeated twice. It has a shape which is practically identical to the other two glass examples, Buckley and Corning, and to the rock crystal ewers too. But there are two features that make the object even closer to the crystal ewers. One is that the carved Kufic inscription is exactly in the same position, around the shoulder, as in the al-'Azīz rock crystal ewer in the treasury of San Marco. The second feature is that the

carved decoration is interrupted behind the handle along the whole length of the body. This feature is exactly the same in the V&A rock crystal ewer (plate 7), where the handle is one piece with the rest of the body, and the decoration of the body is framed by a raised band which at the back of the ewer closes the frame on either side of the handle almost like a textile. This strongly suggests that the glass ewer from Fusṭāṭ was modelled on a rock crystal.

The evidence for both Mesopotamian and Egyptian rock crystal production and for the stylistic resemblances between them means that it may not be possible to determine the provenance of pieces lacking an archaeological context. It also calls into question the assumption that the main production area for Islamic work in rock crystal during the tenth and eleventh centuries was Egypt, and on the basis of the Susa group of rock crystals and a few other objects found in Persia we may begin to identify a school of eastern Islamic rock crystal carving. Rock crystal and cut-relief glass were apparently produced alongside one another at least from the ninth century in the Persian and Mesopotamian area as well as in Egypt.[58] The technique of relief-cut glass was by then well developed, and as far as Egyptian production is concerned we can point to a number of pieces that may be contemporary with the Fatimid rock crystals.[59] These exhibit a common repertoire of shapes and designs that reinforces the assumption that the two crafts overlapped. Whether on hard stones or glass, relief cutting is a highly specialized technique and it would not be surprising if rock crystal and glass objects were actually carved in the same workshops by the same craftsmen.

## TECHNIQUE

The crystal of the V&A ewer is very clear, and the object is very light (plate 7). I was able, if not without difficulty, to measure the thickness of the body, which is 1.7 mm for the ground body and just over 2 mm for the parts with the relief decoration. This is extraordinarily thin, both absolutely, in relation to the size of the object (about 14 cm in diameter), and also comparatively, in relation to other rock crystals.

This leads naturally to a consideration of the techniques used to obtain such a result, a field which has not been explored as far as Islamic objects are concerned. Despite the abundance of Islamic rock crystals, what we know of the history of the technique does not rely on any information arising out of production in the Near East. However, we can at least outline the general principles according to treatises like that of Anselme Boece de Boodt, from Bruges, physician of the Emperor Rudolph II, who wrote a *Gemmarum et Lapidum Historia*, first published in 1609; on the basis of contemporary accounts of traditional German and Chinese lapidaries; and on iconographic evidence, such as the depiction of a lapidary carving a ruby in the early seventeenth-century album for Jahāngīr (fig.23).

## Hollowing out

First of all, how was a rock crystal ewer carved inside? Considering that there is only one opening, the mouth, which is very small in relation to the size of the belly, and considering the great thinness and smoothness of the object not only on the outside but also on the inside, one has to pose the question of how this was achieved. Michel pursued enquiries in 1960 with a group of old lapidaries in Idar-Oberstein (Germany, between Trier and Mainz), where the local rocks have been exploited since the High Middle Ages for the hardstones they contain,[60] and where a centuries-old tradition of hardstone cutting flourished. Their technique of carving the interior of vessels is matched by that reported for Chinese hardstone carvers, and this could very well have been the technique used by the Fatimid rock-crystal carvers working on the ewers. On the basis of these sources the technique can be reconstructed as follows.

The shape of the vessel was probably first roughly cut with a saw and by chipping with a small hammer (a technique still employed in Japan). A hollowed, cylindrical tool was then used to make a cylindrical opening in the object. This tool must have been of a hard metal, quite possibly, as today, of steel, which was already in use in the Arab Middle East in the tenth century and in Persia even earlier, in the ninth.[61] Used in combination with an abrasive, probably of water and sand, it was placed at the top of the vessel and rotated, possibly with a bow drill, in order to start penetrating into the rock crystal. Once the tool had made its way sufficiently into the crystal, a sharp tap would be enough to snap off the crystal core, which could then be extracted together with the tool. This done, the cavity was extended to the required depth by a drill attached to a bow lathe, and used in combination with an abrasive. In order to widen the cavity a steel wire was then introduced in the central hole. When lightly pressed, this wire would curve and, with the help of an abrasive, scratch the inner wall until it had carved out the interior of the vessel as required. It could also have been attached and worked by a bow lathe. A second method is to attach to a steel wire or, in the case of the Chinese, a bamboo reed, an abrasive such as a small mass of emery (fig.22). As a piece in the British Museum demonstrates,[62] if cut rock crystal is not polished it retains a matt appearance, so there remains the further question of how the interior surface was smoothed and polished. For this, presumably, the same abrasive technique was used, but with the emery replaced by finely ground hematite to give a splendid lustrous surface.[63] Alternatively, a smooth finish could have been achieved by introducing through the aperture some small metal balls or even pebbles and an abrasive (like, again, sand and water) and then turning the object so that centrifugal force would press and rotate the balls against the inner walls.[64]

## Cutting

The above are all very delicate operations requiring great skill and a thorough

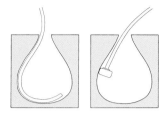

22. Techniques of hollowing out a rock crystal ewer.

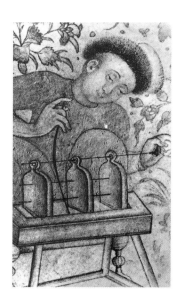

23. A lapidary carving a ruby, detail from a ca. 1620/1030 album of paintings for the Mughal emperor Jahāngīr, fol. 16. Náprstek Museum, Prague

understanding of the fracture planes of the mineral, but they are still in a sense merely preparatory to the working of the outer surface. While the lapidary probably formed the initial outer shape of the object with a saw and by chipping with a steel hammer, to obtain the fine detail he most probably used the bow lathe. This was a fixed spindle to one end of which was attached either a drill or a small wheel. The abrasive was again most probably sand, or a paste composed of diamond dust. One hand rotated the spindle by pushing the bow backwards and forwards while the other grasped the crystal, manipulating it against the drill or disk, and there is actually a depiction of this operation in process on the margin of a page from the album of paintings made for the Mughal Emperor Jahāngīr in about 1620/1030 (fig.23)[65] where a lapidary is portrayed using the bow drill to cut a ruby. The type of wheel would determine the type of cut, and also the angle of the relief in relation to the body (straight or at an angle). The same technique had been used in the ancient world for the cutting not only of other hardstones such as agate and sardonyx but also of glass. It seems likely that cut glass was inspired by hardstone carvings and that the two industries often existed side by side.

## DISPERSAL

Between 1061 and 1069 Fatimid Egypt was shaken by natural disasters and grave social disturbances, with mutinous soldiery causing a state of civil war, and during the resulting depredations the treasury was dispersed and a large number of works in rock crystal flooded the market, among them pieces of the best period. Details are given by al-Maqrīzī of the enormous sums of money – even allowing for exaggeration – that they fetched on the market. Most of those he mentioned were various forms of containers such as ewers and basins, flasks and jars, and in many instances he remarked upon their huge size or capacity. Unfortunately, his descriptions give few indications of the technique and style of decoration, and they are not precise enough to allow identification with surviving rock crystals. Neverthless, when he says that "someone had seen in Tripoli two pieces of genuine rock crystal, supreme in their purity and beautiful in their carvings, a carafe and an ewer, both with the name of 'Azīz bi-llāh written on their sides . . . which he had brought from among the quantity of things which had been taken out of the treasure" one is tempted to think that the ewer could be the one in the San Marco treasury (fig.15).[66]

## EUROPEAN ACQUISITION

But whatever the mechanism of transfer, it is undoubtedly the case that many of these pieces ended up in Europe, and without the church treasuries and the collections in museum such as the V&A the history of the Fatimid rock crystals could not

be written. Already in the early Middle Ages there was a passion for rock crystal; its purity was highly esteemed and it was held to have magical and medicinal properties.[67] The lavish mounts with which Islamic rock crystals were provided are an indication of the value placed on them, and there can be little doubt that every opportunity was taken to acquire them. Some may have been diplomatic gifts, but others were either bought or captured. In the period of the Crusades the relationship with the Orient was intensified, and many of these objects must have come to Europe with the Crusaders who took Jerusalem from the Fatimids in 1099/493, Acre in 1104/498 and finally Ashkelon in 1153/548. One also has to bear in mind that the Fatimids were near neighbours of the Byzantines and fought against them for control of Damascus and Aleppo. Accordingly, certain rock crystals might have reached Venice via Acre or Jerusalem in the twelfth century. But others arrived in Venice only after the sack of Constantinople in 1204, or, indeed, after 1261 when the Venetians were forced to abandon the city. They had been incorporated into the Byzantine imperial treasure and a few, indeed, still retain their pre-1200 Byzantine mounts. It is also the case that precious objects dispersed after the sack of Constantinople did not necessarily go immediately or directly to Venice. Many of the spoils went first to Palestine, and went to Europe via Acre, on its fall to the Mamluks in 1291/690.[68] For example, the extraordinary rock crystal vase – the largest known Islamic rock crystal object – datable to the end of the tenth century, in the treasury of San Marco, seems to have reached Venice in the mid-thirteenth century, when it was mounted by two Venetian goldsmiths.[69]

The tenth- and eleventh-century German emperors and the Grandmont order in thirteenth-century France seem to have possessed a large number of pieces, and Fatimid crystals later enriched such secular collections as that of the Duc de Berry, who at his death in 1416 owned two ewers like that of al-'Azīz: "a crystal ewer, worked with animals, with a handle of the same", which had been given to him unmounted and which he had had mounted in gold, and "a crystal ewer, worked with foliage and birds, mounted in silver-gilt". In any case, what is now preserved is probably only a small fraction of the riches that existed once. The treasuries of Hārūn al-Rashīd and the later Abbasid caliphs of Samarra are legendary, and whether or not they had significant holdings of rock crystal is a matter of conjecture. However, the account by al-Bīrūnī of the expensive rock crystal vessels in the treasury of Muḥammad ibn Ṭāhir, the last Tahirid governor of Khurāsān (deposed in 873/260),[70] or the account of al-Ṣūlī, who considered the Abbasid Caliph al-Rāḍī as one of the great rock crystal collectors of his time,[71] also support the theory that there must have been pre-Fatimid centres of production of rock crystal vessels.

But of the treasury of the Fatimid caliphs of Egypt we have the account of al-Maqrīzī, who relates that "among the objects there were 17000 boxes, each one containing rock crystal either decorated in relief, or plain" and that "from the Royal Halls 36000 jewels of various materials came out, many of rock crystal".[72] His figures are, no doubt, exaggerated: but they at least convey an impression of the great quantity of crystals that the Fatimid caliphs must have owned.

*Treasuries*

According to church inventories some pieces had already reached Europe by the second half of the tenth century,[73] and many more no doubt followed as a result of the looting that took place in the second half of the eleventh. Such pieces were highly prized and adapted for liturgical purposes as reliquaries, chalices and cruets, even when in a fragmentary state.[74] The most striking example of a Christian reliquary incorporating an Islamic rock crystal is the reliquary of the Holy Blood, one of the most venerated relics in the treasury of San Marco.[75] It consists of a small cylindrical rock crystal bottle with a high neck and a secular benedictory Arabic inscription in Kufic script which can be translated as "benediction and glory", that is, for the owner. The body, always carved in relief, has a floral decoration of scrolls and palmettes, laid out symmetrically all around. The mount is in gold, and consists of a two-step foot with six lobes and openings on the sides. On the lobes decorations of floral motives and birds are incised. From the high stem four ribbons arise, sustaining the reliquary. On the horizontal ribbon an inscription in Latin says "Hic est sanguis Christi". The reliquary was contained in a silver case in the form of a church. It is first mentioned in one of the inventories of the treasury of San Marco, dated 1283, which describes it as "A crystal bottle in which the blood of our Saviour Jesus Christ is contained, mounted in gold with a pearl at the top, contained in a silver church" (the pearl is now missing and has been replaced by a baroque flame). In a list of the objects of the treasury dated 1325 the reliquary is again described as above, but with more details about its decoration.

One account has it that this reliquary comes from Constantinople and contains blood that dripped from the body of a Christian crucified in 320, whom the Jews had scorned and pierced with spears. But later on these Jews converted to Christianity, and the bishop collected the blood in several bottles and sent it to princes and kings worldwide. This miracle is described in a sermon by a contemporary, St Athanasius of Alexandria, and was to be quoted in 787 during the second council of Nicea. Over the centuries the story of the poor Christian crucified in 320 regressed to that of Christ, where it had evidently originated. The blood was consequently identified with that of Christ himself, and the reliquary was used to bless the congregation on Good Friday, the Archdeacon of San Marco securing it around his neck with a chain more than three metres long.

The reliquary of the Holy Blood, as well as having great religious significance, is also remarkable as a work of art. In gold it is the only object definitely executed by Venetian goldsmiths to be included in the earliest remaining inventory of the treasury, that of 1283, which also provides a *terminus ante quem* for the date of the mount. The way that the ribbons support the reliquary without touching it is also remarkable, because they emphasize rather than interfere with the beautiful carved decoration of the tenth-century Islamic rock crystal.

The treasury of San Marco, which houses the most important collection of Fatimid rock crystals in the world, is followed by the V&A, for which Islamic

objects were purchased from the very early days, supreme among them the Fatimid ewer.

## V&A ROCK CRYSTALS

### The ewer

The V&A ewer (plate 7) is umblemished except for the broken thumb-rest. It conforms to the standard form of the other ewers but is without the profile band immediately above the foot. Like the second Venice ewer, the cruet, the decoration covers the whole field of the body but it is not crowded and it is harmoniously distributed on the surface, pointing to a better understanding of the space. The whole is framed by a raised band which at the back of the ewer closes the frame on either side of the handle (which as in all the others is not carved in relief) almost like a textile. The "tree of life" arabesque extends well into the main field as also does a secondary arabesque that issues from the rear vertical framing bands. The central theme of the composition, repeated on both sides of the ewer, is a falcon attacking a gazelle. In both creatures the features and pelt are indicated by closely set drilled dots. The legs of the gazelle and the tail feathers of the falcon are lightly incised with horizontal and vertical lines punctuated by concave drilled dots. As in the Venice ewer the fronds of the palmettes and half palmettes have the lightly incised "line and dot" motif (see fig.18).

The increased complexity and supreme quality of the design, together with a greater maturity of execution, point to this piece being the culmination of the series, and the likelihood of this is underlined by a particular technical innovation it exhibits. This is the treatment of the frontal arabesque in which, at certain points, a leaf and stem pass over or under each other, thus creating the illusion of a third dimension. This feature is not found in any of the other rock crystal ewers except in one small detail on that in the cathedral of Fermo. Its first dated occurrence is in the illuminations of the Qur'ān manuscript written by Ibn al-Bawwāb in Baghdad in 1001/391, now in the Chester Beatty Library in Dublin;[76] and it may therefore have been introduced into Fatimid art some time in the eleventh century.

If the V&A ewer is the latest, to what date can it been assigned? Various inferences could be drawn from the different possible positions in the series of the later dated ewer (in the Pitti Palace, 1000–8/391–9; fig.16) but the only safe conclusion is that the V&A piece was most likely produced in the first half of the eleventh century, after the Pitti piece but almost certainly before the violent upheavals beginning in 1061/452, which must at the very least have disrupted production severely. This means that the whole series of ewers could have been spaced out over the latter part of the tenth and the first half, approximately, of the eleventh. The other dated piece, the crescent of al-Ẓāhir (1021–36/411–27; fig.17), does not help in narrowing this period further. Bearing in mind that it is

no more than a decoration for a horse, the poor quality of its carving can hardly be interpreted as an indication of the sudden decline of an industry which had only recently reached its pinnacle. It obviously provides evidence for continuing activity, but not for dating any of the ewers to the same period: suitably large pieces of rock crystal may not have been forthcoming; the demands of patrons may have changed; and any ewers that were made may not have survived. Nevertheless, in the absence of external indications, it is reasonable to conclude from the pronounced stylistic affinities between all the members of the set that it is rather less likely that they were produced sporadically at widely separated intervals over a large span of time, and more likely that they are the result of a relatively brief and intense burst of activity. If so, the V&A ewer would need to be assigned to the early years of the eleventh century.

## Other pieces

Closely associated with the ewer in terms of carving and style are a flask (plate 6, and see also fig.24),[77] one cylindrical bottle (plate 4),[78] a pendant fish (plate 1), a fragment of a cylindrical bottle with a Kufic inscription (plate 5) and a small jug (plate 8), all of which can, therefore, be considered Fatimid. The ewer, flask and cylindrical bottle share the same type of carving, with both bevelled and straight cuts; a very similar decorative repertoire (although the ewer is more complex, having animal figures as well as foliage and palmettes); and the ewer and flask have, in addition, the distinguishing "line and dot" motif (fig.18) which is so characteristic that, it has been suggested, it could be the mark of a particular workshop. The crystal of the fragment with the Kufic inscription is as pure as that of all these pieces, the inscription, carved in a similar way to that found on the al-'Azīz piece, is of very high quality. The fragment is very similar to other fragments, one in Berlin and three in Cairo, all with a carved Kufic benedictory inscription, although that in Berlin seems to be the closest.[79] An interesting example of a small, cylindrical bottle with a Kufic secular inscription, is a reliquary, now in Kuwait, most probably used originally as a perfume bottle, containing a bone of an unidentified saint, and set in a much later European mount.[80] The small jug is really a miniature ewer and although its dating is more difficult, as it is not decorated, it is still likely to be close in time to the big ewer, its shape being almost identical. The pendant fish is related to one in Berlin, having the same groovings (parallel carved lines) on the upper fin and tail, and to another very similar in shape now in the Islamic Art Museum in Cairo, which was dated by Lamm to the early Fatimid period (late tenth century).[81] A similar date can be suggested for the V&A pendant fish. Moreover, the type of carving found on the fish is also found on other pieces datable to this period, such as the V&A flask and cylindrical bottle, particularly in the cuts perpendicular or at an angle. All six pieces can therefore be attributed to the Fatimid period, and dated to the late tenth or early eleventh century.

*24.* Rock crystal flask (H. 10.7; max W. 7.4 cm), Fatimid Egypt, early 11th century. Keir Collection, Richmond, England: R.11

The fragmentary cylindrical bottle (plate 3) and the casting bottle (plate 2), on the other hand, present characteristics that would associate them with an earlier period. The neck of the casting bottle and the restrained decorative elements of both pieces are closely associated to a group considered by Erdmann as Ikhshidid, in particular the so-called Quedlinburg reliquary.[82]

The chess piece (plate 10), although attributed by Lamm[83] to the Fatimid, tenth or eleventh century period, has a decoration that resembles the simple palmettes on Tulunid (ninth- or early tenth-century) woodwork, which is also shared by other rock crystal chess pieces.[84] The two very stylized birds carved at the back of the piece too have parallels with Tulunid woodwork.[85] More importantly, the technique of carving is one associated with the bevelled style of Samarra's stucco, rather than the sharp cut relief of the other pieces. The other fish (plate 9) is very similar to one in Berlin which Lamm[86] dated to the late ninth century, and this indeed seems an appropriate date; therefore it too could be Tulunid.

## NOTES

1. Although, in theory, it might be possible to determine the provenance of rock crystals through analysis of impurities in the body, in practice it would require a huge database of samples which does not at present exist. However, some such work has been carried out on South American rock crystals: at Kingston University work on Aztec rock crystal skulls analysing fluid and gas inclusions has differentiated between South American rock crystal deposits.

2. Devised by the scientist Friederich Mohs (1773–1829).

3. For these technical materials see Michel 1960, pp. 1–9; Hall 1993, p. 25.

4. Aristotle 1490, p. 2 verso; Pliny 1962, books XXXVI–XXXVII, pp. 180–1; Theophilus 1961, book 3, chapter 95, pp. 168–71; Solinus 1587, book XV, chapter 29; al-Bīrūnī, 1936. The most important study on al-Bīrūnī as source for rock crystal is still Kahle-Bonn 1936.

5. For specific examples see Faltermeier 1987. An experiment was carried out in conjunction with Richard Cook of V&A Sculpture conservation on 5 July 1996, when a rock crystal was unevenly heated, half of it being buried in sand. At about 40 degrees the exposed part of the crystal started to turn a milky colour, at about 100 degrees part of it splintered off, and at about 230 degrees it exploded, breaking off at exactly the point between the buried and the exposed part. The buried part was split along the fracture planes.

6. Kunz 1971; Qazwīnī, 1848, p. 212.

7. Pliny 1962, book XXXVII, chapter IX.

8. Pliny 1962, book XXXVII, chapter X.

9. Al-Tīfāshī 1977, p. 202.

10. Al-Akfānī 1908, 11, p. 762.

11. The *raṭl* is the most common weight in the Islamic countries of the early centuries. During the Abbasid period a *raṭl* weighed between 390 and 493 g. Under the Fatimids several *raṭl* sizes were used, varying from ca. 450 g to over 900 g: Ashtor 1990.

12. Nāṣir-i Khusraw 1881, p.149.

13. Erdmann counted them up to ca. 165, but the latest figure is the result of Ralph Pinder-Wilson's additions.

14. There are examples in the British Museum: 1959.5-15.1 to 16, bought by the Brooke Sewell Fund, and said to have been found at Fusṭāṭ.

15. Contadini 1995a, figs 43–5.

16. Like a piece in Cologne: Babelon 1902, fig. 28.

17. Munich 1912, I, cat. no. 2087, pl. 165. Two such rock crystal ewers, French, fourteenth century, are kept in the V&A: 857–1882 and 15–1864.

18. Migeon 1927, pp. 371–80.

19. Schmidt 1912.

20. Kühnel 1925; Longhurst 1926.

21. Von Falke 1930. It may be worth noting at this juncture that the scholarly literature

on Islamic and European rock crystal is large but scattered in individual articles or within general works, and a comprehensive study of all material and sources available is still a desideratum.

22. Inv. no. 80: Erdmann 1971, cat. no. 124; see also Contadini 1995b.

23. Museo degli Argenti, inv. no. 1917: Rice 1956.

24. Germanisches Nationalmuseum, KG695: Munich 1912, II, Tafel 2092; Lamm 1929–30, Tafel 75,21; Ettinghausen and Grabar 1987, p. 193, fig. 178.

25. Among the Fusṭāṭ finds are some fragments of vessels (small bowls, etc.) now in the Benaki Museum in Athens, unpublished. Some of these pieces seem to be unfinished, as if an accident occurred and the vessel was abandoned. I am grateful to Michael Rogers for this information.

26. Nāṣir-i Khusraw 1881, p. 149.

27. Kahle-Bonn 1936, p. 332. We know of a school of crystal carvers in Venice in the twelfth and fourteenth centuries. They were organized in a guild, and we have their *regola* of 1284 from which it appears that there were two well-defined specialities: *l'arte grossa*, which deals with big pieces, and *l'arte minuta*, which is about glyptic art: Hahnloser 1955.

28. Tatton-Brown, 1991, p. 65.

29. Tatton-Brown, 1991, pp. 78 and 90.

30. Tatton Brown, 1991, p. 78.

31. Pinder-Wilson, 1991, p. 115.

32. Kept in the Cabinet des Médailles of the Bibliothèque Nationale. See Montesquiou-Fezensac 1973–77, I, no. 76, p. 187 and II, pl. 46.

33. Lamm 1928, pl. VI.

34. Published in *SPA*, XIII, pls 1438c and 1438d; Oliver Harper 1978, no. 29.

35. Erdmann 1959, p. 203, fig. 4. For the excavation report see Safar 1945, which, however, does not mention the rock crystal.

36. Inv. no. OA1954.10-13.1. See Ghirshmann 1954, fig. 46a; Hayward 1976, no. 102, where it is stated that the curious split-leaf terminals with bored holes at the tip bear a striking resemblance to those in a wall painting at the Tepe Madrasa in Nishāpūr : Hauser and Wilkinson 1942, p. 104, fig. 28; Brend 1991, pl. 21. This goblet now has a shape strongly reminiscent of Persian glass beakers, but it seems to have been cut down and repolished.

37. Sold at Sotheby's, Geneva, 25 June 1985: Sotheby's 1985, lot 188. Also illustrated in the Arts News section of *Arts and the Islamic World*, vol. 3, no. 3 (autumn 1985), pp. 2–3. The dish is of oval form standing on a low foot, with flattened everted rim, the exterior relief cut and the rim cross-hatched. It measures 8.2 cm in length, 4.7 cm width, 1.8 cm in height. Present whereabouts unknown.

38. As regards shape, no precise Islamic parallels can be cited, although an oval dish of relief-cut glass with similar proportions, but without the lip, has been excavated at Samarra.

39. See *SPA*, XIII, pls 1438c and 1438d, as fourth to sixth century.

40. Streck "al-Sūs".

41. For the second ewer in San Marco (inv. no. 86) see Erdmann 1971, cat. no. 125; for that in the cathedral in Fermo see Guidi 1899, pl. II and Grube 1993, no. 58; for that in the Louvre see Migeon 1922, pl. 1 and Paris 1991, no. 26. There are two other rock crystal ewers, one (the handle is lost) formerly in the Abbey Church of the Grandmont (Haute Vienne) and now in the treasury of the church of Milhaguet; and one in the Hermitage. For both Lamm 1929–30, Tafel 67,5 and 6, gives drawings. These seem not to be part of this group. Indeed, Erdmann had already noted that the one formerly in Grandmont does not belong to the group strictly (but he does not say why) and the Hermitage one also he does not consider as it is very different from the others: Erdmann 1953b. However, that in the church of Milhaguet was published as a Fatimid, early eleventh-century piece, in Hayward 1976, no. 112.

42. Erdmann 1951.

43. Inv. nos. 24 and 25. See Ettinghausen 1952.

44. Knops of a candlestick in the San Marco treasury (inv. nos. 24 and 25): Grube 1993, nos 51–2.

45. Knops of a candlestick in the San Marco treasury (inv. nos. 24 and 25); two chess pieces in San Millán de la Cogolla (Lamm 1929–30, Tafel 76,4 and 6); a similar piece in a Spanish reliquary of the sixteenth century in the Berlin Schlossmuseum (Erdmann 1940, pl. 10); three pieces in the cathedral of Osnabrück (Lamm 1929–30, Tafel 76,17); and in the Islamic department of the Berlin Museum (Lamm 1929–30, Tafel 73,2 and 76,19); large vase in the San Marco treasury (Lamm 1929–30, Tafel 68,17).

46. Quedlinburg reliquary (Lamm 1929–30, Tafel 68,13); bottles in the Kunsthistorisches Museum at Vienna (Lamm 1929–30, Tafel

71,1); and in the Kuwait, Dār al-Āthār al-Islāmiyya (formerly Béhague collection, Lamm 1929–30, Tafel 71,2); the reliquary of Santa Chiara in Assisi (Erdmann 1940, fig. 4); the bottles in the Madame Guyard collection in Poitiers (Lamm 1929–30, Tafel 67,13a); in the Louvre (Erdmann 1940, pl. 7); in the Metropolitan Museum in New York (see Erdmann 1951, note 7); and in the Münsterkirche at Essen (Lamm 1929–30, Tafel 75,5); the knob of the Mathilde crucifix at Essen (Lamm 1929–30, Tafel 75,10).

47. Ewer of al-'Azīz, San Marco treasury; two bottles in Florence, San Lorenzo Treasury; small ewer in Herzogliches Museum at Gotha (Erdmann 1940, pl. 4a,b); the pieces grouped around the bottles from Astorga (Lamm 1929–30, Tafel 67,11) of which the most important pieces are the bottle in Halberstadt (Lamm 1929–30, Tafel 67,12); the cups in the Reichs Kapelle at Munich (Lamm 1929–30, Tafel 68,1); and on the pulpit of the cathedral at Aachen (Lamm 1929–30, Tafel 68,2,3); as well as the spherical vessel formerly in Saint-Denis (Lamm 1929–30, Tafel 67,136). These belong to this period, since 1014 is the *terminus ante quem* of the items at Munich and at Aachen.

48. The crescent of Caliph al-Ẓāhir in Nuremberg, Germanisches Nationalmuseum, KG695, diam. ca. 19 cm. See Ettinghausen and Grabar 1987, p. 193, fig. 178.

49. No pieces assigned: attributions to this period are still to be demonstrated (Lamm includes here faceted vessels which Erdmann thinks not to be of Oriental origin).

50. Inv. no. 49-14. See Atil 1975, p. 36, cat. no. 13. The flask has an enamelled gold mount.

51. Erdmann 1940, fig. 3.

52. As shown by a small rock crystal ewer in the V&A: A.74-1952.

53. A Sasanian opaque white glass ewer with no decoration said to have been found at Qazwīn, is now in Tehran, Archaeological Museum, and a Sasanian (fifth to seventh century) clear glass ewer (H. 22.1 cm) found in Gilan province is now in a private collection in Tokyo: Fukai 1977, figs 56 and pl. 29.

The dimensions of all these pieces are also very similar: they range from 16 to 19 cm in height (and the same dimensions also characterize a ca. eighth-century early Islamic, but in Sasanian style, metal ewer in the V&A: inv. no. 434–1906). This was already noted by Erdmann 1953b.

54. Tokyo, 1909, III, pls 152–3; Harada 1932, p. 86, no. 398, pl. LIII; Fukai 1977, fig. 58.

55. Buckley 1935, pp. 66–71, pl. 1,A&B; Charleston 1942, pp. 212–18, pl. 1,D&E; Honey 1946, p. 72, pl. 15A; Oliver 1961, p. 14.

56. The ewer is in the cameo glass technique, colourless glass with a thin light green overlay. Clara S. Peck Endowment, 85.1.1H, H. 16 cm. See Whitehouse 1985.

57. Pinder-Wilson and Scanlon 1973, p. 25, no.19, figs 30–2. Here a date not later than the ninth century is suggested.

58. As fragments from Fusṭāṭ demonstrate. See in particular fragments of a beaker with a decorative motif of a bird carved in relief and fragments from a bowl with a benedictory inscription carved in relief, both datable to ca. 900: Pinder-Wilson and Scanlon 1987, nos 17 and 18.

59. To those found at Fusṭāṭ should in all probability be added the striking bowl in the treasury of San Marco, decorated with lions carved in relief (inv. no. 140): Erdmann 1971, no. 117. The origin of this object remains unclear, but one may strongly argue for an Egyptian, Fatimid attribution on both technical and stylistic grounds. Both the manner of carving and some of the decorative motifs recall cut-relief glass and rock crystal objects of the Fatimid period. Grube 1993, cat. no. 59, gives an account of the scholarly dispute over this piece and a comprehensive bibliography.

60. Even in the West this technique is dying out, as it is very expensive and requires an enormous amount of time.

61. This according to the recent excavations at Merv, see Herrmann *et al* 1996; also Bond 1997. I am grateful to James Allan who drew my attention to the Merv finds.

62. Inv. no. 1959,5-15,1.

63. Kunz 1971, pp. 217–18; Kunz 1886.

64. Michel 1960.

65. The leaf is in Náprstek Museum in Prague. See Hájek 1960, pl. 16.

66. Erdmann 1951, note 15; Kahle-Bonn 1935, p. 345. For an account of how luxurious items from the Fatimid treasury might have been brought to other capitals by merchants see Qaddumi 1990, p. 250.

67. For this particular aspect see Shalem 1996, pp. 142-58.

68. Riant 1875 and 1885.

69. Erdmann 1971, no. 123.

70. Kahle-Bonn 1936, pp. 339–40.

71. Al-Ṣūlī 1935, p. 20.

72. For an account of the Fatimid treasury from the sources see Kahle-Bonn 1935.

73. These are: a macehead, which forms part of the decoration of a crucifix presented to the Münsterkirche of Essen by the Abbess Matilda, who ruled 973–82 (Lamm 1929–30, Tafel 75,10); cup and saucer on the ambo of the Ottonian emperor Henry II in the Cathedral at Aachen, presented between 1002 and 1024 to the palace chapel at Aachen by the Ottonian emperor Henry II (Lamm 1929–30, Tafel 68,2 and 3); and a bottle and fish on the cross of the church of Borghorst in Westphalia (Lamm 1929–30, Tafel 68,9 and 76,25); two chess pieces on the reliquary donated by King Sancho of Navarra in San Millán de la Cogolla in 1033 (Lamm 1929–30, Tafel 76,4); a small bottle on the cross of the Abbess Theophanou in the treasury of the Münster at Essen, 1039–56 (Lamm 1929–30, Tafel 76,31).

74. Such as the so-called "Grotta della Vergine" in the treasury of San Marco, inv. no. 116 (listed in the 1325 inventory: III, no. 18): Pasini 1885–6, p. 68, pl. I,m; Christie 1942, fig. 2; Grabar 1971, no. 92; British Museum 1984, no. 8.

75. Inv. no. 63: Erdmann 1971, no. 128. The one in San Marco is not the only reliquary of the Holy Blood, but it is certainly the most striking. Another Holy Blood reliquary in an Islamic rock crystal with a European mount is in the abbey church of Gandersheim in the form of a tubular bottle, and it is already mentioned in a twelfth-century inventory of the church that names six such objects, one of which might have been identical to the Holy Blood bottle: Erdmann 1959, pp. 200–5, fig. 1. See also Erdmann 1953a.

76. Is.1431: Rice 1955.

77. Cf. similar, perhaps earlier flasks in Vienna, Kunsthistorisches Museum and Paris, Comtesse de Béhague collection (Lamm 1929–30, Tafel 71). For the very similar rock crystal bottle in the Keir collection shown in fig.23, see Pinder-Wilson 1988, no. R11, pp. 303–5 (dated ca. 1025, Egypt).

78. Another example of this type of crystal is in the British Museum, illustrated by Longhurst 1926, p. 150 and fig. c. Another one is in the Metropolitan Museum in New York (inv. no. 17.190.522) mounted as a candlestick. See also Schmidt 1912, p. 53; and Babelon 1902, fig. 33 etc.

79. Lamm 1929–30, Tafel 73,4, and 74,3–5.

80. The piece is now in Kuwait, part of the collection of the Dār al-Āthār al-Islāmiyya, inv. no. LNS43HS. See Atil 1990, no. 20.

81. Islamic Art Museum, I4836, 5 x 4.5 cm. Lamm 1929–30, Tafel 76,21; Erdmann 1942, pp. 7–10, fig. 7; for the fish in the Islamic Art Museum in Cairo (ex Harari collection) see Lamm 1929–30, Tafel 74,9.

82. For the Quedlinburg reliquary see Lamm 1929–30, Tafel 68,13; Erdmann 1953a; bottles in the Kunsthistorisches Museum at Vienna (Lamm 1929–30, Tafel 71,1) and in Kuwait, Dār al-Āthār al-Islāmiyya (formerly Béhague collection, Lamm 1929–30, Tafel 71,2); the bottles in Madame Guyard in Poitiers (Lamm 1929–30, Tafel 67,13a); in the Louvre (Erdmann 1940, pl. 7); in the Metropolitan Museum in New York (see Erdmann 1951, note 7); and in the Münsterkirche at Essen (Lamm 1929–30, Tafel 75,5).

83. Lamm 1929–30, Tafel 76,2.

84. This is like, for example, two in Berlin: Erdmann 1942, figs 1 and 2, and fig. 3 for an example of Tulunid woodwork; at least two of the so-called Ager chess pieces, in the cathedral treasury of Osnabrück: Contadini 1995a, appendix I, 6 and figs 43, 44; a rock crystal chess piece in Capua: Lipinsky 1960–4, pp. 422–3; Gabrieli and Scerrato 1985, drawings opposite p. 500.

85. See for example one in Paris, Louvre, inv. 6023, and one in Cairo, Islamic Art Museum, inv. 6280/1: for both pieces see Anglade 1988, figs 15 and 23a.

86. Lamm 1929–30, Tafel 76,22. See also, for comparative material, Pinder-Wilson 1954.

## ROCK CRYSTAL PIECES IN THE V&A

### PLATE 1

*Pendant in the form of a fish mounted in nielloed silver, parcel-gilt. Fatimid rock crystal (tenth century); French mount (ca. 1300). M.110 -1966*

*H. 6.2 cm, W. 2.5 cm*

*Purchased from P.E.L. Bedford for £2000*

The fish has a fin at the top, carved with diaper work, and two carved fins below. The body ends in a stylized tail with a ribbed ring encircling it. A narrow carved collar figures the gill at the neck. A deep tube is pierced down the centre. The head was cut off probably when the fish was mounted as a pendant. The mounts consist of a moulded rim of silver-gilt, decorated with a pattern of leaves reserved in the metal on a nielloed ground. The mouth is nielloed with the Lombardic inscription: AVE: MARIA: GRACIA: PL[E]NA on a ground of plain silver. The base, upper ends of the body and the ends of the fins are chipped. The crystal was probably originally a perfume-holder. The fish is very similar to another now in the Islamic Art Museum in Cairo (see Lamm 1929–30, Tafel 74,9).

BIBLIOGRAPHY: Lightbown 1968; Evans 1970, pl. 6 (a–c); Wentzel 1972, pp. 51–3, fig. 59c; Lightbown 1992, no. 33, col. pl. 127.

### PLATE 2

*Casting bottle for pepper or spice. Fatimid rock crystal (ninth or tenth century); English mounts (ca. 1540–50), unmarked: silver-gilt cap, body-mounts, chain and foot. M.78-1910*

*H. 13 cm, W. 6 cm, Wt. 264 g/8 oz 12 dwt. (all in)*

*Purchased from J. Hughes for £120*

The crystal is very clear. The circular bottle has a curved base; the body is carved with four concavities terminating in scrolls and the neck is flowering toward the mouth and is faceted. The metal circular foot, chased with acanthus, clasps the crystal body. Two scrolled and chased handles are hinged to a simple quadrilateral flask support. Simple wire rings soldered to the upper part of each handle support a thirty-two-link chain which terminates in a hook. The neck-mount rises from a pierced border clasping the crystal to a plain projecting rim. To this is soldered a tube scored inside with a continuous groove. The cap is a scamed cylinder whose outer face is grooved to fit the neck, and is curved and pierced with three circles of holes of diminishing size and rises to a cast acorn finial, both pinned and soldered.

BIBLIOGRAPHY: Jackson 1911, fig. 1022, p. 787; Watts 1924, pl. 17c; V&A 1921, no. 5; Lamm 1929–30, I, pp. 205–6, II, Tafel 72; Clayton 1985, fig. 94; Berlin 1989, cat. no. 4/7; Glanville 1990, no. 106.

### PLATE 3

*Fragmentary cylindrical bottle. Middle of the tenth century (?). From Egypt. A.46-1928*

*H. 9 cm, Diam. of reconstructed base 3 cm*

*Formerly in Sir Hercules Read's collection. Bought for £450 (with plate 4, A.45-1928)*

The bottle is tubular in shape, and has a band of interlacing ornament about the centre. The neck and part of the foot are missing. The bottle has a pattern of two interlaced bands and two palmettes. (See also note to plate 4.)

BIBLIOGRAPHY: Migeon 1927, II, p. 123; Sotheby's 1928, lot 41; V&A 1929, p. 10, pl. 8; Lamm, 1929–30, I, p. 205, II, Tafel 7,6-7.

PLATE 4

*Cylindrical bottle. Fatimid, tenth or eleventh century. From Egypt. A.45-1928*

*H. 15 cm including new base, Diam. of reconstructed base 3.1 cm*

*Formerly in Sir Hercules Read's collection. Bought for £450 (with plate 3, A.46-1928)*

The bottle is tubular in shape, narrowing at neck and foot. About the centre is a broad band of scroll-work. The neck has plain mouldings. The rim lip is defective and the missing foot has been replaced by a base of metal covered by ceramic. The mouth is chipped half around. Looking through the hole one can see at the flat base of the hole the mark of the drill. The crystal seems to have some impurities, but is otherwise very clear and smooth. There are two major decorative fields containing four interlaced patterns. In general the decoration is coarser than that of the ewer (plate 7) and there is no "dot and line" motif.

BIBLIOGRAPHY: Migeon, 1927, II, p. 123; Sotheby's 1928, lot 413; V&A 1929, p. 10, pl. 8; Lamm, 1929–30, I, p. 205, II, Tafel 7,6-7; Berlin 1989, cat. no. 635 4/5.

PLATE 5

*Fragment of cylindrical bottle. Fatimid, first half of eleventh century. A.11-1942*

*H. 3 cm at highest point, Diam. 1.7 cm across fragment*

*Purchased from A.L.B. Ashton, who bought it in Cairo, with nos 12 to 15-1942, for £16*

This is the lower part of the body of a slender cylindrical bottle carved in relief with a Kufic inscription that reads *baraka li-ṣāḥibih* "benediction for its owner", with just a loop for the ṣ. In its original state the bottle must have been very similar to an example in the British Museum (F.B.Is.13: Longhurst 1926, p. 150, pl. 2c). The crystal is very clear.

BIBLIOGRAPHY: unpublished.

PLATE 6

*Flask. Fatimid, first half of eleventh century. 1163-1864*

*L. 11 cm, W. (max) 8.5 cm tapering towards bottom to 6.3 cm, mouth 2.5 x 2.3 cm outer and 1.6 x 1.4 cm inner*

*Bought for £20 as a Byzantine object (eleventh or twelfth century)*

This flask has a flattened and ovoidal shape, with cut-relief decoration of palmettes and parallel lines around the edges. A palmette motif divides the two fields into two symmetrical halves. On one face it is cracked from mouth to bottom on the right side. The hole through is straight, but subsequently another hole was cut through the base to provide a hole to mount the piece. The crystal is quite clear and has a type of carving and decoration more like that of the ewer, and like the ewer has the distinctive feature of the "dot and line" motif (fig.18).

For a very similar rock crystal flask in the Keir collection (fig.24) see Pinder-Wilson 1988, no. R11, pp. 303–5 (dated ca. 1025/416, Egypt).

BIBLIOGRAPHY: Longhurst 1926, p. 150, pl. 2,D; Migeon 1927, II, p. 112; Lamm 1929–30, I, pp 208-9, II, Tafel 75,2.

PLATE 7

*Ewer. Fatimid, early eleventh century. 7904-1862*

*H. 19.5 cm, Diam. of base 9 cm, openings of mouth 4 x 5.2 cm, H. of handle 14.3 cm, W. of handle 2.7 cm, thickness of handle 5 mm, thickness of ground body 1.7 mm, thickness of the body with relief decoration ca. 2 mm*

*Bought for £450 as a Byzantine object*

The relief decoration is within a frame as if the object were covered by a textile with a decorative pattern. On each side it consists of a bird of prey attacking a gazelle among foliage. The surface is perfectly polished; the crystal is very clear; the object is very light. This is one

of a series in various European collections closely related to the ewer in the treasury of San Marco, Venice, which bears the name of the Fatimid Caliph al-'Azīz (975–96/365–86).

BIBLIOGRAPHY: Migeon 1907, p. 375, fig. 323; Migeon 1927, II, p. 109, fig. 276; Longhurst 1926, pl. 1,A; Kühnel 1962, p. 411, fig. 411; Lamm 1929–30, I, p. 194, II, Tafel 67,4; von Strohmer 1949, fig. 2; Erdmann 1951, fig. 1; Beckwith 1960, fig. on p. 7; Wentzel 1972, pp. 73–4, fig. 76.

---

## PLATE 8

*Jug. Fatimid, late tenth century. A.53-1926*

*H. 4.6 cm, W. 3.7 cm at widest point, Diam. of base 1.7 cm, circumference at the belly 12.5 cm*

*Given by Dr W.L. Hildburgh*

The jug is pear-shaped, has a small neck and one handle, and does not have the spout characteristic of the ewers. The crystal is cracked. The piece has obvious connection with a type of Roman rock crystal jugs, as demonstrated by one in the V&A (A.74-1952).

BIBLIOGRAPHY: Longhurst 1927, I, p. 62; Longhurst 1926, p. 149; Lamm, 1929–30, I, p. 229, II, Tafel 84,6 (Egyptian, tenth to twelfth century).

---

## PLATE 9

*Fish. Late ninth or early tenth century. A.20-1926*

*L. 5.3 cm, H. 3.5 cm, L. of hole drilled through 3.8 cm*

*Bought from E.R.D. Maclagan for £2*

The carving is confined to two bands at neck and tail, and on the back there is a fin. The fish is pierced with a horizontal hole and was perhaps used as a kohl-pot.

BIBLIOGRAPHY: Schmidt 1912, p. 53; Longhurst 1927, I, p. 62; Lamm 1929–30, I, p. 217, II, Tafel 76,22 (Egyptian, late tenth or eleventh century).

---

## PLATE 10

*Chess piece, King or Queen, late ninth or early tenth century. 669-1883*

*H.6.3 cm, front protuberance 3.8 cm, Diam. of base 4.5 cm*

*Bought for £15 as a Byzantine object*

The piece has a hole on top of the protuberance and was probably used as a reliquary. It is carved with the representation of two birds confronting one another, a band diapered with crosses and opposed scrolls. On the top of the object between the two birds and a band with crosses and lines there is a small hole about 0.5 cm deep.

BIBLIOGRAPHY: Longhurst 1926, p.150, pl. 2,J; Migeon 1927, II, p. 114; Lamm 1929–30, I, p. 214, II, pl. 76,2; Berlin 1989, cat. no. 676 4/66, p. 37, fig. 19.

# 2: TEXTILES

## *ṬIRĀZ*: NATURE AND USE

Rock crystal, as we have seen, presents considerable problems, not only for dating and provenance but also in understanding the technology and the social and economic contexts of its production and use. With textiles, on the other hand, information is far more plentiful – even if it is not always easy to interpret. The first major difference is that textiles have survived in considerable quantities, enough for us to discern something of their importance in Islamic societies of the medieval period. For example, as is evident from the Geniza documents,[1] a bride's trousseau normally consisted chiefly of textiles, which were often passed down from generation to generation.[2]

The number of terms found in Arabic for types of fabric and garments is vast, reflecting the many production centres as well as the wide range of uses to which they were put, which included not only clothing in all its variety of fashions but also furnishing. A spectacular and unique example of the latter is provided by the textiles adorning the Ka'ba, made of black silk and embroidered with gold and silver threads. Now produced in a factory established for this purpose in Mecca itself in 1961, they were previously associated with Egypt[3] where they had been made for centuries, a new set being taken with the pilgrimage caravan every year to Mecca.

A particular type of textile which has survived in considerable quantities, indeed making up the bulk of the V&A holdings from the Fatimid period, is a decorated linen known as *ṭirāz*. Found on garments for both men and women (and also, on occasion, on furnishing fabrics),[4] the *ṭirāz* textiles have inscribed or decorative bands, whether embroidered, woven, painted or printed. However, the term *ṭirāz* presents a problem of definition. The original meaning[5] seems to have been of a richly embroidered garment, usually associated with the court and the sultan. Such garments were robes of honour either given as rewards on special occasions or, more usually, supplied annually to court dignitaries and senior officials. In addition, the word *ṭirāz* was and is also used to designate the whole fabric industry, or the place of production of these garments (*dār al-ṭirāz*).[6] As we will see, this place of production seems to have been attached to the court during pre-Fatimid, Umayyad and Abbasid times. In other

words, *ṭirāz* can be understood to refer specifically to such textiles produced for the court and to the system by which they were commissioned and made.

However, many of the *ṭirāz* from the Abbasid and Fatimid periods with explicit caliphal references also specify within their inscriptions to which of two types of *ṭirāz* they belong, *khāṣṣa* or *'āmma*, translatable as "private" or "public", the latter category thus suggesting that *ṭirāz* textiles were not produced exclusively for the court. Further, many typologically similar textiles have inscriptions that are not caliphal but formulaic, or indeed meaningless, and *ṭirāz* can be also understood as a more general term comprising garments with any type of decorative band. Indeed, evidence that the term had this wider sense already during the Fatimid period is provided by an interesting twelfth-century letter from the Geniza documents by someone in North Africa ordering textiles from, probably, Egypt. In it a very clear distinction is made between *ṭirāz* with calligraphic and non-calligraphic decorative bands.[7] The discussion of *ṭirāz* in the scholarly literature has for some time now included all these types, and it is this wider usage of the term that will be followed here. Indeed, it has been suggested that the term "*ṭirāz* fabric" is now obsolete, and that we should examine *ṭirāz*, however defined, within the broader framework of the medieval Islamic textile industry.[8]

Examples exist of *ṭirāz* fabrics from Egypt, Palestine, Spain, Sicily, Yemen, Iraq and Persia, and historical sources also mention other areas of production, such as Sūs or Gabes (both in Tunisia),[9] although these have not yet been associated with specific textiles. However, most surviving examples from the Fatimid period, including the V&A pieces, come from Egypt, where the climate and soil are particularly good for preserving organic materials. The majority were found in burial sites such as Armant (Upper Egypt, plates 21 and 22); Manshiyya (near Girgeh, Upper Egypt, plate 27); al-A'ẓam (near Asyūṭ, Upper Egypt, plates 17, 24, 30 and 797–1898); al-Kharjah (Egypt, plate 23); Akhmīm (Egypt, plate 13). A pre-Fatimid *ṭirāz* too, made under the Umayyad Caliph Marwān II in North Africa, was found at Akhmīm (Egypt, plate 12). Unfortunately, unless the textiles come from an archaeological context, we do not know the circumstances in which they were taken out from the tombs, and we therefore lack any more precise information about them. However, three *ṭirāz* textiles belonging to the Abbasid and Fatimid periods have been recently discovered in a burial context at Iṣṭabl 'Antar, south of Fusṭāṭ, the old capital of Egypt, covering the bodies of, possibly, members of the Fatimid family.[10] Also datable are the pieces from Qaṣr Ibrīm (some of which are in the V&A), which belong to a period ranging from the eleventh to the fourteenth century.[11]

Many *ṭirāz* textiles can be dated from their inscriptions and, as a result, there has been a tendency to make the extraction of historical information the focus of *ṭirāz* studies. But a more recent approach to *ṭirāz* is to study them also as fine examples of textile art.[12] This does not reduce their importance as historical documents but, rather, opens up new dimensions, those of the technical analysis of their structure and the stylistic analysis of their decorative elements: and it seems clear that in order to understand *ṭirāz* more fully a combination of these approaches is required, exploiting to the full the various levels of information

contained within each textile – inscription, calligraphy, fabric and decoration. What is certain is that we are still at a preliminary stage in solving many of the problems associated with *ṭirāz*. These concern the evolution and distribution of the textile industry, materials, techniques, aesthetics and differences in consumption according to social class.

## DISTRIBUTION

For example, if we consider distribution, we find that the chronological spread of the material collected so far, as defined by inscriptions and, to a lesser extent, stylistic features, might be thought to suggest that the production of *ṭirāz* textiles was greater in certain periods than in others. The number of surviving samples seem to rise from the reign of al-Muʿizz (mid-tenth century) through those of al-ʿAzīz and al-Ḥakim (end of the tenth century), only to be followed by a marked decline in the number of examples from the reign of al-Mustaʿlī (end of the eleventh century) onwards. This has been taken to imply something significant regarding the origins, growth and decline of the Fatimid *ṭirāz* industry, but the value of such evidence is called into question by the impossibility of deriving the production rate with any accuracy from the survival rate, especially when finds are random and there has been a lack of systematic excavation to cover the whole period. For the same reason, it is difficult to draw firm conclusions about the geographical distribution of centres of production, although here there is also a considerable amount of textual evidence to be drawn upon.

Many Fatimid *ṭirāz* have inscriptions recording their place of production, and the places mentioned – Miṣr, Damietta, Shaṭā, Būra, Tūna, Tinnīs and Dabqū – are corroborated by literary sources.[13] All, with the exception of Miṣr, are in or around the lagoon at the north-east end of the Nile Delta (see frontispiece map: inset).

As for Miṣr itself, although the name can have a much wider meaning, including Egypt, it is here to be identified with Fusṭāṭ: in the period between the Arab conquest and the foundation of Cairo the name Miṣr was regularly applied to a settlement situated between the mosque of ʿAmr and the right bank of the Nile. It is used in this sense by Nāṣir-i Khusraw (eleventh century)[14] when he tells us that "The fine woollen stuffs that they use in Persia and call Miṣr all come from Upper Egypt, because at Miṣr they do not weave woollens". In addition, from the foundation of Cairo up to the present day, Miṣr has also been used to refer to the city of Cairo (the full name of which is Miṣr al-Qāhira).[15]

As far as the localities in the Delta region are concerned, they seem to fall into two geographical groups. One consists of Damietta, Shaṭā and Būra, the other of Tinnīs, Tūna and Dabqū. Damietta, Shaṭā and Būra were located on the western edge of the lagoon, possibly on small islands or peninsulas. Al-Yaʿqūbī (891/278),[16] for example, mentions them in the sequence Shaṭā (which he says is coastal), Damietta and Būra. The other group consists in the first

instance of Tinnīs and Tūna, which were located on two islands in the centre of the lagoon. According to al-Maqrīzī (fourteenth century) Tūna was one of the dependencies of the province of Tinnīs,[17] and the latter certainly seems to have been by far the more important of the two. Particularly vivid is al-Muqaddasī's (ca. 985/375) description of it. Tinnīs, he says,

> situated between the sea of al-Rūm and the Nile, is a small island in a lake, the whole of which has been built as one city. And what a city! It is Baghdad on a smaller scale, and a mountain of gold and the emporium of east and west . . . Most of its inhabitants are Copts . . . The town manufactures coloured stuffs and garments.[18]

Somewhat problematic is the relationship to the above groups, and to each other, of Dabqā (or Dabqū or Dabquwa) and Dabīq. The former is located by al-Bakrī (eleventh century) and Yāqūt (1179–1229/575–626) near Tinnīs,[19] while for al-Maqrīzī the latter is a dependency of Damietta, thus relating them to the second and first group respectively. It is implied by Yāqūt, however, that the two are, in effect, one and the same. This identification may be no more than a simple confusion of similar names, but the more important point is that both are cited as places manufacturing a fabric called *dabīqī* (a form which must derive, however, only from Dabīq).[20] Although one fragment of material from the Abbasid period and two from the Fatimid period have been found bearing the name Dabīq as their place of manufacture,[21] the town itself is never mentioned in the Geniza documents,[22] and after the earlier confirmation of Ibn 'Abd Rabbih (late ninth or early tenth century) that it was the source of *dabīqī* fabric[23] it is hardly ever mentioned by later authorities and must have faded into insignificance at a quite early date. Indeed, it is evident that already in Abbasid times the term *dabīqī* had become generic, denoting, like "denim" or "muslin", a type of material rather than its source, and in fact various authorities actually mention Damietta and, especially, Tinnīs as cities where this highly prized and versatile white fabric was produced.[24]

More examples survive of the production of the Tinnīs and Tūna group than of the other (while Miṣr is represented by just a few items). During the Abbasid, Tulunid and Ikhshidid periods Miṣr is the name that most frequently appears, followed by Tinnīs and Alexandria. But by the ninth century Delta localities such as Damietta and Shaṭā begin to be mentioned more frequently, presaging a trend which continues through the Fatimid period, when the number of surviving pieces from Miṣr becomes insignificant, and there are no more examples from Alexandria. Thus we can relate most of what little survives of Miṣr production to the reign of al-Muʿizz (mid-tenth century), while the Delta is poorly represented (and only by Tinnīs and Tūna). During the late tenth century we start to see a shift: the Delta localities come to the fore, in particular Tinnīs and Tūna, but also Damietta and Shaṭā, while Miṣr is now virtually absent; and this reversal is confirmed by the surviving eleventh-century *ṭirāz* examples. It is tempting to conclude that we have here evidence for a general long-term shift in production, with the Delta centres gradually displacing Miṣr as the major centre of the industry.

But the same methodological problems mentioned for chronological distribution apply here, and it would be rash to attempt to draw such a clear conclusion about comparative levels of production from the survival rate alone. Further, it is pertinent to add the cautionary note that the absence of a particular geographical location from the surviving *ṭirāz* does not necessarily mean that the textile industry in that centre had ceased to exist. A case in point is Alexandria. A textile-producing centre since Ptolemaic times,[25] it is mentioned by the fourteenth-century Arab historian al-Qalqashandī[26] in relation to the production of robes of honour, and against the lack of any mention of Alexandria on textiles of the Fatimid period may be set the fact that there are many references in the Geniza documents to a type of textile called *iskandar[ān]ī*, usually used for making blankets both as clothing and as nightly cover.[27] But the reverse of the coin, as we have seen in the case of *dabīqī*, is that a name pointing to a particular locality is not necessarily a guarantee of origin. Indeed, there are even cases of textiles being mislabelled to give the impression they were from a famous centre, a notable example of such forgery being a textile known to be Spanish but inscribed "made in Baghdad".[28]

Despite these various complicating factors, if we consider the textile industry in general, rather than the production of *ṭirāz* in particular, a shift in the balance of production from inland Miṣr to the localities of the Delta region still seems the most likely interpretation of the data to hand. And it would find a ready explanation in the commercial advantages enjoyed by a port location during a period marked by a growth in international trade.[29] For example, Ya'qūbī reports that ships came to Tinnīs from Syria and the Maghreb,[30] and we may conclude that because of its location this centre was able to combine the production of textiles from the raw material cultivated in the Delta, the import of other raw materials, like silk, and the export of the finished *ṭirāz* products overseas. In the late tenth and the eleventh century, with the expansion of European markets and new technological advances in shipping,[31] the Fatimid empire grew in wealth and power,[32] so that the general economic climate was particularly favourable to the development of the textile industry at the coastal centres. Miṣr would have suffered by comparison, and it is thus hardly surprising to find that from the end of the reign of al-'Azīz onwards fewer and fewer of the surviving items were produced there. It may be noted, further, that there is literary evidence for the superiority of cloth produced in Damietta and Tinnīs,[33] and the fabrics we have from the Delta region do indeed reveal a wider spectrum of textile qualities, suggestive, therefore, of a more versatile industry.

## THE ORGANIZATION OF PRODUCTION

### Administration

Besides the name of the caliph, the date and the place of production, many Fatimid *ṭirāz* textiles also mention what it is usually thought to be the type of workshop or factory in which they were made: *ṭirāz al-khāṣṣa*, which has been

translated as "private factory", and *ṭirāz al-'āmma*, or "public factory". The former has generally been understood to refer to a factory producing cloth specifically for the caliph and his court, the latter to one producing luxury wares both for the home market and for export. But the structure of the industry as a whole raises a number of complex issues, and the above is not the only possible interpretation of the relationship between the two.

The textiles themselves shed no light on the matter (there is, for example, no difference in quality), so that it is to written sources that we need to turn. The Islamic *ṭirāz* institution doubtless developed out of the institutional forms of its predecessors, whether Persian, or Byzantine and Coptic,[34] and it is a Persian origin that is identified by Ibn Khaldūn (1332–1406/733–809), who, even if he is a fairly late author and does not quote any early authorities, provides the most extensive and coherent analysis of the *ṭirāz*. He also stresses that the industry is a specifically royal one:

One of the splendours of power and sovereignty, and one of the customs of many dynasties was to inscribe their names or certain signs, which they adopted especially for themselves, in the borders of garments designed for their wear, made of silk or brocade. The writing of the inscription was to be seen in the weave of the warp and woof of the cloth itself, either in thread of gold, or coloured thread without gold, different from that of the thread composing that of the garment . . . Thus the royal robes are bordered with a *ṭirāz*. It is an emblem of dignity reserved for the sovereign, for those whom he wishes to honour by authorizing them to make use of it, and for those whom he invests with one of the responsible posts of government. Before Islam the kings of Persia had placed upon their garments either the portraits or likeness of the kings of the country, or certain figures and images designated for their use. The Muslim princes substituted their names for the figures, adding other words considered to be of good augury, which gave the praise of God . . . Under the Umayyads and Abbasids the places for the weaving of those stuffs, situated in their palaces, were called *dār al-ṭirāz*. The officer (*qā'im*) appointed to inspect them was called *ṣāḥib al-ṭirāz*. His duty was to inspect the workmen, instruments, and weavers there, and oversee the payment of their stipends and the renewal of their instruments; he also inspected their work. The princes entrusted this post to one of the great nobles of the empire or to one of their trusted clients. It was the same in Spain under the Umayyads, and under the smaller dynasties (*mulūk al-ṭawā'if*) who succeeded them, as also in Egypt under the Fatimids, and in the East at the courts of the Persian monarchs, their contemporaries. Then when the demand of the courts for luxury of all kinds diminished, as their power diminished in extent, and independent dynasties became numerous, this office fell into desuetude in most dynasties entirely, and consequently nominations to it . . . As regards the Turkish dynasty, which, in our days, rules over Egypt and

Syria, the use of the *ṭirāz* there is very fashionable, by reason of the extent of their dominion, and the great civilization of their country. Yet the stuffs are not made in the palaces and castles of those princes, and they have not got at their court officers assigned for that purpose. Whatever requirements of this kind they have, are satisfied by weavers who exercise this profession, in silk or in pure gold. They call this stuff *zarkash* from a name borrowed from the Persian. The name of the sultan or emir is written upon them. The workmen make those like all the other precious objects which are destined for the use of the court.[35]

Serjeant[36] too thinks that it is very probable that the factory system called *ṭirāz* had its origin in the state factories of the Sasanian kings. On the other hand, Karabacek and others deem this claim hypothetical in the extreme, and propose an origin in the Coptic–Byzantine factories in Egypt before the Muslim conquest; and, in fact, pieces of cloth which substantiate this view have come to light.[37]

Controversy over the origins of the industry is matched by controversy over its structure. Ibn Khaldūn postulates a shift from an earlier model, valid also for the Fatimid period, with a specialized palace workshop with its own internal administration, to a later post-Fatimid model with no palace workshop and, therefore, no court officials overseeing it. The key distinction here is between the *ʿāmma* and *khāṣṣa* branches, and, for all the detail they provide, our sources fail to distinguish between them with sufficient clarity. The scale of operations that their accounts suggest would seem to pertain essentially to the former, but if so what can be inferred about the latter? And if there is insufficient evidence to confirm Ibn Khaldūn's analysis, what other model might be proposed for the ordering of textiles for the court?

It is reasonable to assume, as Grohmann did in the 1930s,[38] that this could have been done simply by court officials placing orders on the caliph's behalf so that there need not have been a palace workshop administered and financed through the state departments, and this hypothesis is still favoured by some scholars. On the other hand, for economic historians the distinction between sectors would make sense only if there was a separate centre of production for the royal wardrobe, with its own administration.[39] Accordingly, one would expect there to have been a special factory, preferably close to the court. Under the Abbasids there had evolved a complicated system of *dīwāns*, the departments responsible for the various functions of the state.[40] During the Fatimid period it seems that this system was expanded and structured more hierarchically, a development often attributed to Yaʿqūb ibn Killīs, vizier under al-Muʿizz and al-ʿAzīz.[42] But in addition to the public *dīwāns*, the Fatimid system also included a privy purse administering moneys and property belonging to the caliph himself. This was called *dīwān al-khāṣṣ*, and we may assume that it is through this route that the royal robes were financed.[43] But whether or not there was a palace workshop in earlier periods, the financial and administrative structure

of the Fatimid *dīwān al-khāṣṣ* did not require one to exist, and in fact we know that *khāṣṣa* material was produced in places far distant from the capital. It is therefore reasonable to argue that once the economic advantages of a Delta location had led to concentration of production there a centralized court-workshop system would be abandoned, and a new system of long-distance administration would evolve.

Nāṣir-i Khusraw tells us that at Tinnīs there were weavers so skilled that they were weaving the royal robes in a royal workshop,[44] which clearly runs counter to the notion of a workshop at the court itself, and confirmation of the production of *khāṣṣa* goods in the Delta is provided by Idrīsī (ca. 1100–65/494–561) who mentions Maḥallat al-Dākhil and Dumaira as cities with factories for both sectors (*ṭuruz li'l-khāṣṣa wa li'l-ʿāmma*).[45] Accordingly, we need to revise the idea of *khāṣṣa* and *ʿāmma* as necessarily referring to different and widely separated workshops.

As noted, in addition to the product, the term *ṭirāz* is also used to refer to the means of production: the workshop and, particularly with respect to *khāṣṣa* materials, the administration. This, we may assume, began at the highest level with the *dīwān al-khizāna* (treasury department), which had as part of its responsibility the storage and upkeep of the state wardrobe. It would have assessed what needed to be ordered and supplied the necessary funds. Execution of the order was then devolved to the *dīwān al-ṭirāz* (*ṭirāz* department), which is portrayed by Ibn Mammatī (d. 1209/606) as a compact administrative entity in the following terms: "The *ṭirāz*. This service (*muʿāmala*) has an inspector (*nāẓir*), an overseer (*mushārif*), a controller (*mutawallī*), and two accountants (*shāhid*)."[46] Local arrangements were carried out through middlemen who would arrange for the acquisition of the necessary raw material and place the orders with the weavers. Such a system allowed a degree of flexibility and devolved decision-making, but at the same time overall control was ensured by the involvement of state officials and the imposition of financial penalties for inadequate performance. Ibn Mammatī sums up matters thus:

> Now, if any sort of article is required to be manufactured, a list is made out of the Dīwān al-Khizāna (Office of the Wardrobe), and sent to them [the ṭirāz officers] along with the required (or computed) money, and goldthread (dhahab maghzūl) for their expenses. When the chests (safaṭ) are brought back, they are compared with the chits which went with them, and checked. If the value comes to more than has been spent on it, the excellent nature of the workmen is inferred from that, but they derive no benefit from it all – that is to say the surplus. If the value is less than the expenditure, the extent of the deficiency is elucidated and requisition is made from the Dīwān, and the employees are required to pay it. The employees take the responsibility of payment on themselves, and extract it from the gold embroiderers (rakkām). A series of happenings of this kind in what they bring, indicates the dishonesty of their character.[47]

A further important official was the ṣāḥib al-ṭirāz (ṭirāz overseer), but against the obvious assumption that he was the head of the dīwān al-ṭirāz we may note the omission of any reference to him in Ibn Mammatī's catalogue of its officers. It is possible, therefore, that he was rather a senior official in the dīwān al-khizāna, the one who supervised the orders which would be passed down to the dīwān al-ṭirāz. In any event, he was evidently a person of considerable ceremonial importance as is shown in the following graphic account by Ibn Ṭuwayr of the presentation of royal apparel by the ṣāḥib al-ṭirāz to the caliph:

When he arrives with the royal requisitions (al-istiʿmālāt al-khāṣṣa) which include the umbrella (miẓalla), the badla, the badana and the royal apparel for the Friday prayer (al-libās al-khāṣṣ al-jumaʿī), etc., he is greeted with great honour, and a beast is assigned to him from the caliph's stables, which remains at his service until he returns to his charge. He stays at al-Ghazzāla on the bank of the river. It used to be one of the royal belvederes, and Shuʿāʿa ibn Shawār renovated it. If the manager of the ṭirāz factories (ṣāḥib al-ṭirāz) had ten houses in Cairo, still he would only be allowed to stay in al-Ghazzāla. Hospitality is dispensed to him as to strangers arriving (as ambassadors) to the state. He comes before the caliph after bringing all the chests (safaṭ) which enclose these precious robes. All he has is displayed while he draws attention to one thing after another in the hands of the royal farrashes [those who display the textiles] in the palace of the caliph, wherever the monarch happens to be in residence. Great honour is shown to his personage, especially when the materials ordered suit the requirements. When this is completed, it is compared with the account which he has with him, and they are delivered to the master of the robes, and he is invested publicly before the caliph, nobody else apart from him being invested in this fashion. After this he returns to his own palace.[48]

But whatever the precise responsibilities of the ṣāḥib al-ṭirāz beyond his role in this ceremony, the broad structure of the system by which court orders were commissioned, funded and executed, and their quality vetted seems clear. Much remains obscure, on the other hand, about the production of ʿāmma goods, but the most likely conclusion seems to be that the interest of the state was less in intervening directly through some kind of economic command system than in maximizing revenue by putting in place an efficient method of tax collection. There is a fascinating passage from the description of Tinnīs by al-Muqaddasī (second half of the tenth century):

Now, concerning Shaṭawī cloth, it is impossible for a Copt to weave any unless the stamp of the sultan has been placed upon it. Nor can it be sold except through the intermediary of brokers, who have been entrusted with this function, and the sultan's officer writes down what has been sold in his notebook. Then it is taken to someone to wrap it up, then to another to be

tied up in wrappings (ḳishr), then to another to be packed in chests (safaṭ), then to another to rope it, each of these men having a due to take. Then at the harbour gates a certain sum is taken. Each one writes his mark on the chest, and then the vessels are inspected at the time of sailing.[49]

This gives an interesting insight both into the quite rigid division of labour and the extent of state control throughout the manufacturing and subsequent transport processes; and in addition to the explicit mention of a port duty it is difficult to think that the initial stamp and the subsequent record of sale to approved brokers were entirely duty-free.

## MANUFACTURE

### Flax

Turning now to the production of the fabric, we find that all the pieces examined in the V&A, and, indeed, the great majority of surviving Fatimid fabrics, have a linen base and are therefore derived from flax. Before the fabric can be woven several preparatory phases are therefore involved, from farming through preparation of the fibres to spinning and, occasionally, dyeing.

The first stage, after gathering the plants from the fields, was to ret them in water to separate the fibres from the woody core. They were then laid out to dry and turned (the Geniza documents state that this was done by the farmers themselves). Next, the fibres were separated from the wooden core by beating, swingling and scutching (tasks undertaken by other workers), and the care with which all these various processes were carried out would determine their quality. Next would come bleaching, and the fibres could then finally be spun.

### Spinning and weaving

Surviving Fatimid fabrics are of S-spun linen, which means that the spinning wheel has turned the flax strings right, following their natural twist. Such uniformity makes it impossible to discern different workshop groupings.[50] Nor, since the same natural spin is typical of Egyptian linen from Pharaonic times onwards, does it permit chronological distinctions to be made. At most it provides a characteristic contrast with different Abbasid, Tulunid and Ikhshidid fabrics which are predominantly Z-spun.[51] We thus find that the pre-Fatimid Egyptian linen *ṭirāz* of al-Muʿtaḍid (plate 13), dated 895/282, also uses S-spun threads (for both warp and weft), while silk textiles, whether pre-Fatimid or contemporary with them, may have a Z-twist, as in the eighth century textile of Marwān from the *ṭirāz* of Ifrīqiya in the V&A (plate 12) or the textile found in S. Ambrogio (plate 16) attributable, because of the characteristic of the name given in the inscription, to south-eastern Anatolia at around 1020/411. Similarly with cotton, as in the Yemeni cotton textile (plate 15), also datable to the Fatimid period.

On receiving the threads, the weaver had first to use a pumice stone to clear off their blackish crust, and what emerges from the loom is a garment woven with the commonest type of weave, called plain or tabby, consisting of the alternate crossing of warp and weft threads, one up and one down, and this appears to have been the only one used in medieval Egypt. In the absence of any variety the quality of the woven fabric would therefore be determined, in addition to the fineness of the threads supplied, by its density. All the Fatimid pieces considered here have this plain or tabby weave ground, including the cotton ikat from Yemen (plate 15), and also the tenth-century textile of al-Muṭīʿ from Egypt (plate 14) and the ninth-century textile of al-Muʿtaḍid (plate 13). Interestingly, contrasts can again be drawn with fabrics from elsewhere, even if they are insufficient in number for general conclusions to be drawn: the eighth-century Marwān textile from Ifrīqiya is a compound twill (plate 12), as is the S. Ambrogio textile from eleventh-century south-eastern Anatolia (plate 16).

## COMMERCE

The principal areas of flax cultivation were Upper Egypt, the Fayyūm and the Delta. From them the raw material was traded by intermediaries either to the textile-producing centres or to the ports on the Mediterranean for shipment overseas. The importance of linen as an agricultural product made Egypt's role in the medieval Mediterranean textile industry and trade a vital factor in the Egyptian economy.[52] Indeed, on the basis of the Geniza materials and documentation on papyri it is evident that flax was the single most important tradable crop produced on Egyptian fields, being exported to various destinations in the Mediterranean. It thus formed to a large extent the basis for the prosperity of Egypt in the medieval period, with a whole network of enterprises and industries built upon it.

Although only one weaving technique was used, there was still a considerable variety of types of linen, each with its own value and market niche. As noted above, differentiation already began with the flax. This was a local, age-old agricultural industry in Egypt, and each locality had developed its own style. The Jewish merchants, who traded the flax threads after they had been expertly treated,[53] carefully distinguished between the various types, each of which had a trade name, mostly, but not always, taken from the place where the flax was grown.[54] Accordingly, there can be no doubt that the various finished linen products differed from one another in durability, smoothness, lustre and fineness, facts certainly well known not only to dealers but also to discerning customers. A Muslim handbook of market supervision warns in the strongest terms not to mingle a poor variety of Egyptian flax with another.[55]

Linen is by far the most common textile mentioned in the Geniza documents, and foremost among the various types and qualities they distinguish is the *dabīqī*.[56] Others included the *sharb*, an extremely fine and expensive linen,

similar perhaps to a loosely woven gauze, and apparently used for underwear, turbans and gala costumes, and the *tinnīsī*, a fabric used mostly for bedding and cushions, but not for garments.[57] The Geniza documents also mention specifically linen from Tūna, which was renowned for its beauty.[58]

## DYEING

Whatever their specific type and quality, these various fabrics were for the most part undyed. Nevertheless, on occasion the linen fabric would be subjected to the further process of dyeing, which had been practised in Egypt since pre-Islamic times. The surviving Fatimid dyed examples are fairly evenly spread chronologically, but are extremely scarce, and it is clear that dyed linen must have been a rather rare commodity. Linen has the advantage over cotton or silk of providing, when tightly woven, a more stable ground providing a better-quality finish, but unlike them it is dye-resistant, reacting in the same way as it does to ink, which runs on the surface, thus making painting on linen difficult. However, although they are rare, linen *ṭirāz* with painted inscriptions in black ink are not unknown.[59] From the Geniza documents we also know that dyeing was generally quite a costly affair, and we may assume that for linen the process took longer and perhaps required more dye-stuff, thereby raising costs even further. It is, therefore, not surprising that we have so few examples with dyed base fabric, and the difficulty of the process is reflected also by the limited colour range of the surviving examples. In contrast to the silk used for the decorative bands, which exhibits a considerable variety of colours, and for which we also have the evidence of the many orders from merchants and private costumers to dyers in the Geniza documents, the linen range is very restricted, with a predominance of black and blue (for a blue example in the V&A see plate 20).

The dyers seems to have been a mobile profession, migrating from one place to another, thus contributing to the diffusion of tastes and techniques.[60] Different names for dyers may also suggest the specialization of dyers in one particular colour. Supplying dyeing material and mordants (the ingredients needed for fixing dyes in textiles permanently)[61] was one of the main branches of international and local trades, with indigo leading the list.

Originally cultivated in India (and sometimes referred to in the Geniza documents as Indian), indigo[62] was also grown in other places, such as Egypt and the Jordan valley. Called *nīl* in Arabic (a word of Sanskrit origin), it appears in the Geniza as a widely traded dyeing stuff, exported also to Europe.

The basic colours noted in trousseau lists and cognate sources are: white, blue, green, red, black, yellow. The leading role of white is underlined by the many distinctions of shade that were made.[63] Blue follows white closely as a favourite colour of Geniza people and is also represented there by a variety of shades. Black appears in the table solely as a colour for clothing, for veils, shawls, etc., but only exceptionally for full robes.[64]

## DECORATION

Although the base fabric is linen, for the inscribed and decorative bands of *ṭirāz* fabrics a different material is used. Wool had been the major decorative material in Coptic textiles, and there is literary and material evidence that wool was being still produced in Egypt for the Muslims in the early Islamic period. An example is a piece in the V&A (plate 11) on a linen ground with a wool-embroidered decoration, in two bands of animals within roundels, which is datable to the seventh or eighth century. It shows the continuation into the Islamic period of a tradition of decorative motifs still very much in the Coptic tradition, sometimes even combined with Arabic inscriptions,[65] as another interesting and very beautiful example also in the V&A (plate 18) shows. This is a fragment of a black-dyed wool ground with a wool and silk woven decoration and two inscriptions, one in Coptic and one in Arabic.

However, wool was gradually supplanted by silk, which remained the standard decorative material throughout the Fatimid period, despite the fact that it was for the most part an expensive import. The little silk that was produced in Egypt itself – mostly in the Fayyūm and Alexandria – was not considered of very high quality, and could not match that imported from Spain, Ifrīqiya, Sicily,[66] Syria and Palestine.

For *ṭirāz* inscriptions and decorations silk was used on its own or in conjunction with wool or silver or gold thread, that is silver or gold threads wrapped around a silk core. A famous example of a fabric with such thread is a linen with silk and gold tapestry bands dating from the reign of the Caliph al-Mustaʿlī (1094 –1101/487–94), which is now known as the "Veil of Saint Anne" (fig.25).[67] It has been assumed that it was given to the cathedral at Apt, by either the lord or the bishop of Apt as part of the booty from the plunder of Jerusalem in 1099 in which they both participated.

Two basic techniques were used for the decorative bands: embroidery and tapestry weaving. With embroidery individual threads are stitched on to a base fabric: the threads may be of more than one colour, and various kinds of stitch may be used.[68] With tapestry weaving, on the other hand, the decoration is integrated into the base fabric by changing the colour (and often the quality of material) of weft threads.[69] In pre-Fatimid material embroidery is the main decorative technique, and tapestry begins to occur sporadically only in the ninth century. But it then becomes more common, rivalling embroidery by the end of the Ikhshidid dynasty (tenth century), and replacing it almost completely by the late Fatimid period, so that over the Fatimid period as a whole tapestry weaving was by far the most common method of decorating and inscribing Egyptian textiles.

## LABOUR

As might be expected from the division of labour that charcterized all the earlier stages of the manufacturing process, the embroidered *ṭirāz* decorations were

*25.* Detail of the "Veil of Saint Anne", linen with silk and gold tapestry bands, (L. 310 cm, W. 150 cm). Made in Damietta (Egypt) under the Fatimid Caliph al-Mustaʿlī 1094–1101/487–94.
Cathedral of Saint Anne, Apt, France.
Photo: Roger-Viollet, Paris.

made by specialist embroiderers[70] (or embroideresses, castigated by Ibn ʿAbdūn (twelfth century) as "women of bad behaviour" to be kept away from the market).[71] Again, those who made the borders or fringes, for example, may not have been the same ones who made the *ṭirāz*.[72] Preparation of the completed garment, too, may have involved different specializations: after weaving a cleaner would need to be engaged if the colour was not uniform; and a newly woven garment, of material described as *khām* (raw), throughout the Geniza documents, would need to be treated by a fuller for proper use. This involved treading it in a solution of fuller's earth, a soapy substance which caused it to shrink, tighten, and become "full" and bulky.[73] Treatment by sprinkling and beating with a club is also mentioned. This operation seems not to have been a part of the work of the fuller (*qaṣṣār*) but yet another separate treatment, carried out by someone called a *mumarrish*. As a final step a garment might be put into a press to make it smooth and shiny. The press (*kamad*) was, again, operated by a specialist presser (*kammād*).[74]

## INSCRIPTIONS

Whatever the techniques and materials used to create them, the inscriptions are often the most vital feature of a textile, from both a historical and an aesthetic point of view. Given that many pieces are datable by the information contained in their inscriptions, it becomes possible to study the evolution of calligraphic styles and also, up to a point, of decoration with regard to preferences in design, colour and technique. These can then provide points of reference when considering, say, calligraphic or decorative styles on undated objects in other media. Thus, we can propose a stratification of calligraphy based on the material considered here which supports and amplifies Marzouk's attempt, made in 1943, to establish a chronology of Fatimid textiles.[75] This begins with, first, the very bold and often undecorated Kufic of the pre-Fatimid period, as in the textile of al-Muṭīʿ (plate 14) in the V&A (967/357). Second, during the time of al-ʿAzīz and al-Ḥākim al-Manṣūr (late tenth century) the size of the letters is still rather large, and there is a decorative band just before the fringe (as in plate 19), or in the middle, between the lines of inscription (as in plate 20). Third, on eleventh-century *ṭirāz*, on the other hand, the inscriptions, while still in Kufic, have smaller letters, and are now placed between decorative bands, as in plates 21, 22 and 23, made under the Caliph al-Mustanṣir. The letters are organized all on one level (that is, they do not have curves that go below the line), with decorative motifs filling the spaces between their stems. This has been considered by Flury and Marzouk as a Fatimid innovation, appearing for the first time towards the end of the reign of al-Ḥākim, characterized by the elegance that replaced the boldness and the perpendicular lines that replaced the swan's neck lines, both of which prevailed in the inscription of the textiles of the Ikhshidid and early Fatimid periods.[76] A further, fourth, period corresponds to the late

eleventh and the twelfth century, when the calligraphic style exhibits a combination of Naskh and Kufic. As we go on in the twelfth century, Naskh becomes predominant although, as in the case of the textile of al-Fā'iz (plate 25), Kufic still occurs. It may be noted, nevertheless, that in this particular instance the letters are not clearly defined, and are also intermingled with foliation between and underneath them. A combination of Kufic and Naskh features is provided by the textile in plate 24, while in plate 26 we encounter a clear case of Naskh.

It is equally interesting to see how the content and tone of the *ṭirāz* inscriptions change during the course of the Fatimid period. The early ones present new and explicitly Shī'ī formulae. In a *ṭirāz* of al-Mu'izz (dated 965/354), the earliest dated Fatimid textile,[77] the most obviously new phrase is "their pure ancestors" (*ābā'uhum al-ṭāhirīn*), which relates al-Mu'izz to Muḥammad's family, the 'Alid line. This then becomes part of official Fatimid phraseology, and is retained in two of our textiles (plates 21 and 22), which are from the time of al-Mustanṣir (1036–95/428–88).

After the reign of al-Ḥākim, when extremist doctrines and various popular beliefs threatened the position of the central authority, the official *ṭirāz* inscriptions responded by becoming more insistent and strident in proclaiming caliphal legitimacy. They stress the divine quality of the "Imām among other Imāms" and mention the caliph's name after those of the accepted line of Imāms.[78] Inscriptions on *ṭirāz* from the reign of al-Ẓāhir (1020–35/411–27), al-Ḥākim's successor, illustrate the point (fig.26),[79] as do *ṭirāz* from the reign of al-Ḥāfiẓ, which was marked by the last legitimacy crisis of the Fatimid dynasty.[80]

As well as the fabrics with inscriptions explicitly related to the Fatimid dynasty there are other textiles in the V&A with inscriptions of a more generalized nature, usually augural formulae as in plate 24 (*al-yumn wa al-iqbāl*, prosperity and glory) or religious formulae (*naṣr min Allāh*, victory is from God). Further, there are fabrics with what look like inscriptions but which are in fact a meaningless sequence of letters (as in plate 28); and there are others on which the decoration includes approximations to letter shapes which seem to do no more then draw upon the aesthetic charge of calligraphy (as in plates 29 and 30). But if it is possible to draw a number of broad conclusions about developments in both the calligraphic norms and the verbal content of inscriptions, it is by no means clear that these provide an adequate framework with which to interpret such stylistic diversity, especially

*26.* Ṭirāz, linen and silk, made under the Fatimid Caliph al-Ẓāhir. Royal Ontario Museum, Toronto: 970.364.2B. © ROM

when the basic dichotomy between *khāṣṣa* and *'āmma* material remains problematic. It might be suggested, for example, that the quasi-inscriptions represent a copy of court practice,[81] being therefore an *'āmma* style. The maintenance of script elements could then be understood in economic and technical terms as an industrial response to a public demand, while at the same time the functional redundancy of the inscription permitted distortion, thus

providing a classic example of "medium as message" or, if we prefer Ettinghausen to McLuhan, of the primary importance of the Gestalt of the calligraphic bands.[82]

Implicit in this interpretation is the presumption that such *ṭirāz* are *'āmma* material embodying a late stage of development parallel to the increasing lack of definition and stylistic hesitation described for period four. However, there is no firm evidence for this, and one can point to examples combining calligraphic elements with other decorative style features that suggest a relatively early dating (plate 29); nor is it necessarily the case that all such material is *'āmma*. On balance, it would be wiser to reserve judgement and, in the absence of dated examples, not reject out of hand the possibility that they may have simply constituted a parallel style domain. In any event, it is clear that *'āmma* textiles are not characterized by the use of such meaningless script elements: there are a number of inscriptions consisting of caliphal formulae executed in bold and legible Kufic that identify themselves as *ṭirāz al-'āmma*. This also indicates that there was no reserved *khāṣṣa* area of expression forbidden to the manufacturers of *'āmma ṭirāz*, and it is perhaps wiser to think of the distinction between *khāṣṣa* and *'āmma* as relating neither to stylistic discriminations nor to differences in the location, management and economics of manufacture, but in the first instance to the social identity and rank of the wearer. In general, it seems that *'āmma* materials were, quite simply, available to those who could pay, and that there were no confessional restrictions is demonstrated by the splendid *ṭirāz* textiles that could form part of a Jewish girl's dowry.[83]

## STATUS SYMBOLS

The presentation of garments is a very old tradition in the East. In Islamic times the custom certainly attained great proportions. It had an important precedent, for the Prophet Muḥammad himself had honoured the poet Ka'b ibn Zuhayr by bestowing his cloak upon him.[84]

The gift of a garment could later be accorded to such as poets, skilful musicians and reknowned physicians. Hārūn al-Rashīd's physician Bakhtīshū' ibn Jibrā'īl obtained annually, along with other perquisites, three robes of figured material from the Yemen.[85] On a more institutional level, not only was the decree appointing high officials of the state usually accompanied by a robe of honour, but these officials also received, at least once a year, a further robe of honour and, at the court of the Mamluk sultans, even twice a year, in winter and summer.[86] Further, the presentation of robes of honour was not made only to secular office holders: according to Ibn Jubayr, who writes in the early thirteenth century, the dress of the Imām in the principal mosque in Mecca – and most probably in other large mosques too – came from the caliph's own stores, so that it too was an official dress given by the ruler.

If these official Arabic-inscribed textiles meant something about the status

symbol of the person wearing them, the question remains of how these inscriptions were displayed. The most specific textual description,[87] and one that is supported fully in the contemporary pottery representations, is the use of *ṭirāz* bands as turban decoration.[88] But also widely documented, by both miniature painting and painting on ceramics,[89] is the use of calligraphic arm bands. The origin of the fashion of arm bands has been the subject of some discussion. Talbot Rice[90] pointed to the pre-Islamic Central Asian fashion of wearing arm bands and thus attributed its appearance in the Islamic world, especially in Seljuk fashion, to a continuity with Central Asian traditions. However, arm bands are not found on the figures represented in the paintings from Samarra, and some of the Pianjikent paintings portray what are not really arm bands but bracelets worn on the upper arm (a fashion which had existed, incidentally, in ancient Egypt). But if the suggestion that arm bands on clothing were a translation of an earlier practice is not wholly convincing, no more obvious explanation has yet been found.

## NOTES

1. These documents, dating from the tenth to the thirteenth century, were written mostly in Hebrew characters but in the Arabic language, and originally preserved in a synagogue in Cairo, and partly also in a cemetery in Fusṭāṭ. The material comprises a great variety of documents, such as official, business and private correspondence, detailed court records and other legal documents, contracts, accounts, writs of marriage, divorce, inventories, etc. These writings originated mostly in the middle and lower classes, and are therefore invaluable for the knowledge of social groups to which historians have had little or no access. The documents have been studied by Goitein 1967–88.

2. Ashtor, examining the trousseau inventories of the Geniza collections, commented that in the twelfth century *khil'as* (robes of honour), some with costly gold *ṭirāz* and some with silk, appeared in greater numbers in these lists than they had in the previous century: Ashtor 1969, p. 166.

3. According to al-Azraqī (seventh century), from the beginning of Muslim domination in Egypt a Coptic cloth was imported into the Ḥijāz, to cover the Ka'ba: al-Azraqī 1857–61, I, p. 176. Al-Azraqī also relates that the Ka'ba was covered by the Tubba' kings of the Yemen long before Islam with *waṣīla*, a cloth of striped stuff, while the

Prophet is said to have covered the Ka'ba with Yemeni cloth: al-Azraqī 1857–61, I, pp. 173–4 and 176.

4. As shown in miniatures: see, for example, the St Petersburg *Maqāmāt*, Oriental Institute, Academy of Sciences, Ms. S23, datable to around 1220, in the cushion and the textile which covers the bench on which an old man is seated: Ettinghausen 1962, pl. on p. 111.

5. According to the classical dictionaries, *ṭirāz* was originally a Persian word that become arabicized. According to Lane-Poole 1863–93 it was "said to be originally *ṭirz*, meaning in Persian 'even measurement'; and a garment, or piece of cloth, woven for the Sultan also arabicized from the Persian *ṭirāz*, meaning a royal robe or rich embroidered garment; and a place in which goodly garments or clothes are woven and this is also arabicized from the Persian *ṭirāz* which has the same meaning". Lane-Poole goes on giving examples of use of the word *ṭirāz* which are all associated with excellency, beauty, etc. Steingass 1930 under *ṭiraz* has: "A royal robe or rich dress ornamented with embroidery; also the place in Persia where they are generally made".

6. Combe 1947.

7. Goitein 1967–88, IV, p. 181–2.

8. Golombek and Gervers 1977, p. 90; see also the large collection of material in Cornu 1992.

9. See Serjeant 1972, p. 158, quoting al-Maqrīzī; Goitein 1967–88, IV, p. 168.

10. Gayraud 1986.

11. See Adams 1986; Crowfoot forthcoming; and for fourteenth-century material Crowfoot 1977.

12. It is relevant to note here that the V&A's acquisitions policy has always been to acquire them as examples of textile art illustrating the development of textile design and technology.

13. Serjeant 1972, chapter XVI.

14. Nāṣir-i Khusraw 1881, p. 173.

15. Wensinck "Miṣr".

16. Serjeant 1972, p. 140, quoting al-Ya'qūbī 1892, VII, p. 337.

17. Serjeant 1972, p. 147, quoting al-Maqrīzī 1900–20, p. 507.

18. Al-Muqaddasī 1994, p. 185.

19. Serjeant 1972, p. 141, quoting al-Iṣṭakhrī; p. 143 quoting al-Bakrī; p. 144 quoting Yāqūt.

20. Serjeant 1972, p. 136, whether or not relying on Yāqūt, also assumes that all these names relate to the same place. But he also includes a quotation (p. 138) from Abu'l-Qāsim which draws a surely crucial distinction between a garment of *dabīqī* material and another of *dabqawī* material. See also Wiet "Dabīq".

21. Wiet "Dabīq". One is a pre-Fatimid, Coptic textile which has within the border the inscription of *dabīq* in Coptic: Karabacek 1883, no. 427.

22. Goitein 1967–88, IV, pp. 165–6.

23. Serjeant 1972, p. 141.

24. See Serjeant 1972, pp. 140–1. *Dabīqī*, widely known in the Middle East in the Middle Ages, was used for clothing as extensively as for bedding. As the phrase "whiter than *dabīqī* garments" indicates, its natural colour was white, and, judging from the prices of pieces forming a dowry, it was also expensive: see Goitein 1967–88, IV, pp. 165–6.

25. Marzouk 1948–9, pp. 112–23.

26. Serjeant 1972, p. 147, quoting al-Qalqashandī 1913–19, VI, p. 7.

27. Goitein 1967–88, IV, p. 166.

28. The textile is in the Museum of Fine Arts in Boston, 33.371: see Granada and New York 1992, p. 104. Cases are known of Abbasid *ṭirāz* that mention Tinnīs, but they are very much in an Iraqi style, and one may wonder whether they were mislabelled to give the impression that they were from the famous Egyptian centre: Kühnel 1927, p. 13;

Serjeant 1972, pp. 88–104; Glidden and Thompson 1988, p. 122, note 11, nos 1 and 2.

29. Goitein 1967–88, I, pp. 209–28 and chapter IV; Frantz-Murphy 1981.

30. Al-Ya'qūbī 1892, VII, p. 337.

31. Kreutz 1976; Ashtor 1980, pp. 441–43; Hourani 1995.

32. For a general discussion of the economic situation under the Fatimids see Goitein 1967–88, I, pp. 30–4; Ashtor 1969, pp. 115–19.

33. For example Nāṣir-i Khusraw: Serjeant 1972, p. 142.

34. See Serjeant 1972, pp. 60–8; Grohmann "Ṭirāz" a and b; Kühnel and Bellinger 1952, pp. 1–3; Marzouk 1965; Golombek and Gervers 1977, pp. 82–3. But, according to André Grabar, the Byzantines' use of inscriptions on their clothes seems to have been introduced in the ninth century, inspired by the *ṭirāz* practices and inscriptions on architectures of the Muslim princes: Grabar 1966, p. 111.

35. Ibn Khaldūn 1862–8, I, p. 66. (Serjeant 1972, pp. 7–8).

36. Serjeant 1972, p. 9. See also al-Qalqashandī, writing in the fourteenth century: al-Qalqashandī 1913–19, IV, p. 7.

37. Grohmann "Ṭirāz" a and b. See note 21.

38. Grohmann "Ṭirāz" a; also Beg "Al-Khāṣṣa wa'l-'Āmma".

39. Ashtor 1976, p. 95; Frantz-Murphy 1981, pp. 292–5.

40. Grohmann "Ṭirāz" a.

41. Al-Imad 1990, pp. 85–91.

42. Members of the royal family and high court officials could have their own *dīwāns* too.

43. Lev 1991, p. 65.

44. Serjeant 1972, pp. 142–3.

45. Serjeant 1972, p. 144.

46. Serjeant 1972, p. 151.

47. Serjeant 1972, p. 151.

48. Serjeant 1972, p. 152, quoting Ibn Ṭuwayr.

49. Serjeant 1972, p. 142.

50. It has been suggested in relation to pre-Fatimid (embroidered) *ṭirāz* from Egypt that the factories of Alexandria, Tinnīs and Miṣr that produced embroidered *ṭirāz* on a large scale "had their identifying characteristics, which can be readily distinguished" (Golombek and Gervers, 1977, p. 84, note 30). These "identifying characteristics", however, relate to the embroidered or stamped factory marks often found in the corners of

the *ṭirāz*, rather than to intrinsic elements of weaving, decoration or style.

51. Kühnel and Bellinger 1952, p. 102; Golombek and Gervers 1977, p. 84.

52. Several authorities relate the expansion and prosperity of the textile industry in Egypt during the Fatimid period: Serjeant 1972, p. 141; Frantz-Murphy 1981, pp. 274–8.

53. See Goitein 1967–88, I; also Weibel 1952, pp. 4–5.

54. Goitein has noted twenty-six types in the Geniza: Goitein 1967–88, I, pp. 455–7 and IV, p. 166.

55. Cited in Goitein 1967–88, IV, p. 166, note 127.

56. The emphasis in the Geniza with regard to linen and silk applies in reverse to cotton. In actual life cotton was probably far more important than can be substantiated from the Geniza. Cotton is absent from the trousseau lists. It was the clothing of the poor, as explained in Goitein 1967–88, III, pp. 304–5. Also cotton is less durable than linen. In lists of belongings of deceased persons cotton cloth occurs rarely, and then is mostly from the Indian route, or the western Mediterranean, where cotton was produced. Among the hundreds of occupations of Jews in the Geniza one does not come across a *qaṭṭān*, a maker or trader in cotton. The only bearer of this name found was a Muslim. Importing large quantities of a cheap commodity of great volume had to be left to the rich Muslim shipowners, who would carry them whenever there was space available. See Goitein 1967–88, IV, p. 170; for the use of cotton see Pfister 1938 and 1939.

57. Noteworthy is "Tinnīsī Rūmī mantilla", which may have been a local imitation of a European piece of clothing.

58. Some pieces bearing this name have been preserved: Goitein 1967–88, IV, pp. 165–6 and note 122; for Tūna see Grohmann "Ṭirāz" a: two pieces of linen, dated 998/388 and 999/390 bear the name of this town. The inscriptions say that the materials were made for the Caliph al-Ḥākim, but in the *ṭirāz al-ʿāmma*. This, according to Goitein, explains why Jewish brides could have Tūnī linen.

59. Kendrick 1924, no. 947, pl. VI. See also Glidden and Thompson 1988, no. 10.

60. Goitein 1967–88, I, pp. 51, 86.

61. Goitein 1967–88, IV, note 166.

62. This was a plant stronger and more reliable than woad.

63. Goitein 1967–88, IV, p. 173.

64. Goitein 1967–88, IV, pp. 172–6.

65. Kühnel 1938; David-Weill 1970; Dimand 1931; Volbach and Kühnel 1926; Grube 1962; Thompson 1965; Thompson 1971; ʿAbbās 1995.

66. Whether "Sicilian silk" was produced in Sicily or not is a different matter: Monneret de Villard 1946.

67. See d'Agnel 1904; Marçais and Wiet 1934; Elsberg and Guest 1936; Hayward 1976, p. 76.

68. For an embroidered example belonging to the early Fatimid period see Contadini 1995.

69. For a stylistic analysis of these tapestry-woven decorations see Wiet 1935.

70. That weavers and embroiderers were separate seems to have been the case according to a document dating from the end of the Fatimid period, which describes the way in which orders were transmitted by the masters (ʿurafāʾ) of the embroiderers to the embroiderers (*raqqāmīn*) themselves: this important text is a small section of the *Minhāj fī ʿilm kharāj miṣr* of Abū al-Ḥasan ʿAlī al-Makhzūmī: Cahen 1964.

71. Ibn ʿAbdūn 1934, p. 237, ll. 14–15, as quoted by Monneret de Villard 1946.

72. This seems to be confirmed by a contemporary Abbasid source: Hilāl al-Ṣābiʾ (969–1056/359–448) describes the traditional vocations of the workmen serving the court at Baghdad, in which a distinction is made between various craftsmen, among them makers of *ṭirāz* (*muṭarriz*) and makers of the borders of robes (*mushahhir*): Serjeant 1972, p. 73.

73. The fuller's work was completed by using a teasel, referred to in Arabic as sizing, for roughening certain fabrics to give them a dense appearance.

74. It seems that the Geniza people had the pressing done by a professional, even by one who lived in another town or overseas. Goitein 1967–88, IV, p. 177–8.

75. Marzouk 1943.

76. Flury 1936; Marzouk 1955, p. 46.

77. Cairo, Museum of Islamic Art, acc. no. 13165. The textile in question, of embroidered cotton, was attributed by Lamm to Khurasan (Lamm 1937, pl. XVI-c), but it was later interpreted by Marzouk as the earliest dated Fatimid textile, and this view is currently accepted by scholars: Marzouk 1957.

78. See Bierman 1980, p. 64.

79. For example, Textile Museum no. 73.474: Kühnel and Bellinger 1952, pp. 71–2, pl. 32. See also Marzouk 1955.

80. See for example, Textile Museum no. 73.199: Kühnel and Bellinger 1952, pp. 81–2, pl. 38.

81. See also Glidden and Thompson 1988, p. 119 and no. 11; Goitein 1973, p. 16 and nos 10, 20, 28, and 60; Stillman 1972, pp. 46–54.

82. Ettinghausen 1974.

83. Goitein 1967–88, IV, pp. 165–6 and note 122.

84. Stillman "Khil'a".

85. *Al-washī al-yamanī*. See Mann 1920–2, II, pp. 262, 267.

86. Al-Qalqashandī, born late fourteenth century, died in 1418.

87. Al-Qalqashandī 1913–19, IV, pp. 52–60.

88. Al-Maqrīzī 1853, I, p. 440. For pottery examples see Britton 1938, figs 96–7; for an example on painting see Dioscorides manuscript dated 1229, *De Materia Medica*, Istanbul, Topkapi Sarayi Library, Ahmet III 2127: see Ettinghausen 1962, plate on p. 71.

89. See, for example, the rider on the Fatimid lustre painted bowl in the Freer Gallery, who wears a very elaborate garment with calligraphic *ṭirāz*; also the extraordinary drawing in black ink on paper datable to around the eleventh century, found at Fusṭāṭ and now preserved in the Museum of Islamic Art in Cairo, see fig. 10. It represents two warriors: the one with the horned helmet could be the sultan, wearing garments with calligraphic *ṭirāz*.

90. Talbot Rice 1969.

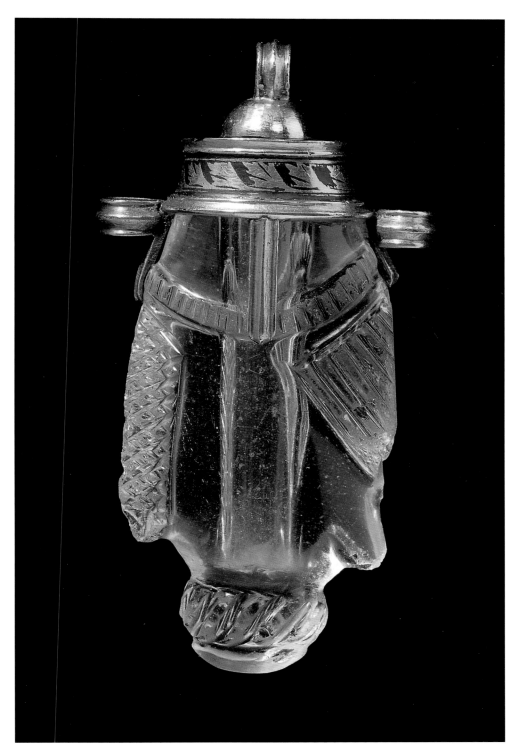

*Plate 1*

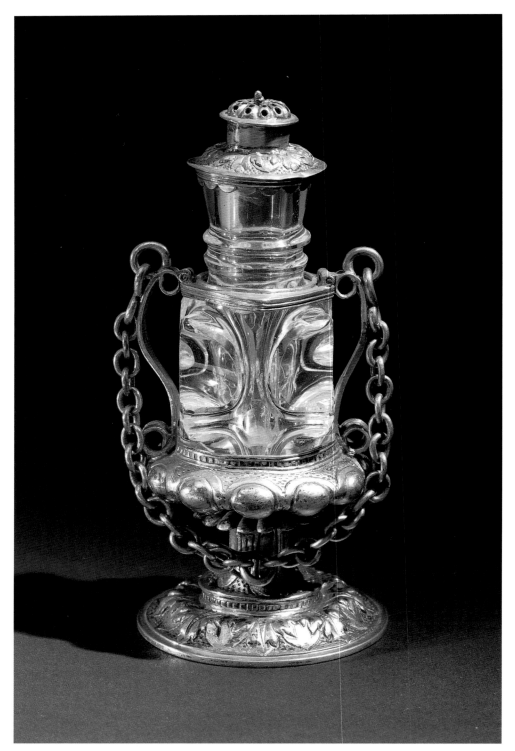

*Plate 2*

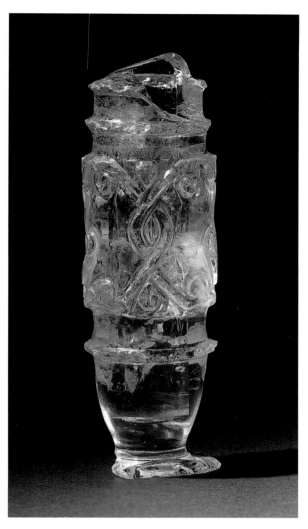

Plate 3

Plate 5

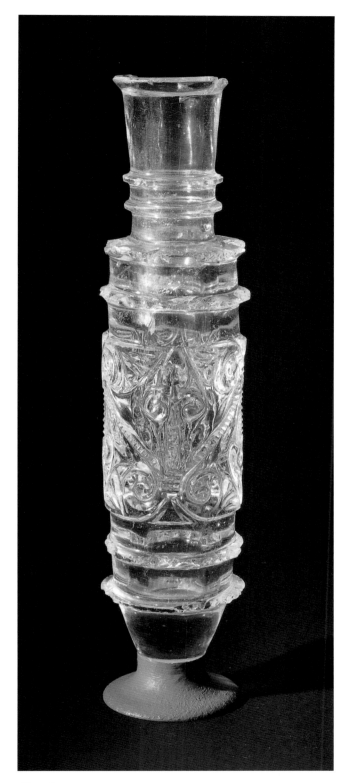

Plate 4

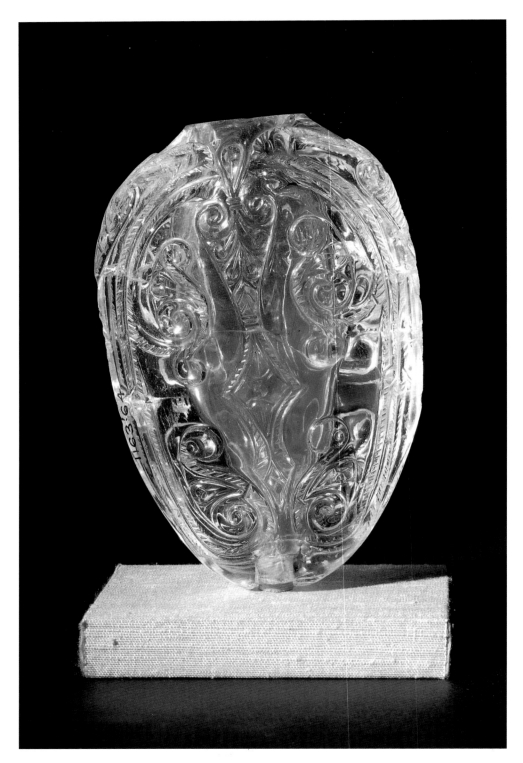

*Plate 6*

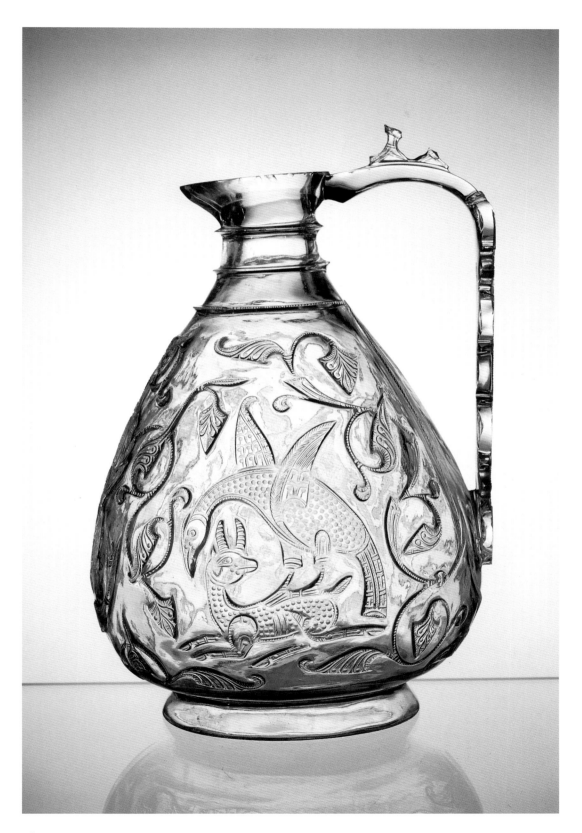

*Plate 7*

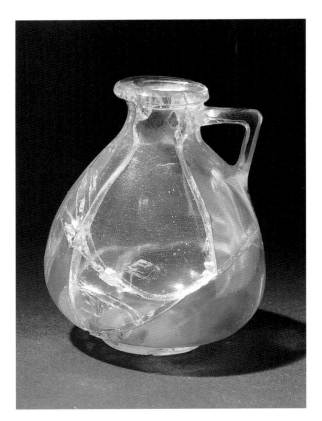

Plate 8

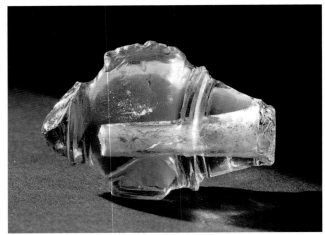

Plate 9

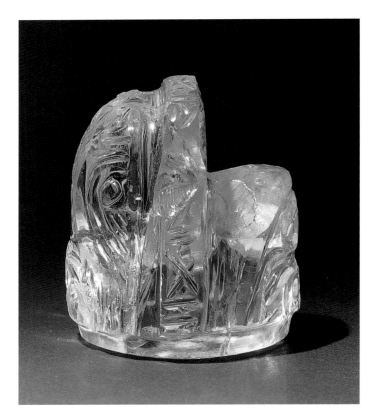

Plate 10

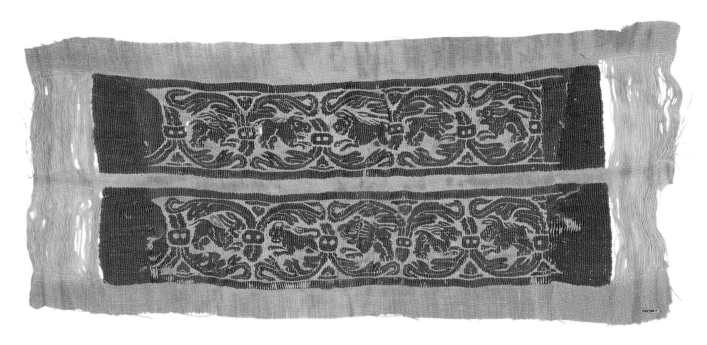

Plate 11

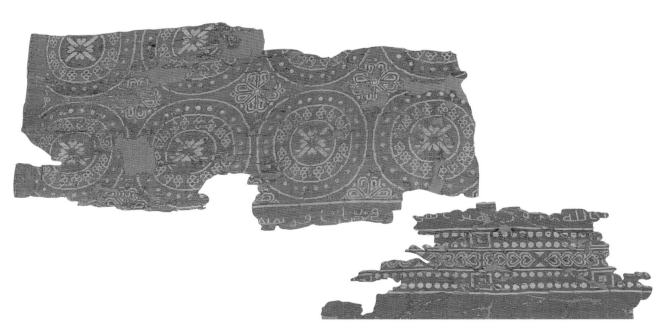

Plate 12

Plate 13

Plate 14

*Plate 15*

Plate 16

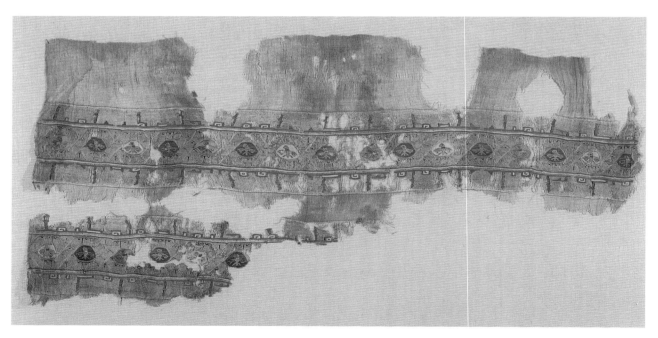

Plate 17

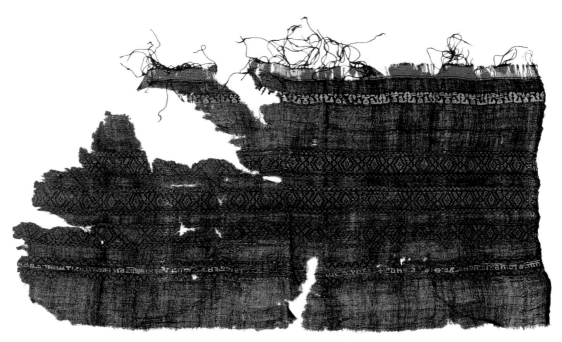

*Plate 18*

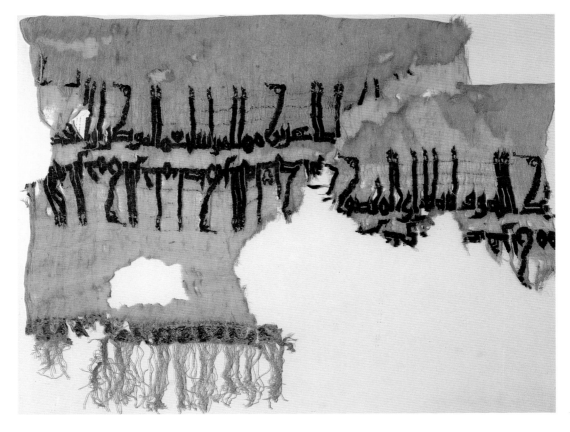

*Plate 19*

*Plate 20*

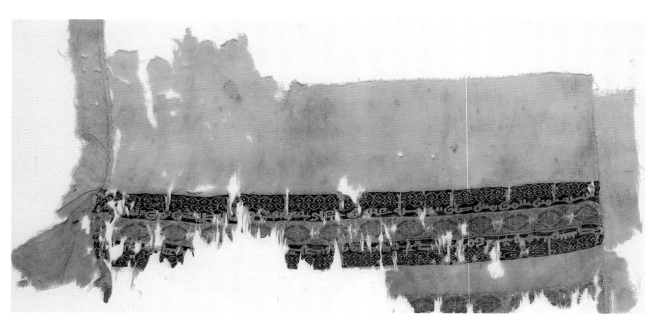

*Plate 21*

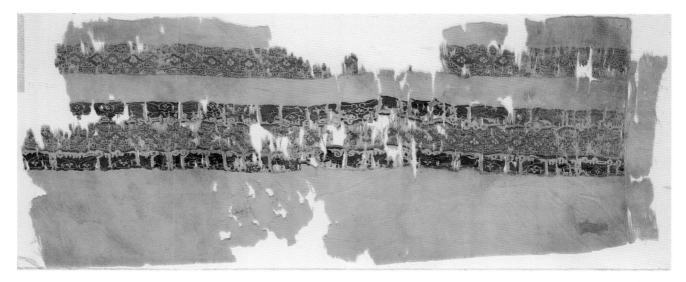

*Plate 22*

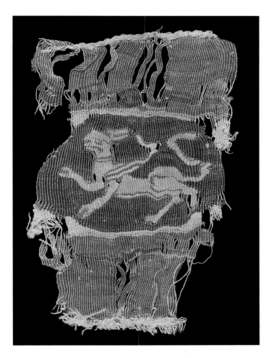

*Plate 23*

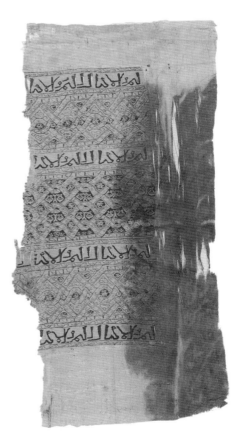

*Plate 24*

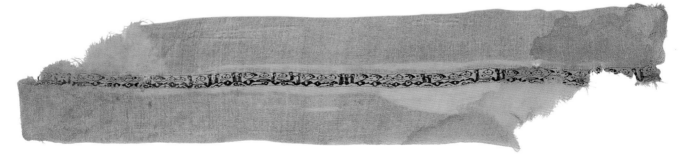

*Plate 25*

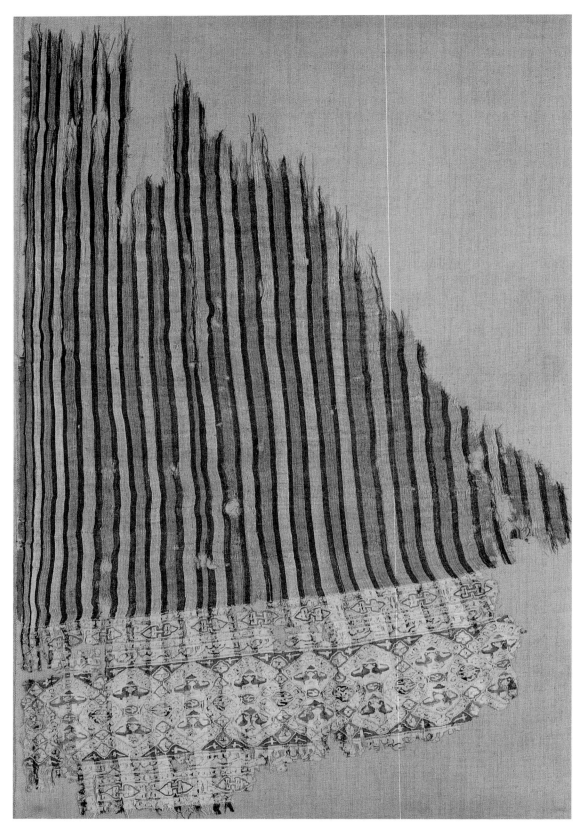

Plate 26

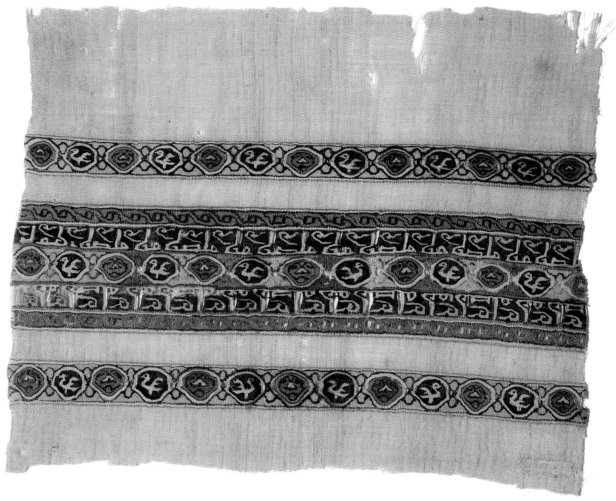

*Plate 27*

*Plate 28*

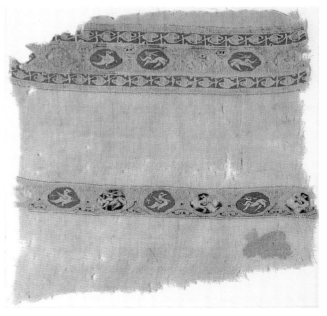

*Plate 29*

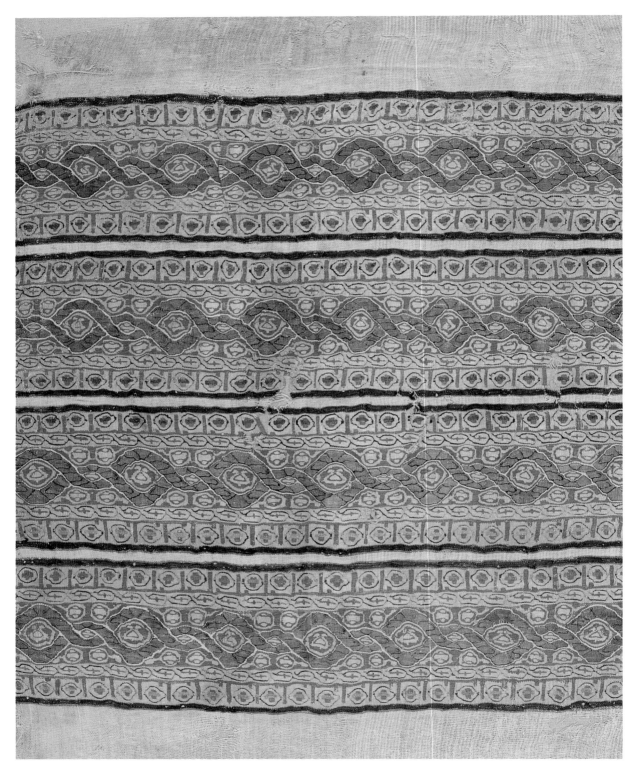

*Plate 30*

Plate 31a

Plate 31b

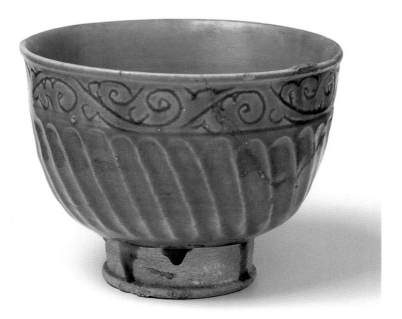

Plate 32

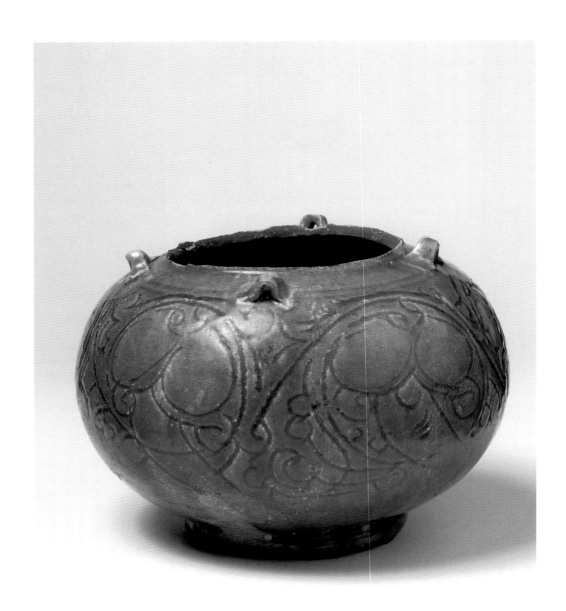

*Plate 33*

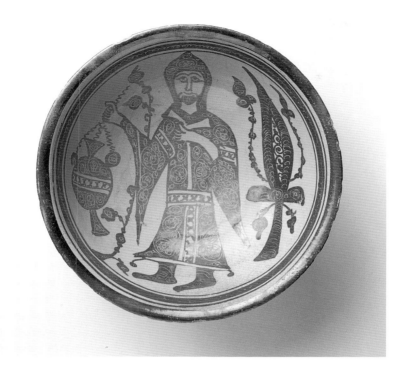

*Plate 34a*

*Plate 34b*

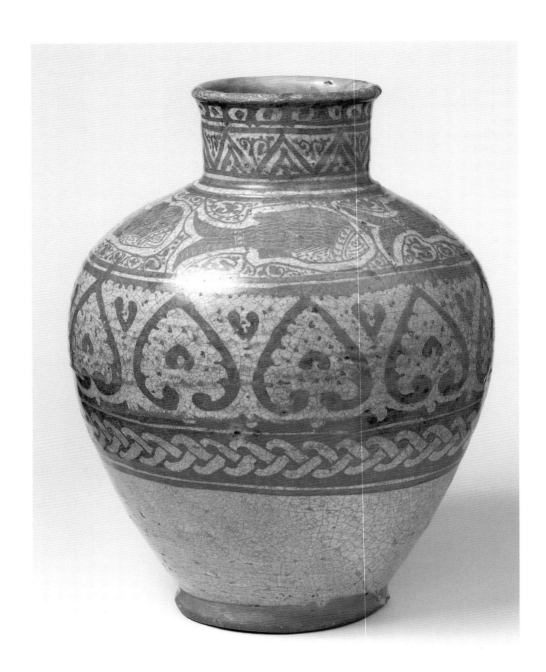

Plate 35

*Plate 36a-c*

Plate 37

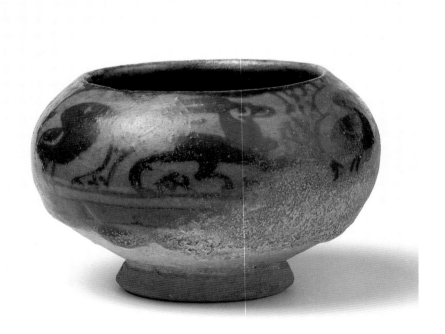

Plate 38

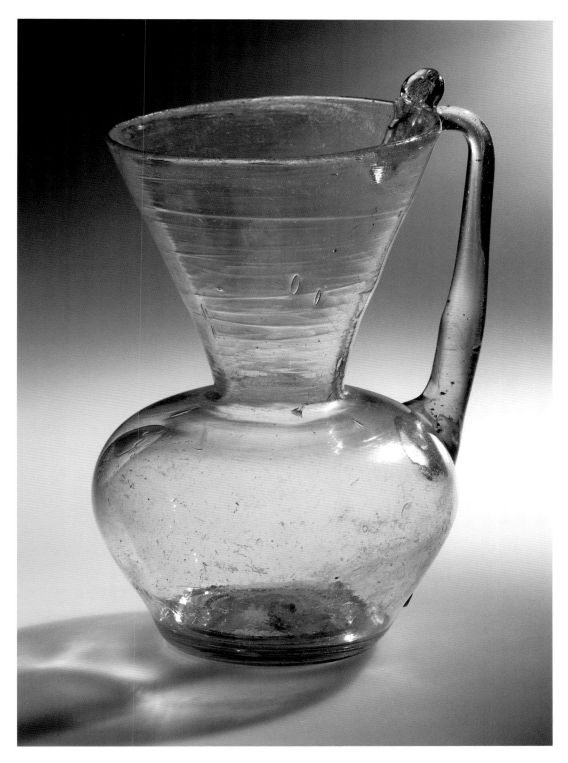

*Plate 39*

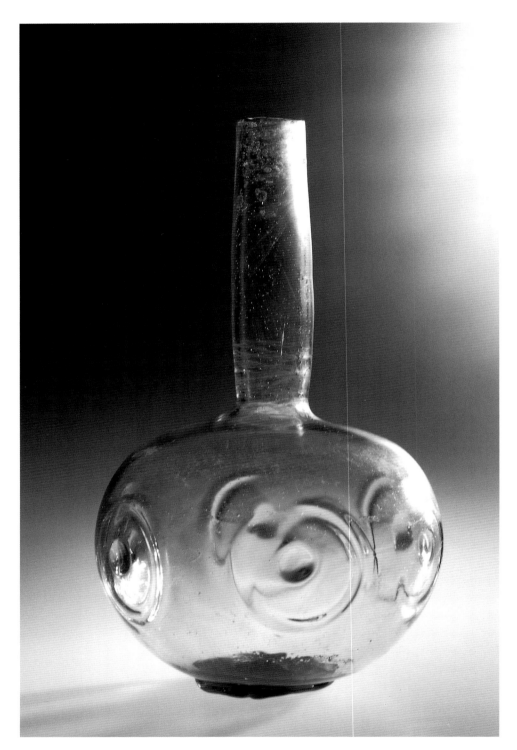

*Plate 40*

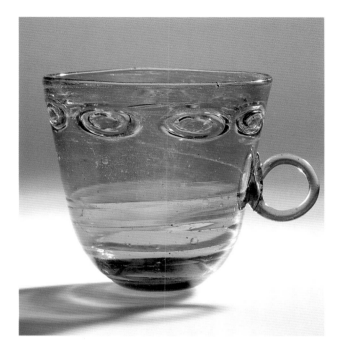

*Plate 41*

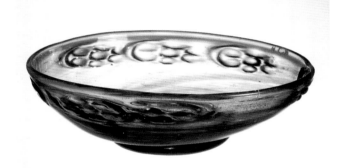

*Plate 42*

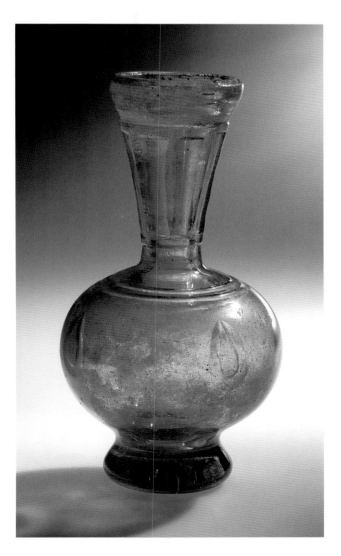

*Plate 43*

*Plate 44*

*Plate 45*

*Plate 46*

*Plate 47a and b*

*Plate 48a-f*

*Plate 49*

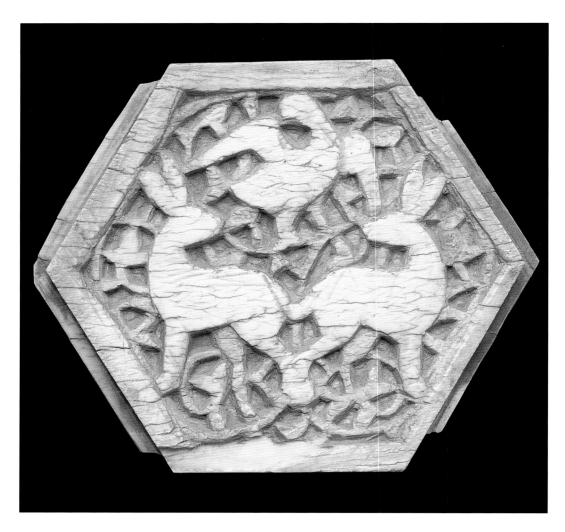

Plate 50

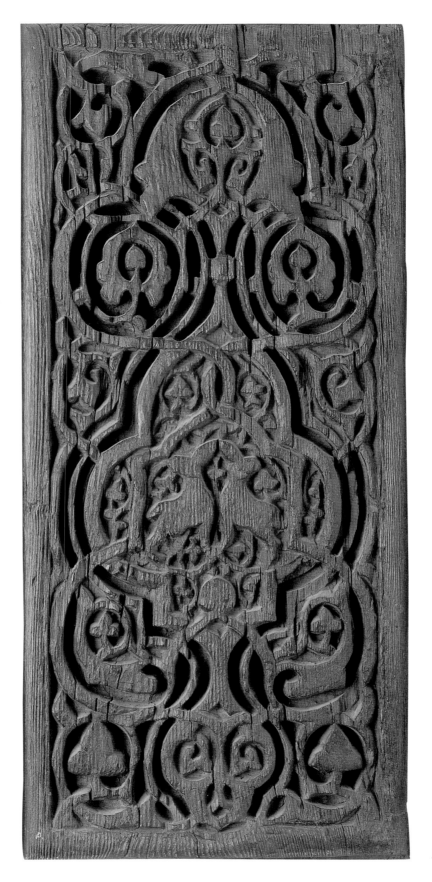

*Plate 51*

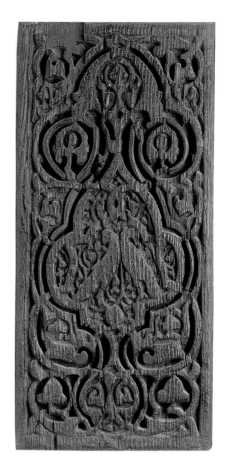
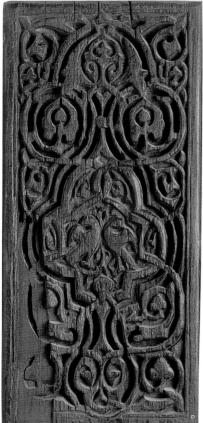
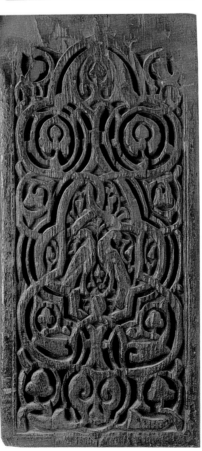

Plate 52a      Plate 52b      Plate 52c

Plate 52d      Plate 52e

Plate 53

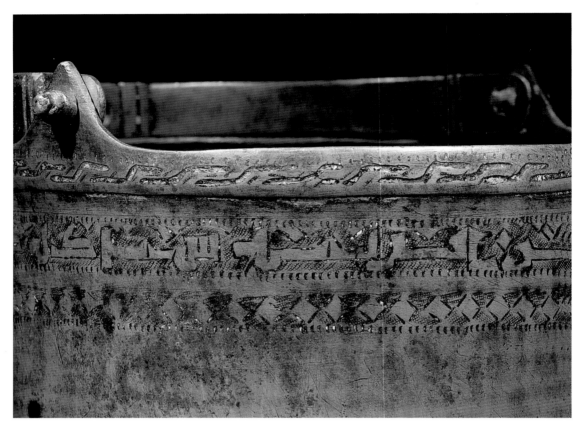

*Plate 54*

# TEXTILES IN THE V&A

<small>TECHNICAL ANALYSES BY LINDA WOOLLEY</small>

## PLATE 11

*Sleeve band from a tunic (?). Linen and wool. Egypt, eighth century (?). Allegedly from a burial site. 253-1887*

*H. (max.) 18 cm, W. (max.) 38 cm*

*Technical analysis:* Plain or tabby woven linen with two tapestry-woven bands, in wool and linen. Ground: warp in undyed linen, S-twist. Thread count approximately 24 per cm. Weft in undyed linen, S-twist. Thread count approximately 12 per cm. Bands: tapestry-woven bands, slit and dovetailed tapestry in wool on undyed linen warps in groups of two and three (not plied). Weft material undyed linen and wool in brown with a few details in red. Range of 22–8 ribs per cm. Additional details in undyed linen in brocading with flying shuttle. At each end of each tapestry band areas of bare warp threads have been left.

Tapestry-woven band, possibly a sleeve band from a tunic. It contains two bands of tapestry-woven brown wool with running animals including hares and lions in curvilinear compartments. See chapter for Coptic practices, materials and decorative motives into the early Islamic period.

---

## PLATE 12

*Ṭirāz. Silk. Marwān I or Marwān II, Umayyad North Africa, 684–750/64–132. From a cemetery at Akhmīm (Egypt). 1314-1888 and T.13-1960*

*Two pieces, L. 50.7 cm and 21.5 cm, W. 30.3 cm and 15.2 cm*

*Technical analysis:* Compound twill with main and binding warps in red silk and wefts of silk in three or four colours. Weft-faced 1:2 compound twill. Warp: red silk, Z-twist, one main to one binding or pattern warp. Weft: silk with no noticeable twist, three or four colours, red, green, yellow continuous; cream interrupted. One pick of each colour in turn. Three hundred main warp ends in a full unit of roundel pattern, or about 150 in half unit. Selvedge on left side: plain red stripe, W. 2 cm, and one cord consisting of about eight ends of Z-twist red silk not plied together.

Silk fabric, woven in colours on a red ground. The inscription is embroidered in yellow silk. This fabric bears a close resemblance in the scheme of colour and manner of weaving to several Byzantine silk fabrics in the V&A which are considered to date from the seventh to the ninth century (cf. nos 558-1893, 264-1900). See above for a discussion on pre-Fatimid ṭirāz.

*Inscription:*

الله مرون امير المو(منين) في طراز افريقية

*. . . Allāh Marwān amīr al-mu' [minīn] . . . fī ṭirāz ifrīqiya*

"[the Servant of] God, Marwān, Commander of the Faithful . . . in the *ṭirāz* of Ifrīqiya".

The writing of Marwān without a long *ā* after the *w* is a case of *scriptio defectiva*, in keeping with seventh- and eighth-century epigraphical practices. The "Allāh" before Marwān is probably part of ʿAbdullāh, used here not as a name but in its literal signification of Servant of God, a style adopted by the earlier caliphs. There are two Marwāns: Marwān ibn

al-Ḥakam (684–5/65–66) and Marwān ibn Muḥammad (744–50/127–133). The date of this textile must therefore be between 684/64 and 750/133. For the inscription see *Répertoire*, I, no. 36.

The bigger piece with the bit of inscription *fī ṭirāz Ifrīqiya* (T.13-1960) was, until 1960, in the Whitworth Art Gallery in Manchester. A third piece from the same fabric, also with part of the inscription, is in the Brooklyn Museum in New York (41.1265),[1] whereas another, uninscribed, fragment is in the Musées Royaux des Arts Décoratifs in Brussels.[2] The inscription of the three fragments together would read as follows: "[the servant of] God, Marwān, Commander of the Faithful, of what was ordered . . . *al-r* . . . [or *al-z* . . .] in the *ṭirāz* of Ifrīqiya".

BIBLIOGRAPHY: Guest 1906, p. 390, no. 1; von Falke 1913, I, pp. 68–77; Kendrick 1924, no. 945, p. 34, pl. III; Guest and Kendrick 1932, pp. 185–91; Day 1952; Hayward 1976, no. 1, p. 73; Baker 1995, p. 39.

---

PLATE 13

*Ṭirāz. Linen and silk. Al-Muʿtaḍid, Abbasid Egypt, 895/282. From a cemetery in Akhmīm. 257-1889*

*Greatest W. 10 cm, greatest L. 16.8 cm, H. (max.) of letters 1 cm*

*Technical analysis*: Embroidered *ṭirāz*. Ground: plain or tabby weave in undyed linen. Warp: slight S-twist, approx 18 per cm. Weft: slight S-twist, approx 14 per cm. Embroidered band: in red silk, slight Z-twist. Stem or running stitch with some of longer shafts couched down and some small horizontal stitches between upright straight stitches.

This is a piece of glazed linen with an inscription embroidered in crimson silk. See above for a discussion of pre-Fatimid *ṭirāz*.

*Inscription*:

الله ابا العباس المعتضد بالله امير المومنين انجزه الله ما امر بفصل سنة اثنين ثمانين مئتين

*. . . Allāh abā al-ʿAbbās al-Muʿtaḍid bi-llāh amīr al-muʾminīn anjazah Allāh mā amara bi-faṣl sanat ithnayn thamānīn miʾatayn*

". . . Allāh, Abū al-ʿAbbās al-Muʿtaḍid bi-llāh, Commander of the faithful. May God fulfil for him that which he commands. In the season of the year 282."

The chief interest of this inscription lies in its early date (inscriptions of that date being rather rare), on account of which the absence of the usual *wa* ("and") between the numbers and the spelling *miʾatayn* deserves attention. One might also note that the year mentioned is that of the reconciliation of Khumarawayh, prince of Egypt, with his suzerain al-Muʿtaḍid, after the house of Ṭūlūn, to which the former belonged, had withheld allegiance from the Abbasids for some twenty-five years. Abū al-ʿAbbās Aḥmad al-Muʿtaḍid billāh ibn al-Muwaffaq was the sixteenth Abbasid caliph and reigned at Baghdad from 892/279 until his death in 902/289. During his reign Egypt was still in the hands of the Tulunid dynasty, the first ruler of which, the celebrated Aḥmad ibn Ṭūlūn, had a few years previously thrown off almost entirely his allegiance to the Abbasids, at most recognising in them a vague nominal supremacy. In 895/282 al-Muʿtaḍid married the daughter of Khumarawayh, the son of Aḥmad

ibn Ṭūlūn, who had succeeded his father as ruler of Egypt. By this means a reconciliation was effected between suzerain and vassal whose houses had formerly been estranged. Khumarawayh's daughter Qaṭr al-Nadā (Dewdrop) went in great state to Baghdad and was there married to al-Muʿtaḍid in June 895/Rabiʿ II 282. The wedding is famous in Islamic history for the vast sums spent on her dowry and on entertainment (in Egypt) by her father. The date 895/282 is therefore a significant one when coupled with the name of al-Muʿtaḍid and on material coming from Egypt.

BIBLIOGRAPHY: Guest 1906, p. 391, no. 2; Kendrick 1924, no. 946, p. 35, pl. III.

---

## PLATE 14
*Ṭirāz. Linen and silk. Al-Muṭīʿ, Egypt (?), 967/357. T.24-1942*

H. (max.) 64 cm, W. 71.2 cm; inscription, H. (max.) of one letter 14 cm

*Technical analysis:* Woven *ṭirāz* in plain and tapestry weave linen and silk. Warp: linen, S-twist, 32–3 per cm. Weft: linen, S-twist, 19–20 per cm. Slit tapestry over paired linen warps. Weft: no noticeable twist, about 60 ribs per cm with oval or round shaped areas in white undyed linen (?) thread.

The textile is a plain piece of undyed, glazed linen with a large red inscription woven across. See chapter for a discussion of pre-Fatimid *ṭirāz*. Comparative Material: a textile (ex Elsberg collection), the inscription of which specifies the name al-Muṭīʿ and *bi-ṭirāz al-ʿāmma bi-Dumyāṭ.*[3]

*Inscription:*

(بسـ)م الله الرحمن الرحيم المط(يع) ... بر

... سنـة سبع وخمسين وثلثمئة

[bis]mi-llāh al-raḥmān al-raḥīm al-muṭ[īʿ] ... br(?) sanat sabʿ wa khamsīn wa thālathi-miʾa

"In the name of God the Merciful the Compassionate. Al-Muṭ[īʿ] ... br(?) ... in the year 357" (967).

---

## PLATE 15
*Ṭirāz. Cotton ikat with inscription in gold. Fatimid Yemen, tenth century. 108-1887*

Larger fragment: H. (max.) 30 cm, W. (max.) 24.7 cm; smaller fragment: H. (max.) 14.4 cm, W. (max.) 10.7 cm; fringe: H. (max.) 9.5 cm; lettering: H. (max.) 4 cm

*Technical analysis:* Yemeni *ṭirāz*. Ground or main part of material: plain or tabby weave. Warp: cotton, Z-twist, some ikat-dyed in two different shades of blue. Thread count about 22 per cm. Weft: cotton, Z-twist. Thread count about 13 per cm. Fringe: formed from groups of warp ends Z-twisted together. Inscription: with letters painted in gold which is outlined in dark blue/black. Some of the gold has rubbed off and can be seen lower down on this fragment of textile.

*Inscription:* بسم الله صـ(لوة)

bismi-llāh ṣ ...

"in the name of God, [prayer?] ..."

This is a very good example of a cotton ikat with an inscription painted in gold and outlined in blue-black ink, which most probably originated in Yemen,[4] rather than being an Egyptian imitation,

as usually ikat from the Yemen are cotton, whereas known Egyptian imitations are linen, as a number in the V&A demonstrate (1661-1888; 327-1889; 296-1891; 297-1891; 791-1898; T.109-1963).[5] The textile is datable to the tenth century, as the type of inscription is similar to tenth-century carved inscriptions on unglazed jars from north-east Persia, or inscriptions on slip-painted ceramics, as in the tenth century plate from north-east Persia,[6] in the Freer Gallery of Art in Washington.[7] The marginal decorative motif also recalls tenth- or eleventh-century Qur'ānic illumination as in the Ibn al-Bawwāb Qur'ān in the Chester Beatty Library.[8]

---

## PLATE 16

*Ṭirāz. Silk. Naṣr al-Dawlah Abū Naṣr Aḥmād, Marwanid of Diyarbakr (south-eastern Anatolia, r.1010–61/401–53), ca. 1025. 8560-1863*

*W. (max.) 19 cm, L. (max.) 18.3 cm; two bands of inscription together, H. 2 cm*

*Technical analysis:* "Incised" silk compound twill with Kufic inscription in mirror image. 1:2 weft-faced compound twill; one main to one pair of binding or pattern warps. Warp: silk, Z-twist, seventeen pairs pattern warps per cm and seventeen main warps. Weft: silk, Z-twist, 30 per cm. The blue weft threads are indigo-dyed.

The textile has a decoration consisting of a small lozenge-diaper pattern in indigo blue and a Kufic inscription in a double horizontal band, the lower repeating the upper, but inverted, in yellow silk. See above for contrast in contemporary Fatimid material.

*Inscription:*

... السيد الامير نصر الدولة ابي نصر

اطال الله بقاه

*. . . al-sayyid al-amīr naṣr al-dawla abī naṣr aṭāl allāh baqā'ah*

". . . the Lord Prince Naṣr al-Dawla Abū Naṣr may God give him long life."

Guest and Kendrick misread the inscription. Van Berchem corrected the mistake, but we have to wait for Monneret de Villard for a full careful translation and discussion. The inscription reveals the Mesopotamian origin and the approximate date. (It wishes long life to the Emir Naṣr al-Dawlah Abū Naṣr, according to the style used prior to the capture of Diyarbakr in 1024–5/415.) The fragment comes, via the collection of Franz Bock, from the tomb of S. Ambrogio (d. 397). It is part of a tunic probably placed there by Aribert, Archbishop of Milan from 1018 to 1045, and probably woven in Baghdad.

Although the inscription in the V&A fragment contains the important section with the name, it is incomplete, as the first four words are missing. The whole inscription reads: *'izz wa baqā' lil-amir al-sayyid al-ajall naṣr al-dawlah abī naṣr aṭāl allāh baqā'ah* (Might and long life to the noble prince Naṣr al-Dawlah Abū Naṣr, may God give him long life).

BIBLIOGRAPHY: Guest 1906, p. 394, no. 7; van Berchem 1910, p. 2, n. 1; Wiet 1900–30: 1921, I, p. 344; Kendrick 1924, pp. 43–4, no. 965, pl. XIII; Grohmann "Ṭirāz"a; *Répertoire*, VII, no. 2640; Monneret de Villard 1940; Capitani D'Arzago 1941, pp. 24–8; Rogers 1983, fig. 20, p. 31.

## PLATE 17

*Ṭirāz. Linen and silk. Fatimid Egypt, tenth century (?). From a tomb at al-A'ẓam, near Aswān, Upper Egypt. 1124-1900*

*W. (max.) 47.5 cm, H. 21.7 cm; bands: W. 6.6 cm*

*Technical analysis:* Woven *ṭirāz* in linen and silk. Very fragmentary, weave of particularly fine quality. Remains of two tapestry-woven bands. Central area of oval compartment with birds and addorsed inscriptions. Ground: plain or tabby weave. Warp: linen, S-twist, 25 per cm. Weft: linen, S-twist, 21–2 per cm. Bands of decorations outlined with borders in dark and light pink silk. They have areas of plain weave with warp of undyed linen and weft in beige silk with no noticeable twist. Plain or tabby weave. Warp: linen, S-twist, 24 per cm. Weft: silk, no noticeable twist, about 32 per cm. Inscription and other decorative devices in tapestry. Tapestry areas slit and dovetailed. Silk weft no noticeable spin in two shades of pink, greenish blue, black faded and beige. About 50 ribs per cm.

This fragment of a garment has two parallel tapestry-woven bands in coloured silks. The two bands are alike. In the middle are interlacings enclosing birds with outspread wings on grounds of different colours. Above and below is a border of repeated inscriptions in Kufic characters in red and white, repeated in mirror image. The inscription is in square characters on a ground unrelieved by ornament. The type of decoration recalls Spanish textiles of the caliphal period, tenth to early eleventh century, as seen, for example, in the so-called "Veil of Hishām II".[9]

*Inscription:* pseudo-inscription.

BIBLIOGRAPHY: Kendrick 1924, no. 873, p. 14, pl. II.

**PLATE 18**
*Fragment of shawl (?). Black wool and silk. Egypt, tenth century (?). T.12-1947*

*Greatest W. 64.5 cm, greatest H. (excluding fringe) 33 cm; fringe: greatest H. 5.5 cm; bands (from near bottom edge up) W. 1.3 cm, W. about 1.7 cm, W. 2.5 cms, three bands W. about 3.5 cm*

*Technical analysis:* Ground: loosely woven plain or tabby wool with a selvedge at left formed from paired warps. Warp: wool, S-twist, about 15 per cm. Weft: wool, slight S-twist, about 14 per cm. Warp fringe, groups of warps S-twisted together. Bands: tapestry-woven band near bottom edge with warp of wool and wefts in silks, no appreciable twist, of black, red and yellow. Plain woven red silk band at border above fringe. At the top, band with embroidery in yellow and red silk in satin and darning stitches. Three bands with additional "brocading" weft forming a pattern of diamond shapes.

This seems to be a portion of shawl of black woollen material loosely woven and with three bands of diamond-shaped design embroidered in red silk. At the top and bottom there is a line of inscription embroidered in yellow and red silk. A plain red band and black fringe are at the bottom. In the Fayyūmi group Coptic inscriptions occasionally appear alongside Kufic/kufesque ones. While the Arabic script is generally executed in tapestry weave, the Coptic texts are usually embroidered.[10] For the relationship of the Fayyūmi group with Fatimid *ṭirāz* see Thompson.[11]

*Inscription:* لا اله الا الله

The Arabic inscription is derived from *lā ilāh illā Allāh*, "There is no God but God",

repeated. The other is in Coptic letters but seems to be a pseudo-inscription.

ᔑᘉᘓ ᔑᔑᘓᔑᘉᘓ

ᘉᘓᘈᘈᘉ·ᔑᘉᘓᘈᘈᘈᔑᘉᘉᘓ ᘉᘉᔑᔑᘈᘈ· ᘈᘓᘈ ᘉᘉᘈᘓᘈᘈᘈᘈᘉ ᔑᔑ

---

PLATE 19

*Ṭirāz. Linen and silk. Al-Ḥakim al-Manṣūr, Fatimid Egypt, 996–1021/386–411. 176-1931*

L. (max.) (excluding fringe) 63 cm, fringe H. 9.0 cm, W. (max.) 39.6 cm; inscription: H. of two rows together, 18 cm, H. (max.) of one letter 8.5 cm; band of decoration: H. 2.8 cm

*Technical analysis:* Ground: plain or tabby weave linen ground. Warp: undyed linen, S-twist, 26–9 per cm. Weft: undyed linen, S-twist, 12–14 per cm. Inscription: slit and dovetail tapestry weave inscription (two rows of letters addorsed), dark blue silk, no appreciable twist, 45 per cm. Band of decoration at bottom above fringe: tapestry weave silk with wefts of yellow, green, blue, black, cream. Fringe: linen, groups of four warp ends S-twisted together (pairs of two Z-twisted then each two pairs S-twisted).

The narrow decorative band of silk is woven with a pattern of two conventionalized birds seated facing one another, with a small tree between, and another tree between each pair. The pairs are alternately green and blue, the background is in two tones of yellow.

*Inscription:*

(بسم) الله الرحمن الرحيم نصر من الله لعبد ...

(عب)د الله ووليه لـ ؟؟ ى ... المنصور

... الطاهرين مما امر باستعماله في طراز الع(امة؟)

[bism] Allāh al-raḥmān al-raḥīm naṣr min Allāh li-ʿabd [al] ... / [ʿab]d Allāh wa walih ... al-Manṣūr / al-ṭāhirīn mimmā umira bi-stiʿmālih fī ṭirāz al-ʿā[mma?] ...

"[In the name of] God the Merciful the Compassionate, victory is from God to the servant ... and agent of God ... al-Manṣūr / the pure ones. This is what has been ordered to be made in the *ṭirāz al-ʿā[mma?]* ..."

The reading *umira bi-stiʿmālih* is in keeping with the phraseology used by Ibn al-Ṭuwayr in his account of the presentation of royal apparel by the *ṣāḥib al-ṭirāz* to the Caliph, where he calls the royal requisitions *al-istiʿmālāt al-khāṣṣa*. See p. 47.

---

PLATE 20

*Ṭirāz. Linen and silk. Al-Ḥakim al-Manṣūr, Fatimid Egypt, 996–1021/386–411. Allegedly from a burial site in Egypt. 133 to 133c-1896*

L. (max.) 51 cm, W. 45 cm (taking all the pieces together); bands with inscription: H. (max.) of letters 6 cm; decorative bands: W. 4.5 cm and 3 cm

*Technical analysis:* Ground: tabby or plain weave warp linen, blue now faded, S-twist, 23 per cm. Weft: undyed linen, blue now faded, S-twist, 9–10 per cm. Bands of inscription: these are in slit tapestry, beige silk wefts, no noticeable twist, 22 per cm.

This is a very fragmentary linen and silk *ṭirāz* consisting of three basic areas of material which have been placed together approximately as they would have been originally. There are remains of seven tapestry-woven bands, four with inscriptions and three with decoration. The decorative tapestry-woven bands are between addorsed rows of inscriptions. They are decorated with animals in oval compartments with silk wefts, no noticeable twist, in black, yellow, beige and light blue. For a contemporary *ṭirāz* from Spain, comparable in style of decoration, see the "Veil of Hishām II".[12]

*Inscription:*

... امير المومنين (ا)بن العز(يز) بالله صل(وة)

(ا)لمنصو(ر)

نصر من الله لعبد(ه)

*Amīr al-mu'minīn [i]bn al-'az[īz] bi-llāh ṣal[wāt] . . . al-manṣū[r] naṣr min Allāh bi-'abd[ih]*

"Commander of the faithful, son of al-'Az[īz] billāh, prayer . . . al-Manṣū[r] victory is from God on [his] servant" . . .

The position of the word *Amīr al-mu'minīn* before *al-'azīz* seems to be sufficient to show that the inscription refers to al-Ḥākim, father of al-'Azīz. This is supported by some other fragments belonging to the same piece of stuff, where part of the names al-Ḥākim and Manṣūr appear to be discernible (see Kendrick in bibliography below). Manṣūr was al-Ḥākim's name – the latter appellation, by which he is better known, being actually a title. Al-'Azīz

was al-Ḥākim's father and immediate predecessor.

Comparative material: a textile (ex Elsberg collection), very similar to this textile, and also attributed to al-Ḥākim, although only the name *al-'Azīz bi-llāh* is clear;[13] and a textile in the Hermitage with an inscription of the Caliph Al-'Azīz billāh.[14]

BIBLIOGRAPHY: Guest 1906, p. 391, no. 3; Kendrick 1924, nos 857, 858, 859, pp. 8–9, pl. I.

---

## PLATE 21

*Ṭirāz. Linen and silk. Al-Mustanṣir, Fatimid Egypt, 1036–94/427–87. From a cemetery at Erment (Upper Egypt). Cf. plate 22. 134-1896*

*H. (max.) 9.3 cm, W. 4 cm*

*Technical analysis:* Tapestry-woven linen and silk fragment. Warp: undyed linen, S-twist. Weft: silk with no noticeable twist, 23 ribs per cm in yellow, red and black.

The fragment has a band woven in coloured silks in three stripes; the two outer ones contain the inscription and small diaper designs, and the inner one has a row of pointed compartments containing ornamental crosses. A fragment of a stripe similar to the last runs along one side.

*Inscription:*

عبد الله ووليه معد (ا)بو تمي(م) الامام المستنصر / بالله

امير المومنين صلوات الله عليه وعلى

(ابائه الطاهرين وابنائه)

*'abd Allāh wa walīh Ma'add [A]bū Tamī[m] al-imām al-Mustanṣir bi-llāh amīr al-mu'minīn ṣalawāt Allāh 'alayh wa 'alā -[ābā'ih al-ṭāhirīn wa abnā'ih]*

"The servant of God and his vicar [A]bū Tamī[m] . . . al-Imām al-Mustanṣir billāh, Commander of the Faithful, blessing of God be on his pure ancestors and his descendants"

عو ۲ مم ۽ ۾ او ۾

This is a Shī'ā formula; see p.10. The inscription affords a remarkable instance of the curtailment of the letters *l* and *ā*. This is the epigraphic characteristic that Flury and Marzouk considered as a Fatimid innovation (see chapter).

Comparative material: 2171-1900: this fragment in the V&A also bears the names Ma'add, Abū Tamīm, al-Mustanṣir bi-llāh.[15]

BIBLIOGRAPHY: Guest 1906, p. 393, no. 6; Kendrick 1924, no. 863, p. 11, pl. II.

---

**PLATE 22**
*Ṭirāz. Linen and silk. Al-Mustanṣir, Fatimid Egypt, 1035–94/427-487. From a cemetery at Erment (Upper Egypt). Cf. fragments in plate 20. 1381-1888*

*W. (max.) 20 cm, L. (max.) 48 cm; bands H. 5.5 cm, band with decoration: H. 2.5 cm*

*Technical analysis:* Linen and silk woven tiraz. Ground: plain or tabby weave ground in undyed linen. Warp: S-twist, 30–1 per cm. Weft: S-twist, 30–1 per cm. Bands: two tapestry-woven bands, one with inscriptions, one in mirror image of the other and decorative area in between. Slit and dovetailed tapestry over single and paired warps. Weft of undyed linen for the letters and other details and of silk with no noticeable twist in dark and light blue, red faded, yel-

low faded and black faded. Twenty-one weft shoots per cm; 60 ribs per cm.

This is a fragment of a garment of fine linen, with bands of tapestry, woven in coloured silks and linen thread on the warp threads of the linen.

*Inscription:*

بسم الله الرحمن الرحيم لا اله الا الله

محمد رسول الله علي ولي الله صلى (الله)

ع(ليه)م(ا) / ... المستنصر بالله

امير المومنين صلوات الله عليه وعلى ابائه

(الاكار)م الطاهرين وابنائه المنتصرين

*Bismillāh al-raḥmān al-raḥīm lā ilāha illā Allāh Muḥammad rasūl Allāh 'Alī walī Allāh ṣallā [Allāh] 'a[layhima] / . . . al-Mustanṣir bi-llāh amīr al-mu'minīn ṣalawāt Allāh 'alayh wa 'alā ābā'ih [al-akāri]m al-ṭāhirīn wa abnā'ih al-muntaṣirīn*

"In the name of God the Compassionate the Merciful. There is no God but God, Muḥammad is the Prophet of God, 'Alī is the vicar of God, prayer . . . / al-Mustanṣir billāh, Commander of the Faithful, blessing of God be on him and on his [noble] and pure ancestors and his victorious descendants."

What follows al-Mustanṣir's name is a well-known Fatimid formula, which is found on several existing monuments (see p.10).

BIBLIOGRAPHY: Guest 1906, p. 392, no. 5; Kendrick 1924, no. 862, p. 10, pl. II.

**PLATE 23**
*Ṭirāz. Linen and silk. Al-Mustanṣir, Fatimid Egypt, 1057/448. From al-Kharjah (Egypt). 2117-1900*

*L. 4.0 cm, W. 6.2 cm; inscription: H. (max.) of letters: 1.6 cm*

*Technical analysis:* Woven *ṭirāz* in slit and dovetailed tapestry; silk and linen. Warp: undyed linen, S-twist, 23–4 per cm. Weft: undyed linen and silk, no noticeable spin, 46 ribs per cm. Wefts in undyed linen and silks in red, yellow and blue and inscription in green.

This fragment consists of a band tapestry-woven in coloured silks of fine linen warps. In the middle is a winged animal in yellow, red and white on a blue oval medallion; above and below are fragments of an Arabic inscription in green on a red ground.

*Inscription:*

المو(منين) ؟ ...

صل ؟ ...

*al-mu'(minīn)* (?); *ṣl . . .* (?).

A larger piece (H. 5.4 cm, L. 8.3 cm) belonging to the same textile is in the Musée du Cluny in Paris (cl. 21.871). It shows the winged animal three times, between two lines of inscriptions. The inscriptions have been read as: (top) *bismillāh al-raḥmān* "in the name of God the Merciful"; (bottom) *thamān wa arba'īn wa arba'mi'a* "four hundred and forty-eight" (al-Mustanṣir, 1056/448).

For this piece in the Musée du Cluny see Paris, Musée des Gobelins 1934, no. 308; Paris, Grand Palais 1977, no. 280c.

BIBLIOGRAPHY: Guest 1923, pp. 407–8, pl. VI b; Kendrick 1924, no. 861, p. 10, pl. VI.

---

**PLATE 24**
*Ṭirāz. Linen and silk. Fatimid Egypt, twelfth century. From a tomb at al-'Aẓam near Asyūṭ (Upper Egypt). 755-1898*

*L. (max.) 29.8 cm, W. (max.) 58 cm; bands: W. 15.5 cm with 0.3 cm between each one*

*Technical analysis:* Woven linen and silk *ṭirāz.* Ground: plain or tabby weave undyed linen. Warp: S-twist, 12 per cm. Weft: S-twist, 12 per cm. Bands: three tapestry-woven bands. Tapestry slit and dovetailed, wefts in silk with no appreciable twist in yellow and red. About 24 ribs per cm.

This is a portion of a linen garment, with a broad band tapestry-woven in yellow and red silk. The band is in three parts, each filled with interlaced stems enclosing birds, animals and scroll devices, and bordered by inscriptions.

*Inscription:* اليمن والاقبال

*al-yumn wa al-iqbāl*
"success and prosperity"

A different fragment from the same piece is published in Guest 1906, p. 399, no. 16, with a creative reading of the inscription derived from the fact that the piece had been mounted and photographed back to front; a different fragment in the V&A (613-1892) from

the same piece is published in Kendrick 1924, no. 887, p. 18, pl. IV (also back to front).

BIBLIOGRAPHY: unpublished.

---

### PLATE 25

*Ṭirāz. Linen and silk. Al-Fā'iz, Fatimid Egypt, 1154–60/549–55. Allegedly from a burial site in Egypt. 2101-1900*

W. (max.) 36.5 cm, H. (max.) 14 cm, band H. 7 cm

*Technical analysis:* Woven ṭirāz in linen and silk. Ground: plain or tabby weave. Warp: linen, S-twist, 21 per cm. Weft: linen, S-twist, 19 per cm. Band: slit tapestry in undyed linen and paired weft shoots in dark blue silk with no noticeable spin. About 35 ribs per cm.

Fragment of a linen garment, with a narrow tapestry-woven band in dark blue silk and undyed linen thread. The band has an Arabic inscription in Kufic characters on a ground relieved with delicate floral stems.

*Inscription:*

(بـ)نصر الله امير المومنين بن الامير (؟) الظافر

الظافر بامر الله امير (الـ)مومنين صلو(ة) ...

*[bi]Naṣr Allāh amīr al-mu'minīn [ib]n al-amīr [?] al-Ẓāfir bi-Amr Allāh amīr [al-] mu'minīn ṣalw[at]*
"[Al-Fā'iz] bi-Naṣr Allāh, Commander of the Faithful, son of the victorious commander al-Ẓāfir bi-Amr Allāh, Commander of the Faithful. Prayer . . ."

The inscription records the titles of al-Fā'iz bi-Naṣr Allāh, and his father al-Ẓāfir bi-Amr Allāh. Al-Fā'iz reigned 1149–54/544–9.

BIBLIOGRAPHY: Guest 1906, p. 394, no. 8; Kendrick 1924, no. 865, p. 11, pl. I.

---

### PLATE 26

*Ṭirāz. Linen and silk. Fatimid Egypt, eleventh to end of twelfth century. T.N.1-1987*

H. (max.) 52.5 cm (including tapestry band), W. (max.) 55.3 cm; tapestry band: H. (max.) 13.5 cm (including fraying warp ends); W. of the wide stripes in pale blue varies between 0.3 cm and 0.7 cm and of the undyed linen stripes between 0.7 cm and 0.9 cm

*Technical analysis:* Large fragment, the curved shape suggesting that it is possibly from a garment. Main area with vertical stripes and a wide tapestry-woven band which includes inscriptions. Main area is plain or tabby weave linen with stripes alternately in undyed linen and pale blue, the latter outlined with narrow bands of dark blue. Warp: (occasionally paired) S-twist, about 28 per cm. Weft: slight S-twist, about 15 to 18 per cm. Remains of selvedges on right-hand side in red silk, W. 0.5 cm. Bands: tapestry band linen warps and undyed linen and silk wefts in blue, red, green and yellow – silk wefts, no noticeable twist. Approximately 32 ribs per cm.

This tapestry-woven band has wide central bands with interlaced medallions, some with confronting birds, others with running hares or small stylized birds or animals. Two narrower outer bands include inscriptions.

*Inscription:* نصر من الله

*naṣr min Allāh*
"Victory is from God"

PLATE 27

*Ṭirāz. Linen and silk. Fatimid Egypt, eleventh century. From a tomb at Manshiyya, near Girgeh (Upper Egypt). Cf. no. 1661-1888. 246-1890*

*W. (max.) 25 cm, L. (max.) 10 cm; bands: wider with inscription, 5 cms, narrower, 1.7 cm*

*Technical analysis:* Woven *ṭirāz*, linen and silk. Ground: plain or tabby weave. Warp: linen, S-twist, 24 per cm. Weft: linen, S-twist, 19 per cm. Bands of tapestry-woven decoration with stylized birds in oval compartments and addorsed inscription on either side. Another band of tapestry with birds in compartments. Slit tapestry, undyed linen and silk weft, no appreciable twist, about 40 ribs per cm. Silk weft in light blue, pink, yellow, blue/black.

This is a fragment of textile in linen, tapestry-woven in coloured silks with bands of guilloche ornament, Kufic inscriptions, and ovals enclosing birds and flowers (?).

*Inscription:* من مصر (؟)

*"From miṣr (?)".*

BIBLIOGRAPHY: Guest 1906, p. 397, no. 13; Kendrick 1924, no. 908, p. 24, pl. VI.

———————

PLATE 28

*Ṭirāz. Linen and silk. Fatimid Egypt, twelfth century. 2094-1900*

*L. about 66 cm, greatest W. 45.7 cm*

*Technical analysis:* Plain or tabby and tapestry weave in linen and silk. Ground: plain weave warp: S-twist, undyed linen, 17 per cm. Weft: S-twist, undyed linen, 17 per cm. Bands: slit tapestry silk weft, no noticeable twist, dark blue, blue, red and light grey. About 24 ribs per cm.

This is a portion of a linen garment, with a band of tapestry, woven in coloured silks and linen thread on the warp threads of the garment. The band is composed of a row of square compartments, each enclosing two birds on either side of a stem or tree; along one side is an inscription.

*Inscription:*

pseudo-inscription derived from Naskh letters. I do not think that a "Naskh" original gives any indication of a greater or a less antiquity than a Kufic one. Still it is worth noticing that we find the inscriptions falling into these two classes – derived from Kufic or derived from Naskh.

BIBLIOGRAPHY: Kendrick 1924, no. 879, p. 16.

———————

PLATE 29

*Ṭirāz. Linen and silk. Fatimid Egypt, eleventh century. 245-1890*

*L. (max.) 21.7 cm, W. (max.) 23 cm; tapestry bands: H. 5.4 cm and 2.2 cm*

*Technical analysis:* Ṭirāz woven in linen and silk in plain or tabby weave with two tapestry woven bands. Ground or main part of material: warp material and twist: undyed linen, S-twist. Thread count 24 per cm. Weft material and twist: undyed linen, slight S-twist. Thread count 16 per cm. Band: slit tapestry on undyed linen warp. Weft material and twist: undyed linen, silk with no noticeable twist in red, black, green and yellowish/beige (faded yellow). About 22 ribs per cm.

This textile has two bands of yellow silk worked with a black silk thread forming oval medallions enclosing animals and

birds on a black, red, or green ground, and a trefoil pattern in the intervening spaces. One of the bands is bordered by smaller bands of floral ornament and pseudo-Kufic inscriptions.

*Inscription*:

it has become an ornament.

BIBLIOGRAPHY: Kendrick 1924, no. 876, p. 15, pl. I.

---

PLATE 30

*Ṭirāz. Linen and silk. Fatimid Egypt, twelfth century. From a tomb at al-A'ẓam, near Aswān (Upper Egypt). 1162-1900*

*H. (max.) 40 cm, W. (max.) 31 cm; four bands each W. 7.2 cm; bands in between W. 0.4 cm; central pattern area W. 0.4 cm*

*Technical analysis:* Fragment woven in tabby or plain weave with tapestry-woven bands. Ground: plain weave undyed linen warp and weft. Warp: undyed linen, S-twist, 24 per cm. Weft: undyed linen, slight S-twist, 18 per cm. Bands: four wide tapestry woven bands. Warp: linen, S-twist. Weft: undyed linen and silk with no appreciable twist. In between tapestry woven bands are plain weave bands.

This is a fragment of garment of linen, with bands of tapestry, woven in coloured silks and linen thread on the warp threads of the garment. The four parallel bands are of similar design, consisting of a stripe of plait ornament in blue, bordered on either side by narrower stripes of scrolling. Ornament chiefly in red and yellow. The central pattern area is of interlaced compartments with stylized motifs and borders of dark blue outlined in red.

*Inscription:*

it has become an ornament.

BIBLIOGRAPHY: Kendrick 1924, no. 889, p. 19.

## NOTES

1.  Day 1952, pl. VI, fig. c.
2.  Errera 1907, no. 1HH, fig. on p. 10.
3.  See Guest 1931, p. 131, no.3.
4.  See Britton 1942, p. 166, and Britton 1938, pp. 72–5.
5.  See Golombek and Gervers 1977, p. 84, ftn. 23.
6.  See, for example, one in Philadelphia Museum of Art, inv. no. 19-632: see Golombek and Gervers 1977, fig. 2, p. 93.
7.  Inv. no. 54.16. See Golombek and Gervers 1977, fig. 1, p. 91.
8.  Ms. 1431: see Rice 1955, pl. IX.
9.  See Granada and New York 1992, cat. no. 22.
10. Golombek and Gervers 1977, p. 88, ftn. 59.
11. Thompson 1965; also Golombek and Gervers 1977, p. 88.
12. Granada and New York 1992, cat. no. 21. Pérez Higuera 1994, pl. at pp. 86–7.
13. Guest 1931, p. 133, no. 5.
14. Guest 1918, p. 263, no. 1.
15. Guest 1930, p. 765, no. 3.

# 3: CERAMICS

Studies on Fatimid ceramics have concentrated hitherto on questions of chronology and on tracing the pictorial styles of the lustre painting on the vessels. With regard to the latter, scholarship has been concerned primarily with establishing the sources (Persian, Abbasid, Egyptian, North African) of stylistic features relating to figurative and decorative elements on lustre ware, and trying to establish what characterizes them as Fatimid. In North Africa a glazed, polychrome pottery of remarkable variety was developed[1] and continued to be produced after the Fatimid conquest of Egypt. There, however, a totally different range of pottery wares started to be made,[2] so that, as with the other arts, Fatimid ceramics from Egypt exhibit affinities not so much with Ifrīqiya, but rather, when not part of a broader Mediterranean style which also includes Byzantine elements, with the Persian and Mesopotamian areas. However, both forms and decorative motifs serve to differentiate Fatimid from Persian or Mesopotamian ceramics. The geometric and vegetal motifs are closely related to specifically Egyptian features found in, for example, masonry, wood carving and textiles, while the human and animal figures have a style indebted to a classical tradition[3] and sometimes also humour, which is rather distant from the more formal Abbasid conventions.

With regard to chronology, recourse has been had in the first instance to the inscriptions on the objects, which have been used in addition as evidence of provenance. Three lustre-painted vessels are datable by their inscriptions to the reign of al-Ḥākim (996–1021/386–412) and, as with rock crystals, serve as a point of reference for other ceramics which are closely related in style and technique. Two of the three are dedicated to Egyptian notables,[4] which strongly suggests local provenance, and the production of lustre ware in Egypt is confirmed by the third vessel, which bears the name of a painter known to have worked during the reign of al-Ḥākim, while there is a further lustre-painted vessel that identifies itself as having been produced in Miṣr, to be identified here with the capital.[5] As with textiles, inscriptions are also evidence for the development of calligraphic styles, an aspect hitherto little studied, while the presence on some of words such as *sa'd*[6] (seen in plates 34 and 36) raises the issue of signatures and trade marks.

The great majority of examples of Fatimid pottery known today have been excavated from the ruins of Fusṭāṭ. But another important, if unexpected, source

of material is found in churches in Italy, particularly Pisa, where there are many buildings decorated with *bacini* (ceramic bowls), the oldest examples dating from the beginning of the eleventh century, and the latest from the fifteenth.[6] In most cases the *bacini* were mortared into the walls during construction, and as the building of some of the churches is well documented they provide further valuable chronological evidence, for it may be assumed that contemporary ceramics were utilized.[7] In addition to stylistic identification of some of the *bacini* as Fatimid, chemical analyses of the bodies now allow us to distinguish, for example, eleventh- and twelfth-century Fatimid from Spanish and Maghribi ware.[8]

It is fair to say that the study of Fatimid pottery has hitherto revolved mainly around a narrow range of art-historical issues and has largely ignored classification, technical analysis and the wider ramifications of production. Moreover, it has focused on just one segment of the range of ceramic objects produced. The reason for this is straightforwardly that, from a traditional art-historical perspective, lustre ware represents the most glamorous type and is consequently the type European museums concentrated on when building up their collections. Such was also the case at the V&A, even if its Fatimid ceramic collection also includes important non-lustre-painted pieces.

Predictably, however, archaeological evidence reveals that lustre ware represents only a small fraction of the total range of types of pottery produced and used in Fatimid society. The excavations at Fusṭāṭ[9] have confirmed, for example, as might have been anticipated, a predominance of pottery fragments mostly of unglazed wares of various types. But despite its importance, such material cannot be easily dated – yet another reason for neglecting it in favour of slip-painted and glazed fragments with their dating possibilities. The problem is exacerbated by the fact that the unglazed pottery types tend to be conservative in shape, technique and decoration and only a few have filters that have been classified for dating purposes. For the most part, in the absence of precise stratigraphy it is difficult to establish even a relative chronology. For the moment we can only await forthcoming studies of the finds in dated contexts in Fusṭāṭ, in the hope that they will lead to a better understanding of the history of these materials.[10]

During the last two decades there has been an increasing awareness of the necessity to examine the pieces in a different number of ways, including microscopic and petrographic analyses of the composition of both bodies and glazes.[11] But although some progress has been made, it is still the case that Fatimid pottery is poorly understood.

## MATERIALS

### Body

Egyptian clays varied a good deal in colour: most of the pieces are made of a grey or buff body, but yellow, pink and sometimes red clays also occur. The

custom was probably to blend the slimy, fusible Nile clays, which fired white, with coarser red clays found in villages south of Cairo which gave stability to the body for throwing and prevented the ware from deforming too easily during firing.[12] However, earthenware was supplemented by a more sophisticated material, known as stone-paste or frit-ware, probably created in an attempt to imitate white, fine and translucent porcelain from China.[13] A study conducted by Oliver Watson on a series of Fatimid fragments in the Victoria and Albert Museum[14] has shown that Egyptian frit-ware exhibits a far wider range of body types than Syrian and Persian frit-ware, suggesting much greater experimentation and the probability that it was in Egypt, during the course of the Fatimid period, that the frit body was developed.[15] Earthenware continued to be used for utilitarian objects such as water storage jars (plate 31), as is still the case today,[16] with the finer clays and frit-ware being reserved for luxury vessels (plate 37, for example).

According to a recipe given by Abu'l Qāsim, a member of the Abū Ṭāhir family of potters who wrote a treatise dated 1301/701,[17] stone-paste at that date was made in the proportions of ten parts ground quartz to one part glaze frit to one part fine white clay. The ground quartz was obtained from pebbles collected from dry river beds and from sand. The glaze frit was made from a combination of pounded quartz and dried soda, extracted from vegetal ashes, heated until melted into a clear glass which was then ground: it served in the firing as a binding agent. The third essential element is a fine white clay, the importance of which is underlined by the fact that Persian potters of the fourteenth century often had to bring it from far away.

The composition of stone-paste is very similar to that of the material often called faience, employed by the potters of ancient Egypt and pre-Islamic Persia for making beads, and during the Achaemenid period (539–330 BC) for glazed bricks. The material seems to have disappeared thereafter but once fully rediscovered in the twelfth century it proved very popular and has been used almost continuously in Persia up to the present day.[18] Although it was difficult to throw, the combined strength and malleability of the material made possible a greater fineness and versatility of moulded shapes as well as permitting new possibilities of decoration.

## Slip

To the earthenware body a whitish opaque layer of liquid clay, termed slip, could be applied, thereby giving it a uniform colour and providing a good background for decorating the object, though surface cracks in the slip might result if it did not expand and contract at the same rate as the body when fired. As well as clay, stone-paste could be used for the slip, and analyses recently conducted on Fatimid and earlier Egyptian wares[19] have led to the discovery that stone paste was used in slips in the ninth and tenth centuries, thus indicating that stone-paste had long been part of the Egyptian potter's repertoire, even if only

later utilized for the body. Stone-paste slips continued to be used during the Mamluk period (fourteenth to fifteenth centuries).[20]

## GLAZE

A glaze applied to the surface is not merely decorative but also functional. An unglazed vessel will sweat, allowing its liquid contents to seep out. This may seem to be a serious disavantage, but porosity leads to evaporation which has the effect of cooling the liquid that remains within the vessel. A glaze, on the other hand, renders it impermeable, with consequent advantages for the storage of precious liquids, for instance in pharmacies, and for the production of plates and bowls as table ware. The glaze, made of glass ground into powder and poured or brushed over the vessel in a watery medium before refiring to fuse it with the body, would usually have added to it a substance termed a flux which lowers the melting or fusion temperature. In the early Islamic period the predominant type was a lead glaze, that is, a glaze fluxed with lead oxide, which had the property of good adhesion to the body, but ran easily. Such a glaze would be transparent, but it was also quite common to add mineral pigment in powder form to produce a coloured glaze finish. Indeed, the commonest glazed pottery of the period has a coloured transparent lead glaze, often green, brown or turquoise, over a grey, pink or yellow clay body, with and without decoration in clay slip and sgraffiato drawing (plates 32 and 33).

Polychrome glaze, as the name suggests, is distinguished by decoration applied in the form of differently coloured glazes. Pieces with colours that run as a result of using a lead glaze are generally termed "splashed ware".[21] Egyptian ware of this type, opacified, however, generally with tin oxide, which has also been found in Fusṭāṭ,[22] is often called "Fayyūmī" and is considered to date from the tenth to the early thirteenth century.[23] There is some debate as to how and when polychrome glaze was introduced into the Islamic world. According to the traditional Samarra chronology, this type of ware was introduced in the ninth century from China. However, the discovery of Coptic polychrome glazed ware in Alexandria[24] and in Aqaba (Jordan)[25] has led to the assumption that polychrome glazed ware originated in Egypt, and that the tradition continued into the Islamic period. The glazed finds from Fusṭāṭ provide a range of comparative material, although the typology which would allow greater certainty of dating has not yet been established for this early Islamic glazed pottery.

A coloured glaze can be applied directly to the body, but colour can alternatively be obtained by staining the slip, as was done by tenth-century Nīshāpūr potters, while a further and more frequent method is to use the slip, when dry, as a base on to which colours can be painted before a transparent glaze is added. Lead-tin glaze, which was already used on Tulunid and early Fatimid pottery, contains particles of tin oxide which have an opacifying and whitening effect. This innovation can be dated to the mid-ninth century, emerging in

Mesopotamia and Persia. There were thus two techniques available for whitening the body. It could be coated with a fine white clay slip and then with a transparent glaze or the slip could be omitted and a lead-tin glaze applied. As a rule white slip ware and lead-tin glaze ware have a different texture because on the one the colour is under the glaze and protected by it, whereas in the other the colour actually fuses with the glaze and permeates it; however, the difference may sometimes be hard to detect.[26] Both could be used, in the Fatimid period, for lustre-painted ware.

## DECORATIVE TECHNIQUES

### Lustre painting

The word lustre describes a metallic sheen which may vary in hue according to the angle of the light. The effect is produced by applying silver and copper oxides mixed with clay or ochre to the cold surface of a vessel.[27] The vessel is then fired again in a reduction kiln (one where the air supply is restricted, producing carbon monoxide) which extracts oxygen from the oxides and fixes them to the surface in a pure metallic state. The variations in the percentage of the oxides will produce a range of hues, but an equally important factor in determining the final colour is the extent to which an even temperature can be maintained over the whole firing chamber. The colour range goes from brownish to reddish to yellow gold, and it has been suggested that lustre might, indeed, have been produced with the idea of imitating gold and the light of the sun.[28]

But the value of the object could be further enhanced by the complexity of design that could be achieved with lustre. Images could be either positive, with figures in lustre on the white glaze background, or negative, the white slip forming the figures, the shape of which is defined by the surrounding lustre.[29] Further, more detailed effects could be obtained by using a sharp tool to make minute scratchings through a lustre field to suggest, for example, plumage or fabric designs (as in plates 34 and 35).

Lustre pottery was produced in Iraq in the ninth and tenth centuries; in Egypt from the eleventh century until around 1170; in Syria from the twelfth century[30] until 1250; and in Persia from ca. 1170 until the mid-fourteenth century. But lustre first seems to have been used on glass, and its earliest appearance has been assigned, even if controversially, to fourth-century AD fragments from Egypt.[31] Although continuous production from then until the Islamic period cannot be demonstrated, it is also the case that the earliest example of Islamic lustre-painted glass is from Egypt: a goblet which bears an inscription with the name of an Egyptian governor who ruled in 772/155.[32] However, the Mesopotamian area has also been considered a possible centre of origin,[33] and two fragments of lustre-painted glass have been found in Iraq, bearing an inscription with the name of the city of Baṣra.[34]

As is the case for glass, the earliest ceramic examples are in monochrome as well as polychrome lustre. An Islamic innovation, lustre ceramics first appear in Samarra in the early ninth century,[35] in the form of tiles. Also in the ninth century lustre ceramic tiles appear decorating the *miḥrāb* of the Great Mosque at Qayrawān in Tunisia,[36] but as there is no evidence for local production it has been generally assumed that they were imported from Iraq as they have close parallels in Samarra pottery, even though the tiles found at Qayrawān are exclusively geometric and floral in decoration, whereas those at Samarra exhibit greater variety of design, including floral and animal motifs. We do know that lustre-painted tiles were produced in North Africa during the Fatimid period,[37] but there is no evidence of them having been produced in Fatimid Egypt, where the surviving lustre ware seems to consist solely of vessels.[38]

Monochrome lustre flourished particularly during the eleventh and twelfth centuries in Egypt, presenting both geometric, floral and figurative motifs. After the fall of the Fatimid caliphate in 1169–71/565–7, it has been alleged that the technique of lustre was brought by craftsmen from Fusṭāṭ to Syria and also to Persia,[39] where it flourished between the twelfth and fourteenth centuries at the potteries of Kāshān.[40] The first lustre made in Syria is known today as "Tell Minis" ware, after the site in central Syria where examples were first excavated in the late nineteenth century,[41] and because of its decoration it was at first thought to have been imported from Egypt, although excavation at Hama later showed that a lustre industry had existed in Syria itself.[42] But if the first lustres in Syria and Persia bear a resemblance in decorative style and imagery to those of Fatimid Egypt,[43] the earliest Fatimid lustres likewise resemble the vessels of Abbasid Iraq.[44] This suggests, especially given the absence of evidence for the continuation into the Fatimid period of the production of glass lustre ware in Egypt, the possibility of another and earlier migration of workers. An important reason for presuming the transfer of lustre ware styles by travelling craftsmen is that the technique cannot be copied simply by the observation of objects. There is a need for specially prepared materials not used in other kinds of pottery; the painting requires a special skill; and the firing follows a special programme. To judge from later practices, as reported, for example, by Piccolpasso, it is very likely that the manufacturing process was a trade secret closely guarded by the potters.

## Sgraffiato, carving and modelling

Sgraffiato decoration is obtained by making narrow, sharp-edged but shallow incisions through a white slip into a red or yellow earthenware body (as in plate 33) which is subsequently given a coloured lead glaze. Under this the decorative lines appear brown or black. During the Islamic period this technique first appears on Abbasid wares found in Samarra,[45] but pre-Islamic examples are to be found in Egyptian Coptic ware of the fifth to seventh centuries.[46]

The term carving is applied to a basically similar technique producing wider but still shallow incisions with bevelled edges.[47]

Found both separately and in conjunction with sgraffiato and carving, a further decorative technique used by Fatimid potters was modelling (as in plate 32). The most common effect produced was a series of ribs.[48]

## KILNS AND FIRING

The commonest type of kiln used in the Islamic world in general was the updraught one. This consists of a structure with a round or oval ground plan, divided into two chambers: a lower firebox, and an upper firing chamber with a perforated floor. The heat circulated within this upper chamber in which the pottery was contained, and the domed roof was also perforated in order to create the updraught.[49] Abu'l Qāsim described a kiln in his treatise as follows:

> This is a high tower and inside has row upon row of fired earthenware pegs . . . fitted into holes in the wall. The vessels are placed on them and fired for twelve hours with a hot even fire, with this stipulation: that no wood be put on until the smoking has stopped, so that the smoke does not ruin or blacken the pots. In Kashan they burn soft wood and in Baghdad, Tabriz and other places the wood [of a willow] stripped of its bark so that it does not smoke. The vessels are removed from the kiln after a week [after they have cooled].[50]

At Fusṭāṭ kilns have been found dating from the thirteenth and fourteenth centuries, and there are also traces of Fatimid kilns, together with wasters from kiln sites of the twelfth century.[51] Potters still work today near the Fatimid kiln-sites in the vicinity of the al-'Amr mosque,[52] and it is likely that there has been continuous production in this area, if not of the most sophisticated objects for which demand could fluctuate or even, in times of political upheaval, cease altogether, then at least of staple earthenware vessels. Such kilns would have rows of earthenware pegs (between 60 and 70 cm long) as described by Abu'l-Qāsim: examples have been unearthed at a number of sites, including Sīrāf[53] on the Persian Gulf and the Īl-khānid palace of Takht-i-Sulaymān (1270–4/669–72),[54] and they are still used in traditional potteries today.[55]

The loading of the kiln was a skilled task, as the objects needed to be arranged in such a way as to maximize the use of the space available, and could be spoiled if they were clumsily placed, particularly for the first (biscuit) firing. The size of a kiln could vary considerably: it is quite striking to see, in contemporary potteries, how long the process of loading a kiln takes and how many objects can be fitted in: among the potters of Fusṭāṭ even for unglazed material the process can take five or six days and a large modern kiln can be loaded with between thirty and forty thousand pieces.[56]

Lustre firing takes place, Abu'l-Qāsim tells us, in the following way. Place the vessels "in a second kiln specially made for this purpose, and give them light

smoke for seventy two hours until they acquire the colour of two firings [which is like gold]. When they are cold, take them out and rub them with damp earth so that the colour of gold comes out . . . That which has been evenly fired reflects like red gold and shines like the light of the sun."[57] The construction of the lustre kiln was a crucial factor, as were the positions of the objects inside it and the amount of fuel used. The Italian potter Piccolpasso,[58] writing in 1558, says that "many make [the lustre kilns] on the floors of houses which are locked and under close guard for they look to the manner of making the kiln as an important secret and say that in this consists the whole art" and he underlines the difficulties faced by potters in their attempt to achieve satisfactory results by concluding that "the art is treacherous for at times of one hundred pieces of ware tried in the fire, scarce six are good".

## DOCUMENTS

Arabic sources for Egyptian ceramics are sparse in the extreme. In the fifteenth century al-Maqrīzī describes ceramics which have been understood as pottery made in Egypt in 1056/448,[59] while Nāṣir-i Khusraw, writing in the eleventh century, relates that pottery of every kind was made in Egypt, including bowls, cups, dishes and other articles of a translucent ware, and that they used colours which changed according to the position in which the vessels were held as on a shot silk, called *būqalamūn* (from the Arabic for chameleon).[60] But such anecdotal descriptions, interesting as they are, confirm merely the existence of luxury goods, and for more factual information the obvious sources to turn to are documents from the Cairo Geniza,[61] though the yield is scanty, for textual references to the production of pottery in Fusṭāṭ are rare. On the one hand, glass, china and pottery fail to appear in the trousseau lists where textiles figure so prominently, the reason being, presumably, that they were considered too fragile to be reckoned among the durable items that would be retained by the wife in case of divorce.[62] On the other hand, there does not seem to have been any extensive Jewish involvement in the pottery business, whether in the supply of raw materials, in manufacture or in marketing. Unlike textiles, there may in any case have been far less long-distance trade in raw materials, for, whereas flax was virtually an Egyptian monopoly, clays of requisite quality were more widely available. However, as demonstrated by references above to the *bacini* of Fatimid origin and the well-documented presence in Egypt of Chinese imports,[63] there certainly was a long-distance trade in high-quality ceramics, and we know of exports (or gifts) sent from Egypt to Sicily.[64] Nevertheless, documentation remains sparse, and the economics of the industry cannot be reconstructed. If, as has been cogently argued,[65] the iconographical repertoire exploited by Fatimid potters lies predominantly with the range of the princely cycle, it may well be that much of the best material was produced for the court. But there is no evidence for any kind of manufacturing structure or commissioning agency for ceramics parallel

to the *ṭirāz al-khāṣṣa* for textiles. The most that can be concluded is that the ceramics industry in general must have occupied a smaller niche than the textile industry in the economy of Egypt as a whole, and in particular as a generator of income from international trade.

Equally, although it is clear that the manufacture of pottery involved various stages and hence various specializations, not all of these are known. According to the Geniza documents, the *fakhkhār, fakhūrī* or *fakhūrānī* manufactured clay pipes and other clay material used in buildings and installed them himself (so that he appears in documents relating to the repair of the houses). The *qaddār* made pots and other receptacles (and we have evidence of a shipment sent from Tinnīs in Lower Egypt to Ramla in Palestine). In fact it is likely that each type of vessel was made by a separate group of artisans, although so far only two such specialists have been noted in the Geniza documents: the *kūzī*, a maker of narrow-necked water jugs without a spout, and the *ghadā'irī*, a maker of porcelain-like translucent dishes. But there were no doubt others specializing on a particular segment of the great variety of forms developed by the ceramics industry for pharmacies and doctors' dispensaries.[66]

## DECORATIVE REPERTOIRE

The lustre-painted Abbasid pottery imported to Egypt from Iraq by the Tulunids in the ninth and tenth centuries is usually monochrome decorated with highly abstract palmette designs set against a white background. But animals, birds and human figures also occur, in a rather schematized style that is typically Abbasid. The origins of this have been sought either in Central Asia[67] or, given a certain affinity with late-classical stylized renderings of the human figure, in the eastern Mediterranean.[68] An attribution to local Tulunid potteries of some of the lustre-painted fragments with human figures of the Abbasid type has been mooted, in parallel with the production of similar items at sites as far apart as Rayy and Madīnat al-Zahrā'.[69] In fact there is no evidence of lustre ware production in Iraq during the Tulunid period, and it may be suggested that because of the political instability there potters had moved to Egypt.[70] Likewise, during the upheavals that accompanied the end of the Fatimid rule, production ceased in Egypt, but continued in Syria,[71] and commenced in Persia,[72] and this has again been attributed to a migration of lustre ware potters.

But whatever the origins, Fatimid potters produced lustre ware that was as rich and varied in decoration as the Abbasid. Moreover, they rapidly developed a new and complex figural repertoire that is quite independent of Abbasid models, both in the range of themes treated and in the style of representation. It is this figural Fatimid pottery that has been most widely discussed by art-historians, and one suggestion that has been made to account for the sudden widening of the thematic range is that it was triggered by the dispersal of the treasury in the second half of the eleventh century.[73] Among the items which went on sale

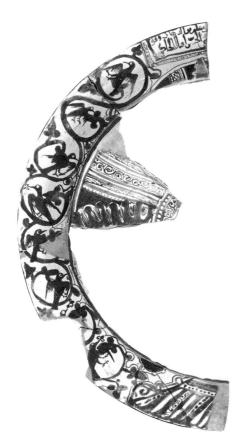

*27*. Lustre-painted ceramic fragment of a plate (max. Diam. 38 cm) signed by Muslim ibn al-Dahhān, made under the Fatimid Caliph al-Ḥakim, late 10th–early 11th century. Benaki Museum, Athens: 11122

would have been gifts of state especially from Byzantium and the rulers of the quasi-independent Persian provinces, and these objects, it is argued, could have introduced exotic themes to the craftsmen and artisans who used them as models for new works in different media, including pottery. But apart from the lack of evidence regarding specific objects that could have served in this way as models for the new Fatimid style, there are examples of such figurative lustre pottery which may date from before the dispersal of the treasury, and one which certainly does, having been produced during the reign of al-Ḥākim, 996–1021/386–411. Fig.27 is a fragmentary plate in Athens[74] consisting mainly of a rim with scrolled cartouches containing birds of prey, some of them with outstretched wings; judging from what remains, the subject that was depicted on the centre of the plate was most probably an eagle with outstretched wings, the whole composition being rather different from Abbasid lustre ware examples. The rim bears an inscription stating that it was made by "Muslim ibn al-Dahhān for al-Ḥasan Iqbāl al-Ḥakimī", an individual who has not yet been identified[75] but who, judging from his *nisba* (the final part of the name, denoting descent or origin), must have been an official at al-Ḥākim's court. Related to this is another fragmentary piece in Athens,[76] a bowl representing a musician and a cup-bearer, with the name "Muslim" both on the rim and inside the footring, and the same name appears on several other objects[77] including a complete bowl in the Metropolitan Museum of Art in New York decorated with an eagle shown frontally with wings outspread,[78] similar to the eagle that must have been represented in the centre of the fragmentary Athens plate. If, as is generally assumed, "Muslim" is the signature of a painter,[79] then pottery signed by him can be securely dated to the period of al-Ḥākim's reign; and even if it is thought rather to be the trade name of a factory which may have produced such wares over a longer period than a single lifetime, the distinction is not relevant here: the bowls might be later, but the inscription on the fragmentary plate still dates it to before the dispersal of the treasury.

A further item of Fatimid lustre pottery that can be dated with precision is a fragmentary bowl in the Museum of Islamic Art in Cairo (fig.28) which bears a dedicatory inscription to "Ghabān", who was an officer in al-Ḥākim's service.[80] In the inscription he is given the title of *qā'id al-quwwād* (Commander of the Commanders),[81] which he bore only from 1011/402 until his death two years later. Although non-figural, its decorative repertoire again distances it from Abbasid models, and it therefore provides further evidence of the innovative character achieved by Fatimid pottery before the dispersal of the treasury.[82]

These datable objects provide a point of reference for the chronology of Fatimid lustre-painted ware but, although attempts have been made to date individual pieces or groups of pieces in relation to them, we are still far from being able to establish an accepted chronological sequence for the whole corpus.

## "SIGNATURES" AND TRADE MARKS ON THE LUSTRE-PAINTED PIECES

As we have seen, several vessels with the name "Muslim" have been identified, some in the V&A collection (figs 29 and 30).[83] Other such names also occur, such as "al-Ṭabīb", "Fawz", "Aḥmad" and "Ḥasan",[84] and, although it is unusual in the Islamic medieval period to encounter the signatures of individual artists, it has been suggested that these names are indeed those of the artist, and indicate that the piece in question was particularly valuable.[85] However, since unique objects that were presumably even more highly valued, such as rock crystals and ivories, are rarely signed, this is not wholly convincing, although one might speculate that the absence or presence of a signature could correspond to the difference between individually commissioned pieces, where the craftsman is known in advance, and pieces produced by a specialist for the open market.

A further problem is raised by a large number of objects which, on the basis of comparisons with decorations on other media such as textiles, can be assigned to the period of al-Mustanṣir (1035–94/427–87).[86] They have on them, sometimes repeated more than once, the word *saʿd*, and the particular issue is whether this is the name of another and prolific potter or painter (the view put forward by traditional scholarship)[87] or whether it is not a name at all but rather a formula meaning "good luck" or "good fortune".[88] The arguments against considering it the name of an artist are quite strong: for example, it is always in large Kufic letters, unlike *muslim* and the other names that are always in cursive. It also always appears alone and without the preceding word *ʿamal* often found in conjunction with other names. Therefore, the hypothesis that it is a formula seems a perfectly reasonable one. But *saʿd* is rarely attested elsewhere.[89] On other contemporary objects (textiles and metalwork) the corresponding good-luck formula is *saʿāda* (happiness, prosperity), and, as with other formulae, the definite article is attached. Further, where we find such single-word formulae they are always repeated to form a decorative pattern.[90] With *saʿd*, on the other hand, we never encounter the definite article and there is only one example of such pattern repetition:[91] in all other cases, including our V&A pieces, the word is boldly drawn in isolation or repeated once, but without forming a pattern. *Saʿd* in isolation, moreover, does not occur on other media, but only on lustre-painted ware. Further, the style of decoration and specific design features, like the scratched decoration through the lustre, create a degree of homogeneity among the *saʿd* material, despite the generally wide range of motifs with which they are combined. A particularly notable common feature is the consistently bold Kufic of the word itself. Such consistency would be readily explained if it were the trade name of a particular pottery or, more specifically, one specializing in lustre ware. The fact that the word *saʿd*, drawn in exactly the same manner as found on the ceramics, also appears on a glass lustre-painted fragment (fig.33)[92] would point to an enterprise dealing in glass as well as pottery. Technically, the same kiln could well be used for the lustre firing of ceramic

*28.* Lustre-painted ceramic bowl made for Ghabān, officer to the Fatimid Caliph al-Ḥākim, early 11th century. Museum of Islamic Art, Cairo: 12297-14389

*29.* Lustre-painted ceramic fragment (H. 7.6 cm; W. 9 cm) signed by Muslim, Fatimid Egypt, late 10th–early 11th century. C.1718-1921

*30.* Reverse of fig.29, showing the artist's signature.

and glass and further evidence for such joint production is provided by a lustre-painted glass signed by Muslim,[93] one of the major ceramic artists.

## NOTES

1.  For North African pottery see Ventrone 1974, pp. 85–102; for the rich material recovered in Italy see Berti and Tongiorgi 1981.
2.  For the hypothesis of an indigenous tradition as a source of ceramic production in Egypt at that time see Ballardini 1964.
3.  Ettinghausen 1956 has defined this style as "realistic", but this has been very convincingly disputed by Grube 1976, pp. 140–4 and Grube 1984. For the influence of a classical, Hellenistic tradition on Fatimid art see Grube 1962.
4.  Grube 1976, p. 126.
5.  Lane 1947, p. 21, pl. 22A. For the frequent identification of Miṣr with Fusṭāṭ see Chapter 2.
6.  For the Pisan *bacini* see the comprehensive work by Berti and Tongiorgi 1981; for *bacini* in other Italian cities such as Pavia see Blake and Aguzzi 1990.
7.  The Fatimid dishes attached to the walls of the churches of San Sisto, Sant'Andrea and San Zeno can be dated, as the construction of these churches is well documented. San Zeno was built in stages during the eleventh century; San Sisto was built between 1070 and 1133, and Sant'Andrea belongs to the beginning of the twelfth century: Berti and Tongiorgi 1981, pp. 17–21, 49–64, 70–82 respectively.
8.  Berti and Tongiorgi 1981, p. 266 and appendix I, p. 288 and Berti and Tongiorgi 1986, pp. 315–16.
9.  Scanlon's reports of excavations at Fusṭāṭ: see bibliography. This is true also in general in archaeological sites of the Middle East. See, for example, reports of Qusayr al-Qadīm (on the Red Sea): Whitcomb and Johnson 1979, who state at p. 104: "The majority of the vessels and sherds recovered during the excavations were unglazed ceramics, rarely reported in detail for Islamic excavations", and, we might add, difficult to distinguish as types.
10.  And their relationship with other material from Nubia and Upper Egypt. The presence of slip-painted fragments from Faras of the Christian period in Nubia in a foundation fill at Fusṭāṭ demonstrates the relations between Faras and Fusṭāṭ: Scanlon 1970a, p. 54 and fig. 15d. The presence of Fusṭāṭ glazed wares in Nubia is attested by Fusṭāṭ Fatimid sgraffiato fragments and an imitation Chinese wine-cup at Wizz: Scanlon 1970a, p. 43, pl. XLII-3. For parallels between painted wares at Qusayr al-Qadīm and Nubian painted pottery see Whitcomb and Johnson 1982, p. 151.
11.  For material from Fusṭāṭ see Michel, Frierman and Asaro 1976; Mason and Keall 1990.
12.  Caiger-Smith seems to think that this would be the case today too: Caiger-Smith 1973, p. 37; also Sinclair 1990, pp. 6–7.
13.  See Scanlon 1970b; Gyllensvärd 1973–5; Crowe 1975–7.
14.  Oliver Watson has studied a series of sherds which seem to illustrate the different stages of development from the clay body to stone-paste, suggesting that experiments were carried out by Egyptian potters during the Fatimid period. I am very grateful to Oliver Watson for sharing with me his unpublished finds.
15.  Porter and Watson 1987, p. 189.
16.  See Golvin, Thiriot and Zakariya 1982.
17.  For a translation into English of this treatise see Allan 1973.
18.  Wulff 1966, pp. 151 and 165; Centlivres-Demont 1971, p. 20.
19.  Mason and Keall 1990.
20.  Mason and Keall 1988.
21.  For "splashed ware" of the early Fatimid period see Philon 1980, pp. 41 ff.
22.  Scanlon 1974b, pp. 69 ff.
23.  Philon 1980, p. 35 and 39.
24.  Rodziewicz 1976 and 1983.
25.  Whitcomb 1989.
26.  See V&A C.49-1952 (plate 34): this, according to Caiger-Smith 1973, pl. B, has a white clay slip that has the effect of tin-glaze.
27.  For the recipe of lustre paint see Allan 1973, p. 114, paragraph 27; Watson 1985, p. 34; Caiger-Smith 1985, p. 198; for the microstructure of lustre see Kingery and Vandiver 1986, pp. 111–20.
28.  See Caiger-Smith 1985, chapter 11 for the

symbolism of lustre. See also Hillenbrand 1995.

29. For a "positive" example see the bowl in the Benaki Museum with the representation of a hare in the middle, and for one painted in reserve see, in the same Museum, the bowl with an old man and a leopard: Philon 1980, pl. XV, fig. 414 and pl. XXIII, fig. 467.

30. Watson 1985, pp. 37–44.

31. Lamm 1941, especially pp. 19–21, and pp. 13 ff. for a discussion on the origin of lustre.

32. Scanlon 1966, p. 105, fig. 15; Pinder-Wilson and Scanlon 1973, pp. 28–9, figs 40–2.

33. Kühnel 1934, p. 152.

34. Ettinghausen 1942.

35. See Sarre 1925. On the origin of lustre on ceramic see Ballardini 1928; Frierman, Asaro and Michel 1980.

36. Marçais 1928.

37. From the Qal'a of the Banū Ḥammād: Marçais 1913; Porter 1995, fig. 16.

38. Lamm 1941, p. 53. A few tiles are known, but these are decorated with colour glaze and sgraffiato technique: Porter 1995, p. 30, fig. 15.

39. For the earliest known dated lustre-painted piece found in Persia, a fragmentary bottle dated 1179/575 now in the British Museum, see Lane 1947, pl. 52B.

40. Watson 1976.

41. For Tell Minis ware see Porter and Watson 1987.

42. Riis and Poulsen 1957.

43. For early Persian lustre pieces in Fatimid style see *SPA*, II, pp. 1550 ff, V, pls 632 and 633,B; also Watson 1985, p. 28, pls 1 and 2.

44. See, for example, fragments and a jar in the Benaki Museum in Athens: Philon 1980, pls XI and XII.

45. Sarre 1925, pp. 74–7, group XII.

46. Lane 1937–8, p. 34, pl. 15a.

47. See examples in Lane 1947, pl. 40B; Philon 1980, pls XXXI and XXXII.

48. See references in entry for plate 32.

49. See explanatory drawings in Caiger-Smith 1973, fig. 33 and Porter 1995, fig. 2.

50. Allan 1973, p. 114.

51. See Bahgat 1914; al-Ṣadr 1960; Scanlon 1965, p. 19.

52. Abu-Lughod 1971, p. 201; Matson 1973, pp. 129–39; Golvin, Thiriot and Zakariya 1982; Sinclair 1990.

53. See Whitehouse 1971, p. 15.

54. See Naumann 1971, pp. 185–7, and Naumann 1976.

55. As in the modern pottery kiln at Kangan (in the Persian Gulf): see Allan 1971, pl. 1; see also Centlivres-Demont 1971, p. 29 and pl. 27; and among contemporary potters of Fusṭāṭ: see Golvin, Thiriot and Zakariya 1982.

56. Golvin, Thiriot and Zakariya 1982, pp. 58–9 and 78.

57. Allan 1973, paragraph 27.

58. Lightbown and Caiger-Smith 1980.

59. Grabar 1972.

60. Nāṣir-i Khusraw 1881, p. 151. It has been suggested that the comparison with the *būqalamūn* stuff does not refer to pottery but to lustre-painted glass: Lamm 1941, pp. 38–9. The passage is, however, ambiguous.

61. See Chapter 2, note 1.

62. Goitein 1967–88, IV, p. 106, and III, p. 128.

63. Gyllensvärd 1973, fig. 50 and pls 12–18; Whitehouse 1971, pl. IXa; Whitehouse 1972, pl. XI; Whitehouse 1974, pl. XIIa; Gray 1975–7.

64. Goitein 1967–88, I, p. 110. A Fatimid lustre-painted dish with motifs of birds among foliage was found in Sicily: see Lane 1947, pl. 28A.

65. Grube 1976, pp. 129 ff.

66. Goitein 1967–88, I, pp. 110–11, where he mentions inventories, although no reference is given. For vessels possibly used in pharmacies and doctors' dispensaries see Paris 1996, pp. 148–57.

67. Fehérvári 1963, pp. 79–88.

68. Grube 1976, pp. 29–33.

69. Ḥasan 1933, pp. 310–12. The idea that there was an Egyptian production of these wares was also shared by Bahgat and Massoul 1930, pp. 42 ff., and pls II–IV.

70. For the "migration theory" see Lane 1937–8, pp. 39 ff., but for a rather cogent argument against this theory see Lamm 1941, pp. 56–7 and note 64.

71. Porter 1981, p. 5.

72. Watson 1985, p. 26.

73. Grabar 1972.

74. Philon 1980, p. 198, fig. 404, pl. XXIV.

75. There is another fragment with the name "Muslim ibn al-Dahhān" in the Museum of Islamic Art in Cairo: see Yūsuf 1962, p. 179, figs 9, 10, and, in the same Museum a lustre-painted bowl with a griffin signed "'amal Muslim ibn al-Dahhān": see Ettinghausen and Grabar 1987, fig. 175.

76. Philon 1980, p. 222, fig. 468, pl. XXV.

77. For this see Philon 1980, p. 168, note 53 where forty-four pieces with the inscription "Muslim" are recorded.

78. Acc. no. 63.178.1: see Grube 1965, p. 215, fig. 10.

79. Jenkins 1968.

80. Inv. no. 12297-14389: see Lane 1947, pl. 25A; al-Bāsha 1956; Yūsuf 1958; and Pinder-Wilson 1959, p. 139.

81. Note that the rock crystal in the Pitti Palace bears a dedicatory inscription to the *qā'id al-quwwād* (commander of the commanders) which has always been associated with Ḥusayn ibn Jawhar, who had a high position at the Fatimid court between 992 and 1011. See Chapter 1, p. 19.

82. As cogently argued by Pinder-Wilson 1959.

83. Those showing the full name, Muslim, are: C. 1363-1852; C. 1646-1921; C. 1718-1921; all found at Fustāt.

84. Yūsuf 1962. A lustre-painted fragment found at al-Fustāt, datable to the twelfth century, with the name "Ḥasan Saʿ . . ." is now part of the V&A collection: C.1605-1921. The name is painted on the outside.

85. Caiger-Smith 1985, p. 49.

86. Lamm 1941, p. 48; Jenkins 1988.

87. See, for example, the ample discussion in Lamm 1941, pp. 47–52.

88. Jenkins 1988.

89. Jenkins 1988, figs 16 and 17, illustrates two examples which, however, are in the context of an inscription and have the definite article.

90. See for example the fragments in the Benaki Museum illustrated in Philon 1980, figs 509, 512, 514.

91. A bowl in Washington, Freer Gallery of Art, inv. no. j6.2: Jenkins 1988, fig. 1.

92. In the Benaki Museum in Athens, no. 3507, acquired in Egypt: Lamm 1941, pl. XVIII,1; Clairmont 1977, fig. 134; Philon 1980, p. 176.

93. I am grateful to Michael Rogers who himself handled the object. To my knowledge the piece is unpublished.

# CERAMICS IN THE V&A

## PLATE 31a and b

*Water-jar with a filter. Buff-white earthenware with incised decoration. From excavation at Fustāt. Fatimid Egypt, eleventh or twelfth century. C.899-1921*

*H. 19.2 cm, Diam. of mouth 10 cm, Diam. of filter ca. 9.1 cm*

Unglazed jar of whitish earthenware, with damaged conical foot, large body and an everted neck and mouth that contains a filter with a pierced decoration of a rosette at the centre with thirteen petals, and triangles and dots all around, giving the effect of lace work.

Other jars similar to this have been recovered at Fustāt and are thought to be water-bottles, with the filters to keep insects out. One of these, assigned to the eleventh century, has a foot and is glazed in white with daubs of blue about the shoulder; the filter itself is missing, but its position and dimensions are clear.[1] Others, unglazed, are assigned to the Ayyubid period on stylistic grounds.[2] Isolated Fatimid filters from water-bottles of buff-white ware have also been recovered, sometimes glazed or even with a lustre-painted decoration.[3] The filter of the present jar falls into category D of Scanlon's classification which belongs to the Fatimid period.[4]

BIBLIOGRAPHY: unpublished.

---

## PLATE 32

*Bowl. With modelled and sgraffiato decoration under a turquoise glaze. Found at Fustāt. Fatimid Egypt, eleventh or twelfth century. C.1052-1921*

*H. 13 cm, H. of foot 3.6 cm, Diam. of mouth 16.9 cm, Diam. of foot 8.5 cm*

The bowl is glazed on both the inside and outside except for the high ring base, which is left bare. The body was fragmentary and has been restored using a similar glaze and decoration. The body is modelled to create ribs in relief, while a band underneath the rim has sgraffiato decoration of stylized scrolls. The mouth has a rolled rim.

A bowl with sgraffiato decoration and a turquoise glaze datable to the eleventh century has been recovered in Fustāt.[5] Another vessel with both modelled decoration and a band of sgraffiato below the rim as in the V&A bowl but with a green glaze has been also recovered in Fustāt,[6] datable to the eleventh or twelfth century.

BIBLIOGRAPHY: unpublished.

---

## PLATE 33

*Vase with neck missing. Yellow earthenware with sgraffiato decoration and green glaze. Found at Fustāt. Fatimid Egypt, eleventh or twelfth century. 1777-1897*

*H. 13.5 cm, Diam. of mouth 10.7 cm, Diam. of foot 9.9 cm*

The vase has a small, unglazed ring base. The body is spherical with sgraffiato decoration of large, stylized round scrolls that form a typical large three-petalled flower, of Chinese origin. At the top of the body there are four small lug handles, and the uneven rim suggests a broken-off neck.

The four small rings suggest that the object was to be suspended, as a lamp or an incense or perfume burner. Alternatively,

they could have been added just as a decorative motif. A jar (albarello) of light red pottery with interlacing designs forming large round scrolls similar to this, also incised under a green glaze, is in the British Museum, found in Upper Egypt and datable to the twelfth century.[7]

BIBLIOGRAPHY: unpublished.

---

### PLATE 34a and b

Sa'd *bowl. Frit-ware painted in lustre on a white slip and transparent glaze. Said to have been found near Luxor. Fatimid Egypt, second half of eleventh century. C.49-1952*

*H. 10.4 cm, Diam. of mouth 23.5 cm, Diam. of foot 10.2 cm*

*Formerly in the Kelekian collection*

The bowl has a high cylindrical footring, convex sides and a slightly out-turned rim. According to Caiger-Smith the bowl does not have a tin-glaze, but a white clay slip, though the effect is very like tin-glaze.[8] Inside, framed by two broad bands, is painted a figure of what is traditionally called a "Coptic priest", carrying a lamp or possibly a censer suspended by chains in his extended right hand.[9] Traditionally, the object beside him, to the right, has been considered a cypress, but it has been suggested that this could be the representation of an *ankh*, or key of life cross, an ancient Egyptian hieroglyphic sign for life, which the Copts adapted to Christianity.[10] Scratches through the lustre are everywhere, forming spiral designs. These are very characteristic of the *sa'd* material as also seen in plate 35 (C.48-1952), plate 36a (C.1827-1921), and plate 36b (C.1792-1921). The gradation of colour in the lustre was caused by uneven heat in the kiln.

On the outside of the bowl a band of lustre is painted around the rim, and the inscription *sa'd* in Kufic characters is written twice, in reverse order (the first letter being the last one). Another piece, a fragment in the Islamic Art Museum in Cairo, has the word *sa'd* written in reverse order.[11] The reason for the reversal is obscure.

This is the only extant complete Fatimid lustre-painted bowl with Christian imagery. Another striking but fragmentary example is a sherd painted in lustre with the head of Christ surrounded with a cross-nimbus in the Museum of Islamic Art in Cairo.[12] Even if we need not accept Butler's suggestion that the inscription was the "attempt of a Copt in early Muslim days to render in Arabic the original Greek for prior or abbot",[13] the question must be posed as to whether such pieces were produced by Coptic potters.[14] It is now generally accepted that the inscription marks one of the several *sa'd* pieces. For a discussion on the meaning of the word *sa'd* see page 81.

A *bacino* of very similar shape, technique and style was found set into the façade of the church of San Sisto in Pisa, which was built and decorated between 1070 and 1133.[15]

BIBLIOGRAPHY: Kelekian 1910, pl. 6; Munich 1912, II, Tafel 92; Butler 1926, p. 54 and pl. XI; Lamm 1941, p. 50, pl. XVI,1; Lane 1947, pp. 22–3 and pl. 26A; Caiger-Smith 1973, p. 37 and pl. B; Fehérvári 1985, p. 105; Jenkins 1988, fig. 6; Contadini 1995, cat. no. 7.53; Jenkins 1997, cat. no. 273, pl. 417.

---

### PLATE 35

*Jar. Earthenware painted in lustre on a white slip and transparent glaze. Found at Fusṭāṭ. Fatimid Egypt, eleventh century. C.48-1952*

*H. 33 cm, Diam. of base 14 cm, Diam. of mouth 10.5 cm*

*Formerly in the Kelekian collection*

The jar has a low unglazed ring base. The body has a swelling/full jar-like shape, and a narrow neck. The mouth has an everted rim, which has been partially restored. The decoration consists of yellowish/copper lustre painted over a white opacified glaze forming, at the bottom, a band of interlaced ribbons in reserve (they are left unpainted and the contour has been lustre-painted); a larger middle band of heart-shaped leaves painted in lustre against the white background; a band all around the shoulder of the jar of five fish with details of parts of their body, fins, etc. scratched through the lustre. The space around the fish is filled with scrolls of leaves and palmettes; the neck is decorated with a band of triangles and a smaller one of dots. The fish may well be a Christian motif, and the repetition of stylized fish (and birds) is in the tradition of early Coptic textiles.

A very similar lustre-painted jar, but with completely abstract decoration, has been also found in Fusṭāṭ and dated to the first quarter of the eleventh century.[16]

BIBLIOGRAPHY: Munich 1912, II, Tafel 91; Kühnel 1925, fig. 71, p. 108; Butler 1926, p. 53, pl. XXV; Migeon 1927, II, fig. 332; Lane 1947, pl. 24; Caiger-Smith 1985, fig. 17; Hayes 1992, pl. on p. 111.

## PLATE 36a
Sa'd *fragment: part of the rim of a bowl. Earthenware with white slip, transparent glaze and lustre decoration. Found at Fusṭāṭ. Fatimid Egypt, eleventh or twelfth century. C.1827-1921*

*L. 6 cm*

On the inside the fragment has a white slip and transparent glaze and a golden/brownish lustre decoration that consists of a band of triangles around the rim; a band of lustre with spirals scratched through; a band with a pseudo-cursive inscription; and the beginning of another band of lustre with spirals scratched through. On the outside the fragment also has a white opacified glaze; a plain band of lustre covering the rim; another thin line of lustre and a fragmentary inscription of the word *sa'd* (part of the *s*, the *'* and part of the *d* are visible) in large Kufic letters.

A very similar fragment is found in the Benaki Museum in Athens, but the inscription consists of the word *al-yumn*, repeated.[17]

BIBLIOGRAPHY: Jenkins 1988, fig 24b.

## PLATE 36b
Sa'd *fragment: part of the rim of a bowl. Frit-ware (?) with white slip, transparent glaze and lustre decoration. Found at Fusṭāṭ. Fatimid Egypt, eleventh or twelfth century. C.1792-1921*

*L. 9 cm*

The fragment has an everted and broad rim, which forms an angle with the body. Immediately under the rim a horizontal fluting is modelled in a protruding curve. On the inside the fragment is decorated with white slip, transparent glaze and a rather dark/brownish lustre decoration that consists of cartouches on the rim containing the word *al-yumn* in Naskh within foliage; a band of lustre with triangles scratched through; and on the body interlocking white ribs forming rhomboid shapes filled with lustre with scratched decoration of spirals. On the outside the fragment is also covered with white slip and transparent glaze, and a plain band of lustre covers the rim. Part of the inscription *sa'd* (part of the *'* and *d* are visible) in large Kufic letters is found. Two

very similar sa'd fragments are found in the Benaki Museum in Athens.[18]

BIBLIOGRAPHY: Jenkins 1988, fig. 23a.

---

### PLATE 36c
Sa'd fragment of a vessel. Grey earthenware with white slip, transparent glaze and lustre decoration. Fatimid Egypt, eleventh or twelfth century. 1691-1897

L. 8 cm, W. 3.5 cm

The fragment is probably part of the body of a bowl. On the outside three horizontal flutings are modelled, producing three slight depressions. The inside is decorated with a golden/brownish lustre forming broad squares containing rhombs, in their turn containing roundels. The triangles formed by the rhombs at the corners of the squares are filled with scrolls. The outside has white slip, transparent glaze and a fragmentary inscription of the word sa'd (only the s remains) in broad Kufic.

BIBLIOGRAPHY: Jenkins 1988, fig. 23c.

---

### PLATE 37
Sa'd fragment (base) of a dish or bowl. Frit-ware with white slip, transparent glaze, bands of cobalt blue and lustre decoration. Found at Fusṭāṭ. Fatimid Egypt, eleventh century. C.1614-1921

H. 6 cm, Diam. 15 cm, H. of the foot 1.3 cm

The fragment retains the unglazed footring. The interior is decorated with six bands radiating from the centre, consisting of oval ribs containing straight lines with thin spirals, giving a floriated Kufic-like effect, in yellowish/light brown lustre. Two bands of cobalt blue painted under the glaze run across the fragment. The exterior is also covered with a white slip and transparent glaze down to the edge of the foot, which remains uncovered. A fragmentary inscription of the word sa'd in large Kufic letters is on the exterior (only part of the sīn remains). Similar fragments are found in the Benaki Museum in Athens.[19] Compare this fragment with one also found in Fusṭāṭ.[20]

BIBLIOGRAPHY: Lane 1947, p. 23; Jenkins 1988, fig. 24c.

---

### PLATE 38
Closed bowl. Frit-ware painted in lustre over a cobalt glaze with birds and hares. Fatimid Egypt, eleventh or twelfth century. C.114-1930

H. 7.1 cm, Diam. of mouth 7.6 cm, Diam. of foot 5.6 cm

The object is damaged, and the lustre decoration and glaze are partially lost. The bowl has a small ring base and a spherical body, and the mouth has a very lightly everted rim. The glaze does not cover the bottom part of the object and foot. The decoration around the body consisted originally of three birds alternating with three hares within roundels of foliage. Only two hares and three birds are now visible. The lustre has a brownish tone.

Although lustre on a cobalt blue glaze is more common in Syria during the twelfth and thirteenth centuries, the technique is also found in Fatimid Egypt. Compare for example the peacock bowl in lustre on blue opacified glaze in the Museum of Islamic Art in Cairo.[21]

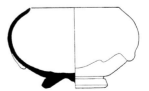

# NOTES

1.  See Scanlon 1974a, pl. XXXVI, fig. 10.

2.  See Kubiak and Scanlon 1973, figs 3 and 5, and p. 12 and note 7.

3.  See, for example, those in Scanlon 1974a, pl. XXXV, fig. 9; for lustre-painted filters see Olmer 1932, pl. A.

4.  Scanlon 1970a, p. 43, fig. 5; see also Olmer 1932, pls XXIX, XXX.

5.  Scanlon 1984, fig. 8.

6.  Scanlon 1984, fig. 57.

7.  See Hobson 1932, fig. 19.

8.  Caiger-Smith 1973, pl. B.

9.  Butler 1926, p. 54; Lamm 1941, p. 50. But for a lamp interpretation rather than censer see illustrations in Coptic manuscripts, Leroy 1974, pls 58, 63, 64.

10. Lamm 1941, p. 50; Caiger-Smith 1973, p. 37.

11. Bahgat and Massoul 1930, pl. XII.

12. Inv. no. 53971: Bahgat and Massoul 1930, pl. XXXII,2; Caiger-Smith 1973, fig. 17.

13. Butler 1926, p. 54.

14. See Caiger-Smith 1973, p. 37. In discussing this bowl Lamm 1941, p. 50, regards it as "reasonable to suppose that Sa'd was of Coptic origin; this Arabic name is known to have been in use among the Copts".

15. Lane 1947, p. 22.

16. Scanlon 1966, pl. XXIX, fig. 3.

17. Philon 1980, fig. 512.

18. Philon 1980, figs 502 and 516.

19. Philon 1980, figs 509–11.

20. Bahgat and Massoul 1930, pl. F,45 and 45 bis, 41.

21. Inv. no. 15575: Cairo 1969 cat. no. 116.

# 4: GLASS

## ORIGINS AND PRE-ISLAMIC TECHNIQUES

Glass production around the Mediterranean and in what were to become the central lands of Islam, Egypt, Palestine, Syria and Mesopotamia has a very long history. The earliest examples are glass beads made in imitation of precious stones dating from about 2500 BC, while glass vessels first appear in north Mesopotamia around 1500 BC, and glass-making is described on a cuneiform tablet of the fourteenth to twelfth centuries BC.[1] The Egyptian industry seems to start shortly after the Mesopotamian one, and from these two major centres the making of glass rapidly spread throughout the Near and Middle East and along the Mediterranean coasts, helped by the fact that the basic ingredients are widely found. These are silica, usually in the form of sand; soda or natron; and calcium, with lime often being added as a stabilizing substance which increases strength and durability.

The early techniques of glass-making (core-forming, mosaic glass, casting and mould-pressing) proved remarkably durable. Only one failed to survive into the early Islamic period, and some are still used today. The first consists of dipping a core of animal excrement mixed with sand or clay into molten glass paste. The glass that adheres to it is then smoothed by marvering (rolling it on a suitable smooth surface) and can be reheated and decorated by the addition of further pieces. The core is then broken up and extracted. The main drawback of this method is that the interior surface of the glass is never completely smooth and shiny, and only small objects can be made.[2] Mosaic glass is produced by fusing together pieces of monochrome or polychrome opaque glass and then shaping them around a core or form, while the casting process consists of pouring glass into moulds to form beads, amulets, inlays, statuettes, etc.[3]

The mould-pressing technique, which consists of pressing a mould into soft glass that has been poured on to the flat surface of a marver, was still being used during the Fatimid period,[4] for example for glass weights. Casting and mosaic glass, however, do not seem to have survived beyond the Abbasid period, while core-forming had disappeared even before the Islamic period, its demise brought about by the major innovation of glass-blowing, which had been introduced during the first century BC, possibly in the Syria–Palestine area.[5] Glass-blowing was

to prove a revolution that affected the industry in a way unmatched before the invention of power-driven machines for glass-making in the nineteenth century.

The furnace used in the Islamic period consisted of three parts: the lowest chamber for the fire (which needed to produce a temperature of at least 1100° C), the middle for the crucibles for the molten glass, and the upper for annealing, the process of gradual cooling whereby the thicker and thinner parts of the object are enabled to cool at a uniform rate. We do not have any visual representations of glass-makers from the early Islamic period, but there is a much later miniature from a Turkish manuscript datable to around 1582[6] in which a furnace is depicted as described, with a craftsman blowing through a pipe into an object placed on a marver. Remains of glass kilns have been found in Fusṭāṭ, probably of the fourteenth century, but it has been suggested that they are on the sites of earlier, Fatimid kilns.[7]

## EARLY ISLAMIC FINDS

Our knowledge of glass in the early Islamic era is entirely dependent on archaeological excavations or casual digs, and many more sites remain to be studied (and discovered). Some of the most important archaeological finds so far are those made at Samarra, in excavations which were begun by the Germans early in the twentieth century.[8] The range and quality of the material, which dates from the ninth to the tenth century, is very varied, as one would expect from the seat of the empire. The findings are, however, fragmentary, so that it is difficult to trace a coherent development of techniques, decoration and shapes. Another important site is Nīshāpūr, in eastern Persia, where fine examples of luxury glassware, again of the ninth and tenth centuries, were revealed by the American excavations carried out just before the Second World War.[9] To the same period belong the objects found in the excavations at Sīrāf (in the Persian Gulf), which was an important trade port.[10]

Much glass has also been found in North Africa and Islamic Spain, but a comprehensive study of it has only just started.[11] One basic problem here is to determine whether it was produced locally or imported from the eastern Mediterranean, Persia or Mesopotamia. Al-Maqqarī makes reference to ninth-century glass in al-Andalus (Murcia), but this may be interpreted as glass imported from Iraq.[12] However, according to recent archaeological finds it seems that glass was being produced by the end of the tenth century in Bajana/Pechina (north of Almeria), therefore providing evidence for glass-making in al-Andalus during the caliphal period.[13]

Of fundamental importance for the history of Islamic glass, and for Fatimid glass in particular, have been the excavations carried out at Fusṭāṭ by the American Research Centre in Egypt between 1965 and 1981.[14] They have produced a large amount of material, including domestic and luxury wares, ranging from the eighth to the eleventh century. An even more spectacular

archaeological achievement has been the recovery of the cargo of a ship wrecked off the coast of Turkey at Serçe Limani, near Bodrum,[15] consisting of many tons of broken glass, or glass cullet,[16] plus over eighty intact glass vessels from the living quarters at the bow and stern, presumably goods belonging to the merchants occupying these quarters. Further, an astonishing number of more or less complete vessels have been reconstituted from the tens of thousands of fragments of cullet examined by George Bass and his team. In addition, the ship contained Byzantine coins of Basil II (976–1025) and glass weights of the Fatimid Caliphs al-ʿAzīz (975–96/365–86), al-Ḥākim (996–1021/386–412) and al-Ẓāhir (1021–36/412–28),[17] which suggests that it sank some time during the second quarter of the eleventh century. Consequently, the glass probably dates from the first half of the eleventh century, for it seems unlikely that it would not have been of recent production, and given its date this extraordinary cargo thus provides additional evidence for Fatimid glass.

## EARLY ISLAMIC GLASS PRODUCTION

Because of its comprehensiveness, the Serçe Limani cargo also gives a general indication of the competence of Islamic glass-makers. It exhibits not only a wide range of shapes and types of vessel, bowls, bottles, glasses and beakers, but also a variety of decorative techniques, including pincered and moulded forms alongside finer pieces with wheel-cut designs.

As with ceramics, neither the mechanisms whereby such techniques were transferred nor the precise locations of the earliest Islamic sites of production have yet been fully established. There was still a glass industry in the Byzantine provinces of Syria and Egypt in the early seventh century, on the eve of the Arab conquest. Small flasks, often zoomorphic, and cosmetic bottles were produced in considerable quantities, but in general little is known of Egyptian and Syrian glass production during this period.[18] On the other hand, it has become clear from archaeological excavations in Persia and Mesopotamia that the glass industry flourished there without interruption into the Islamic period. Fine glassware, including cut-relief glass, was certainly being produced up to the sixth century, and in general the quality and range is superior to that produced in Egypt and Syria, so that it is likely that the greatest contributions to the development of glass production during the first three centuries of Islam came from Persia and Mesopotamia, which had undergone an artistic revival under the Sasanian emperors (third to seventh centuries), rivals of the emperors of Rome and their successors of Byzantium.

### Forms

These contributions concerned form as well as technique. Persian ewers with incised decoration of the eighth to tenth centuries,[19] for example, can be related

in form to Sasanian metal ewers (which, in their turn, can be traced back to a classical prototype). The same shape is also found among the eleventh-century glass of Serçe Limani,[20] and is very similar to that of a Fatimid cut-relief glass ewer found at Fusṭāṭ (fig.21)[21] and to that of Fatimid rock crystal ewers (for these and a discussion about origins see Chapter 1).

But the Islamic period is not just one of continuation: certain old forms and techniques are relinquished while new ones emerge. Thus the hemispherical bowl, so typical of the Sasanian period, gradually disappears, while innovations include mallet-shaped and bell-shaped flasks; and on the technical side mosaic glass is no longer produced while lustre painting assumes great importance.[22]

## DECORATIVE TECHNIQUES

With ceramics it is possible to think of a body to which various substances and processes may be applied (slip, paint, glaze, lustre), but in the case of early Islamic glass it is not so easy to separate the two: certain forms of decoration are, to pursue the analogy, integral to the body, and cannot be considered apart from the techniques that produce them. The most obvious are mould-blowing and pincering, but one may also place under the same rubric the introduction of colour into the glass.

### Cutting

Various aspects of glass cutting (especially cut relief) have already been discussed at some length in the chapter on rock crystal. One common technique, wheel-cutting, has been known since Roman times, and glass decorated with facet wheel-cutting is also characteristic of Sasanian ware.[23] This produces a honeycomb-like surface,[24] and wonderful examples include semispherical bowls and flasks.[25] The wheel-cutting technique continues well into the Islamic period, examples having been found in Iraq (Samarra), Persia (Rayy) and Egypt (Fusṭāṭ), datable to the ninth or tenth century.[26] But there are also new developments, one being a sophisticated type of wheel-cutting which gives a relief-carved effect: the vase in plate 43 provides an example from the Fatimid period. There are also smaller vessels exhibiting this technique, such as toilet bottles, either blown into a mould and then carved or directly carved on the wheel.[27]

Also attributed to Fatimid Egypt by some authorities and usually dated to the twelfth century is a group termed "Hedwig glasses", which are also characterized by wheel-cutting.[28] However, even though they have some motifs in common with known Fatimid pieces, they also contain stylistic features that mark them off as rather different, and an equally good case, especially in view of the fact that none of them has been found on Middle Eastern sites,[29] could be made for either a Byzantine or even a southern Italian origin.[30]

*Colour*

Coloured glass may be either transparent or opaque (to which latter the term 'paste' is often applied). Glass was coloured by the addition of metal oxides. For example, copper oxide, depending on the dosage, will give turquoise, transparent pale blue, dark green, ruby red or a dark opaque red, while cobalt produces a dark green. Manganese produces yellowish or reddish glass; antimony opaque yellow and opaque white; and iron pale blue and bottle green. Opaque coloured glass had been employed from the very beginning, and in the Roman period, as before, it was sometimes produced in imitation of semi-precious stones.[31] A number of fragments of this type from the Fatimid period have been recovered in Fusṭāṭ, some with, in addition, lustre-painted decoration.[32]

Of particular interest are the several examples of opaque turquoise glass. One coin-weight among the V&A glass weights belongs to the period of the Fatimid Caliph al-ʿĀḍid (r. 1160–71/556–67; plate 49: see discussion on the glass coin-weights below). A third example is a kohl bottle (used for make-up) with lustre-painted decoration datable to tenth-century Egypt.[33] A fourth, datable to around 1000/391, is an exceptional bowl, now in the treasury of San Marco in Venice[34] and almost certainly from the Fatimid treasury, even if its ultimate origin has still not been firmly established. It has a lobed rim in imitation of Chinese porcelain[35] and, around the body, hares cut in relief within a raised ridge. Within the footring there is an inscription in Kufic, also cut in relief, which has traditionally been read as "Khurāsān", a region of Persia, and the bowl has, accordingly, generally been ascribed either to Iraq or to Persia.[36] However, its weight and thickness differentiate it from known opaque turquoise glass objects from Persia,[37] which are invariably of rather thin and light glass; indeed, it could easily be taken for either real turquoise stone or pottery, and because of this the ingenious suggestion has been put forward that the inscription is a fraud, the bowl being a fake to be passed off as turquoise, which was chiefly mined in Khurāsān.[38] However, even the reading "Khurāsān" is by no means certain, and other readings have been proposed suggesting, rather than a place name, possibly a trade mark, as on ceramic pieces (for which see Chapter 3).[39]

The origin of this object thus remains unclear, and another possibility that needs to be considered is that it could be Egyptian. The reasons are technical and stylistic. Both the manner of carving and some of the decorative motifs recall cut relief glass and rock crystal objects of the Fatimid period.[40] (For the relationship between cut-relief glass and rock crystal, see Chapter 1.) Further, its "heavy" opaque turquoise glass may be compared with that of two fragments found in Fusṭāṭ which have a lustre decoration with typical Fatimid motifs, including on one elements appearing on *saʿd* ware.[41] Given the uncertainty about the inscription, the case for an Egyptian origin appears at least as strong as the others hitherto advanced.[42]

The colour range of Islamic opaque glass also included white, celadon, pale blue and pink. As with turquoise, such pieces could be decorated inside and out-

side with lustre paint and, sometimes, with gilding.[43] Fatimid opaque glassware was used alongside ceramics in imitation of porcelain.

As for transparent glass, the range exhibited by Islamic materials consists predominantly of blues, greens and purple. Fatimid vessels of this type occur with or without additional decoration in the form of, for example, lustre painting or marvering.[44]

### Trailing and marvering

Decorating glass with trailed threads, another technique known from antiquity, was popular in the early Islamic period. Molten threads, which could be of various colours, were trailed on the body after an initial blowing. The object was then sometimes reblown, causing the threads to become more firmly embedded in the body. Quite a few fragments with trailed decoration belonging to the Fatimid period have been recovered in Fusṭāṭ.[45]

A quite different effect could be attained by marvering trailing threads, thus creating a totally smooth surface with the threads fully integrated into the body.[46] Generally termed marvered glass, this type usually differs stylistically from glass with trailed decoration: the lines are normally separate horizontal rings, sometimes straight but often combed to produce pattern effects. Some fragments and a group of chess pieces with this form of marvered and combed decoration (and, possibly, gilding as well), have been attributed to the Fatimid period.[47]

*31.* Sandwich glass fragment (H. 6.7 cm; W. 4.4 cm) from Egypt, 10th century (?). 363/45-1900

### Sandwich glass

Another technique found in the Islamic period, if much more infrequently, is that of sandwich glass. This is a technique, widely practised during the late Roman period,[48] whereby gold-leaf decoration is embedded between two layers of glass. Two Islamic vessels are in the British Museum and the David collection in Copenhagen,[49] and two fragments, one from Egypt (fig.31) and one from Syria (fig.32), are in the V&A.[50] A new characteristic of these pieces is the introduction of decorative blobs of cobalt blue. The bowl in the David collection has a pseudo-Kufic band underlined by blue points in the style of Qur'āns of the ninth and tenth centuries, where the coloured points constitute the diacritical marks. Accordingly, the whole group has been assigned to this period, and attributed to Syria.[51]

*32.* Sandwich glass fragment (H. 3 cm; W. 4.5 cm) from al-Mina (Syria), 10th century (?). C.333-1937

### Cameo glass

An extension of cut glass is cameo glass. This is made by immersing the partially blown object, usually of transparent glass, into molten coloured glass. After blowing the whole into the wanted shape the coloured layer could be cut away, revealing the layer beneath, to form decorative patterns. This technique, known

from the first century AD, is rarely found in the Islamic period, but pieces are known to have been produced in Persia and Egypt during Tulunid and early Fatimid periods.[52]

## Mould-blowing

As mentioned above, this ancient technique, which still survives, was also used by Fatimid craftsmen (see plate 40). Its main attraction is that it was far easier to produce relief designs by this method than by relief-cutting, which was reserved for costly rarities demanding highly specialized skills. Indeed, blowing the gather into a mould of metal or pottery made mass production possible, so that moulded vessels could be a cheap substitute for the more expensive cut glass. It was evidently a speciality of Egyptian craftsmen, given the quantity of such vessels that has been found at Fusṭāṭ,[53] including a bowl and a fragment with the inscription "made in Miṣr".[54] But it was also used in Persia and Mesopotamia,[55] and pottery moulds datable to the tenth century have been found in the Mesopotamian area.[56]

## Pincering

A technique widely found in Egypt in the Islamic period, this consists of creating decorative patterns by pincering the surface of the vessel while still hot and pliable (plates 41 and 42). This technique is possible only in open vessels where any distortion in the wall can be subsequently be corrected by reheating and reworking. A range of pincered glass vessels of various dates has been recovered at Fusṭāṭ,[57] including cups and vases, but the technique seems to have been used most frequently on cups, both with and without handles. The type of decoration is usually geometric (roundels, triangles, dots, etc.),[58] but occasionally figurative, as in the case of a cup from Egypt where a series of small birds have been pincered around the body.[59]

## Lustre

Lustre-painted glass,[60] the final category to be considered, is found in some quantity during the Fatimid period. The technique employed is practically identical to that for lustre-painted pottery, and it may be assumed that the same craftsmen were involved and the same kilns used.[61] However, the two do not appear at the same time, lustre on glass predating that on ceramics, which appears for the first time in an Islamic context (Samarra). Lustre painting on glass, it has been suggested, was employed in Egypt well before the Islamic period, from the fourth or fifth century AD (see Chapter 3).

In the early Islamic period lustre painting on glass is usually polychrome, combining brownish, yellowish and often reddish tinges, which were produced by a combination of copper and silver oxides in different dosages.[62] But by the

*33.* Lustre-painted glass fragment (H. 5 cm; W. 5.9 cm) with the word *saʿd*, Fatimid Egypt, late 10th–early 11th century. Benaki Museum, Athens: 3507

tenth century monochrome lustre (within the same colour range) had come into fashion and, in a development parallel to that taking place with ceramics, it was to replace polychrome lustre completely during the Fatimid period.

Such monochrome lustre decoration was applied to both transparent and coloured glass. On transparent glass, most of which has a greenish tinge, it generally has a dull brownish shade, having lost (or never acquired) the sheen peculiar to lustre (see plate 44). During the Fatimid period this sort of painting was generally applied to one side of the glass only, not to both sides as had been the rule previously. Typical devices are spiral scrolls, rosettes, star motifs formed by interlacing polygons and ornaments derived from Kufic letters.[63] But figurative motifs are also found, generally close to those on contemporary lustre ceramics, including human figures (plate 46) as well as animals.[64]

Numerous fragments of opaque and transparent coloured glass with lustre decoration have been recovered from a number of sites, including Fusṭāṭ.[65] Among the latter the majority belong to the Fatimid period.[66] In the lustre ornament patterns on the manganese violet (purple) glass, birds or hares predominate (as in plate 47a), painted in a style corresponding to that of lustre pottery of the same period. One example of this glass is with the word *saʿd*[67] (see discussion in Chapter 3),[68] fig.33. Other examples in the V&A have floral decoration (plates 45 and 47b). Unlike the clear transparent glass, with this type of glass different hues of lustre, when hit by the light, appear in all their brilliancy, giving either a silver (plates 45 and 47a) or gold (plate 47b) appearance to the decoration.

The dating of early Islamic glass is beset by the same difficulties that we have seen with ceramics. However, there are at least three published pieces of lustre-painted glass of the Islamic period which are dated or precisely datable: the earliest is the goblet found in Fusṭāṭ with an inscription containing the name of an Egyptian governor who served in 772/156.[69] The other two are a fragment bearing the date 163 (AD 779),[70] and a Fatimid fragment found at Fusṭāṭ, dated 391 (AD 1000), and bearing an inscription according to which it was made by ʿAbbās ibn Nuṣayr ibn Abī (?) Yūsuf Jarīr (?) ibn Saʿīd al-Ṭalawī, from the Egyptian town of Ṭala.[71]

In conclusion, in the early period of Islamic glass-making, which includes the Fatimid, we find both the retention of several ancient techniques and, as far as decoration is concerned, a considerable degree of experimentation. Inevitably, there are differing preferences: sandwich glass is extremely rare, while mould-blowing becomes more common, as does thread trailing. But the most significant change on the decorative side was the development of lustre painting. The major innovation of the post-Fatimid period was to be the discovery (or, more precisely, rediscovery) of enamel decoration, at first imitating the wavy effects of marvered and combed decoration before developing along more individual lines during the Mamluk period.

## NOTES

1. See Tatton-Brown and Andrews 1991, p. 22 and pl. 16. The cuneiform tablet is in the British Museum: see Tait 1991, pl. 2.
2. Ancient Egyptian small glass bottles and flasks made with this technique are found at the V&A: for example inv. no. 1011-1868, Egypt 1400–1336 BC: Liefkes 1997, pl. 9. See also Tait 1991, pls 20–31, for examples in the British Museum.
3. Examples of cast and mosaic glass are found in the V&A: Liefkes 1997, pl. 6 (cast, inv. no. 422-1917) and pl. 5 (mosaic, inv. no. 969-1868). For other examples from the British Museum see Tait 1991, pls 38 (cast), 53, 56–61 (mosaic).
4. For early Islamic examples of mosaic glass see fragments found at Samarra: Lamm 1928, Tafel VIII and IX; also a piece in the British Museum for which see Pinder-Wilson 1991, pl. 156.
5. The earliest fragments have been found in Jerusalem: see Tatton-Brown 1991, p. 62.
6. The *Sūrnāme-i humāyūn*, Istanbul, Topkapi Sarayi Museum, H.1344, fol. 33r. For a colour reproduction of the illustration in question see Pinder-Wilson 1991, pl. 136.
7. Scanlon 1967 and 1981.
8. Lamm 1928.
9. Hauser, Wilkinson 1942; Kröger 1995.
10. Whitehouse 1968.
11. See Cressier 1993, where a bibliographical summary on the subject is given at p. 75.
12. Gómez-Moreno 1951, pp. 341–4.
13. For Bajana/Pechina see Castillo Galdeano, Martínez Madrid and Acién Almansa 1987; for Murcia see Navarro Palazón and García Avilés 1989; for production of glass during the caliphal period see also Pérez Higuera 1994, pp. 53–4.

14. See Scanlon's reports in bibliography to Chapter 3.
15. Bass and van Doorninck 1978; Bass 1984; Bass *et al.* 1988; Bass 1996, pp. 37–53.
16. Cullet was often used as an addition to the batch to speed up the melting and economize, as it recycled the waste from the glass house.
17. Bass and van Doorninck 1978, p. 126.
18. For examples of this material see Jenkins 1986, pls 1–3.
19. Lamm 1929–30, Tafel 56,3–4, from Persia or Iraq and Egypt, eighth or ninth century. For incised glass see al-'Ush 1971.
20. Bass and van Doorninck 1978, fig. 17.
21. Pinder-Wilson and Scanlon 1973, p. 25, figs 30–2.
22. A Sasanian hemispherical bowl with honeycomb decoration is in the V&A, C.58-1963, datable to the fifth or sixth century; for one in the British Museum see Pinder-Wilson 1991, pl. 138; for examples of the early Islamic period, seventh or eighth century, see *SPA*, VI, pl. 1440B; Lamm 1929–30, Tafel 54,4–5. A mallet-shaped bottle is in the V&A, inv. no. C.20-1965, possibly from Persia, datable to the tenth century: Liefkes 1997, pl. 29. For mallet-shaped and bell-shaped examples from Persia in the British Museum see Pinder-Wilson 1991, pls 141, 152.
23. For an example of honeycomb pattern produced on the wheel on a jug of the first or second century AD see Tait 1991, pl. 97.
24. As one in the V&A: see note 22.
25. See note 22. For a flask in the Corning Museum of Glass see Charleston 1990, no. 24, pp. 64–5.
26. For examples from Samarra see Lamm 1928, Tafel V; from Rayy see Lamm 1935,

pls 30–9; from Fusṭāṭ see Lamm 1929–30, Tafel 59, also Scanlon 1974, fig. 11b.

27. For examples from Egypt see Lamm 1929–30, Tafel 59 and 62.

28. For the problems of attribution see Gray 1972.

29. For one Hedwig glass found in the fortress of Coburg and considered of Fatimid production see Kohlhausen 1967.

30. See Kühnel 1925, fig. 142, p. 176; Lamm 1929–30, Tafel 63; Pinder-Wilson 1991, pp. 126–28.

31. See, for example, Tait 1991, pl. 58.

32. Lamm 1941, pp. 38–9 and 44; Bahgat and Massoul 1930, p. 40.

33. In the Metropolitan Museum of Art in New York (inv. no. 10.130.2649): Jenkins 1986, pl. 21.

34. Inv. no. 140. See Erdmann 1971, no. 117; British Museum 1984, no. 29. The bowl was mounted in Europe with Byzantine gold plaques of the late tenth century on the inside of the rim, and Byzantine enamelled plaques of the eleventh century, alternated with ca. fifteenth-century filigree plaques, on the outside.

35. Imitation of Chinese ware is a well-known phenomenon in Fatimid Egypt: see Chapter 3.

36. An attribution to Fatimid Egypt was however put forward by F.R. Martin: see discussion in Lamm 1929–30, Tafel 58,23. For an historical account on a turquoise bowl which could or could not be identified with the San Marco bowl see Shalem 1993-95.

37. One example is in the V&A, C.134-1936, Persia, twelfth or thirteenth century; for another example see also *SPA*, VI, pl. 1445B.

38. Lamm 1929–30, Tafel 58,23; also Lamm 1941, p. 38, note 5, who suggests that the bowl could have been made in Baghdad; the same view is shared by Pope in *SPA*, III, p. 2597; VI, pl. 1444A.

39. Rogers 1994, p. 138.

40. Pinder-Wilson 1991, pl. 147.

41. For these fragments from two bowls of turquoise glass with lustre decoration see Lamm 1929–30, Tafel 45,4 and 5, now in the Museum of Islamic Art in Cairo, datable to the eleventh century. For the lustre-painted aubergine glass fragment with the word *sa'd* see discussion in Chapter 3, note 92 and fig. 33.

42. Whereas I was able to handle the Venice bowl and the V&A Persian cup, together with other Persian fragments of opaque turquoise glass, for the Cairo fragments I have to thank Michael Rogers who himself handled them.

43. Lamm 1941, p. 44.

44. For Samarra lustre and marvered fragments see Lamm 1928, Tafel VIII. For marvered glass see Allan and Henderson 1995.

45. For Fatimid examples see Lamm 1929–30, I, p. 78, II, Tafel 21,4, 11–13; I, p. 82, II, Tafel 24,1–3; I, p. 84, II, Tafel 25,16–22; I, pp. 85–6, II, Tafel 26,2, 5, 15–16.

46. For a comprehensive study on marvered glass see Allan and Henderson 1995.

47. Lamm 1929–30, I, p. 96, II, Tafel 29,2; I, p. 99; II, Tafel 30,6-7, 11–12; I, p. 101, II, Tafel 31, 5; I, p. 102, II, Tafel 32,4. The chess pieces are in Cairo, Islamic Art Museum: Lamm 1929–30, I, pp. 101–2, II, Tafel 31, 8–16; a King or Queen in the Metropolitan Museum of Art in New York, inv. no. 1972.9.3;21: Jenkins 1986, pl. on p. 52; two Pawns in the Freer Gallery of Art in Washington, inv. nos 09.779, 09.980: Ettinghausen 1962, figs 69, 70; Contadini 1995, appendix I, no. 8 and note 83.

48. See, for example, the medallion in the V&A (inv. no. 1052-1868): Liefkes 1997, pl. 19. See also Tait 1991, pl. 123.

49. For the bottle in the British Museum see Pinder-Wilson 1991, pl. 155; for the fragmentary bowl in the David collection see von Folsach 1990, pl. 231.

50. Inv. no. 363/45-1900 (from Egypt) and C.333-1937 (from al-Mina, Syria). This also shows, like the pieces in the British Museum and David collection, several dots of blue enamel: Lane 1938, p. 71, where he attributes the al-Mina piece to the late twelfth century; Honey 1946, p. 46.

51. Pinder-Wilson 1991, pp. 123–4, pl. 155.

52. Lamm 1929–30, I, pp. 162–3, II, Tafel 60,1–2, 9. Also, for a bottle with the figure of a hare in green glass against transparent glass in the British Museum, attributed to Fatimid Egypt, see Pinder-Wilson 1991, pl. 148.

53. See examples in Scanlon 1974, pl. IVa.

54. The complete vessel is now in the Islamic Art Museum in Berlin: see Kröger 1984, no. 69; the fragment is in the Benaki Museum in Athens: Clairmont 1977, p. 46, no. 128, pl. IX.

55. For examples in the British Museum see Pinder-Wilson 1991, pls 151–2.

56. Lamm 1929–30, Tafel 13.

57. Scanlon 1974, fig. 4, datable to the ninth century; Lamm 1929–30, Tafel 19,10–11 (Egypt, ninth and tenth century).

58. Another cup of this type with pincered geometric decoration, possibly from Persia, ninth or tenth century, is in the V&A, C.571-1925: Lamm 1929–30, Tafel 18,16.

59. Lamm 1929–30, Tafel 19,10: Egypt, tenth century.

60. For a discussion of the chemical aspects of lustre painting on glass see Brill 1970.

61. Lamm 1929–30, I, p. 126, II, Tafel 45,4–5. See also discussion in Chapter 3.

62. Among the V&A fragments see, for example, C.17-1934, datable to the eighth century. See also the bowl in the Metropolitan Museum of Art in New York (inv. no. 1974.74), datable to the eighth or ninth century: Jenkins 1986, pl. 20.

63. As in two bowls in the British Museum: Lamm 1929–30, I, p. 116, II, Tafel 37,9–10, no. 9 having been found at Aṭfīḥ.

64. For fragments found in Fusṭāṭ with animals see Lamm 1929–30, Tafel 37,1–2.

65. See Lamm 1941, pp. 21–2.

66. Baghat and Massoul 1930, p. 40.

67. Lamm 1941, pl. XVIII,1.

68. For other examples found in Egypt see Lamm 1929–30, Tafel 40.

69. Scanlon 1966, p. 105, fig. 15; Pinder-Wilson and Scanlon 1973, pp. 28–9, figs 40–2; Hayward 1976, no. 119.

70. In the Museum of Islamic Art in Cairo. The date is in Coptic numerals: see Yūsuf 1972, where, however, the piece is not illustrated.

71. Cairo, Islamic Art Museum: Lamm 1929–30, I, p. 117, II, Tafel 39,5.

# GLASS IN THE V&A

## PLATE 39
*Jug. Transparent glass. Egypt, tenth or eleventh century. 338-1900*

*H. 13.0 cm, W. 8.7 cm*

*Bought from the Myers collection*

The jug is in plain, transparent glass with a yellowish tinge. It has a bulbous body and a conical flared neck. The right-angled handle, attached to the body, has a small thumb-rest in the form of a disk. This shape, a simple water jug, is found also in metalwork and ceramics.[1] Such jugs in clear transparent glass, with or without decoration, are generally ascribed to Egypt or, if to Persia, on Egyptian models.[2] A similar clear glass jug has been found among the eleventh-century glass from the shipwreck at Serçe Limani.[3]

BIBLIOGRAPHY: unpublished.

## PLATE 40
*Mould-blown bottle. Clear, pale manganese-coloured glass, with decoration of disks in slight relief with a central round depression. Egypt, ninth or tenth century. 350-1900*

*H. 16.6 cm, W. 9.7 cm*

*Bought from the Myers collection*

The bottle has a very low and narrow base with a pontil mark, a globular body and a long narrow neck. The shape is found in the early Islamic period in Persia and Egypt, with examples from the ninth to the twelfth century.[4] The mould-blowing technique in this piece is of a very high standard. The decoration seems to be derived from the wheel-cut relief disks found in similar bottles of Persian production.[5] A similar mould-blown bottle is in Berlin, attributed, however, to ninth- or tenth-century Persia.[6]

BIBLIOGRAPHY: unpublished.

## PLATE 41
*Cup. Green glass with pincered decoration. Egypt, ninth to eleventh century. C.28-1932*

*H. 11.4 cm, Diam. 11.5 cm*

The cup has a pincered or tonged decoration forming a series of ovals just below the rim. An annular handle is attached.

A similar cup with an annular handle (but not decorated) has been recovered from the eleventh-century Serçe Limani shipwreck.

BIBLIOGRAPHY: Brooks 1975, illustrated on p. 4; Liefkes 1997, pl. 27.

## PLATE 42
*Shallow bowl. Pale manganese-coloured glass with pincered decoration. Egypt (or Syria?), tenth century. C.157-1936*

*H. 3.2 cm, W. 10.2 cm*

*From the Wilfred Buckley collection*

The bowl has a low foot and a pincered decoration forming a series of six-petal rosettes just below the rim, a style often found at Fustāṭ. A somewhat similar footed bowl, attributed to ninth- or tenth-century Egypt, is in Berlin, but with a moulded rather than pincered decoration.[8]

BIBLIOGRAPHY: unpublished.

PLATE 43

*Vase. Yellowish-green glass with wheel-cut decoration. Egypt, eleventh century. C.29-1932*

*H. 14.7 cm, W. 7.8 cm*

The vase has a deep outward curving foot, a round body and a tall, flaring but relatively narrow neck. The transparent yellowish-green glass is rather thick, and it has been cut to create drop motifs on the body and rectangular panels of four-sided facets on the neck encircled by two cut lines. Around the top of the body, but below the neck, are two cut-relief ribbons.

Necks of comparable bottles cut on the wheel with similar decorative motifs have been found in Persia, datable from the second half of the ninth to the early tenth century,[9] and in Egypt, datable to the ninth to eleventh centuries.[10] A very similar bottle has also been found among the eleventh-century glass of the shipwreck of Serçe Limani.[11]

BIBLIOGRAPHY: Honey 1946, pl. 13H.

PLATE 44

*Lustre-painted bowl. Egypt, eleventh or twelfth century. C.23-1932*

*H. 7.7 cms, W. 12.9 cms*

Greenish glass painted inside in brown lustre pigment with a band of panels with drop-like ornaments separated by strips of arabesque motifs; in the bottom a conventional flower. Domed base.

The bowl belongs to a group of bowls with similar shape and decoration, such as two in the British Museum.[12] The stylized scroll decoration is characteristic. A similar bowl, with similar lustre decoration, has been found in Egypt, also datable to the eleventh or twelfth century.[13]

BIBLIOGRAPHY: Ashton 1932, pl. B; Honey 1946, pl. 16A.

PLATE 45

*Fragment of a bowl. Purple glass with lustre-painted decoration.*

*Found in Egypt. Egypt, eleventh or twelfth century. C.16-1934*

*H. 5.9 cm, W. 6.0 cm*

The olive-coloured lustre, derived from copper oxide, is used both for the large arabesques in the centre and for the two bands around the rim.[14]

BIBLIOGRAPHY: Honey 1946, pl. 16E.

PLATE 46

*Fragment of a bowl or beaker. Clear glass with lustre-painted decoration. Found in Egypt. Egypt, eleventh or twelfth century. C.51-1934*

*H. 3.6 cm, W. 2.1 cm*

The lustre-painted decoration consists of a face and scrolls. The style of drawing of the head relates to lustre-painted pottery of the Fatimid period in Egypt, as a very similar

example found in Fusṭāṭ, datable to the twelfth century, demonstrates.[15]

BIBLIOGRAPHY: Honey 1946, pl. 16E.

---

## PLATE 47a

*Fragment of a dish or bowl. Purple glass with lustre-painted decoration. Egypt, eleventh or twelfth century. C.116A-1947*

*H. 7.7 cm, W. 5.0 cm*

*Gift of W.L. Hildburgh*

Middle of dish or bowl. Painted in pale silver-looking lustre with a bird with complex collar and wing markings with its back to branching foliage.

In the group of manganese violet (purple) glass the lustre ornamentation has patterns in which birds or hares predominate, painted in a style corresponding to that of lustred pottery of the same period. One exampe of this glass is with the word *sa'd* (fig.33).[16] Another close example was found in Fusṭāṭ datable to the same period.[17]

---

## PLATE 47b

*Fragment of a dish or bowl. Purple glass with lustre-painted decoration. Egypt, eleventh or twelfth century. C.116H-1947*

*H. 4.0 cm, W. 3.5 cm*

*Gift of W.L. Hildburgh*

Purple glass painted in gold-looking lustre with coiled stems forming medallions.

BIBLIOGRAPHY: Honey 1946, pl. 16E.

---

# NOTES

1  For a metal example see Fehérvári 1976, no. 8, pl. 3b (ninth or tenth century). For an unglazed pottery example, see Bass and van Doorninck 1978, fig. 10; for a lustre-painted pottery example see *SPA*, V, pl. 576B (tenth or eleventh century).

2.  See Lamm 1929–30, Tafel 18, 13 and 17; *SPA*, VI, pl. 1442D.

3.  Bass and van Doorninck 1978, fig. 18.

4.  Lamm 1929–30, Tafel 12, 21. See also a bottle in the British Museum, which, however, has a cameo decoration: Pinder-Wilson 1991, pl. 148.

5.  See, for example, the bottle in the Iran Bastan Museum in Tehran, dated from the ninth to the thirteenth century: Pinder-Wilson 1976, fig. 122.

6.  Kröger 1984, no. 112.

7.  See Jenkins 1986, pl. at p. 9.

8.  Kröger 1984, no. 69.

9.  Lamm 1935, pl. 33; *SPA*, VI, pl. 1442B.

10.  Lamm 1929–30, Tafel 59.

11.  Bass and van Doorninck 1978, fig. 13c.

12.  Lamm 1929–30, I, p. 116, II, Tafel 37, 9–10.

13.  Now in the Islamic Art Museum in Berlin: Lamm 1929–30, I, p. 109,4, II, Tafel 34,4.

14.  This piece was considered to be of ruby glass by Honey 1946, p. 45, but this seems not to be the case. However, the piece has not yet been analysed.

15.  Scanlon 1965, frontispiece pl. i.

16.  In the Benaki Museum in Athens: Lamm 1941, pl. XVIII,1; Philon 1980, p. 176.

17.  Lamm 1929–30, Tafel 45,7.

# GLASS COIN-WEIGHTS

A.H. MORTON

The V&A possesses a few dozen medieval glass pieces with legends stamped on them in Arabic, most of which are known to have been manufactured in Egypt. Most of them are small disks, and in the collections disks bearing the names of the Fatimid caliphs are usually plentiful. The Museum's small collection has thirty or so of these in various states of preservation. The series of stamped glass objects as a whole extends over the greater part of a millennium, from around AD 700 to, probably, the fifteenth century. The earliest, Umayyad, sub-series itself represents a continuation of Byzantine practice.

When the disks with Arabic legends came to the attention of European scholars it was at first conjectured that they might be a kind of token currency. However, in a study appearing in 1847, Castiglioni pointed out that on some early specimens the legends clearly state that they are weights for particular denominations of coinage; he also described a few examples of Fatimid disks with less explicit legends, and noted that their weights corresponded to those of some of the earlier types. He concluded therefore that such glass disks were in fact coin-weights.[1] Some of the details of his exposition can now be seen to be incorrect. In particular, he took the weight standard of the Islamic gold dinar to be the same as that of the Byzantine solidus, which is in fact heavier, and had to argue that the discrepancy shown by the glass dinar weights was due to their being worn. In 1873 E.T. Rogers, unaware of Castiglione's work, published an article in which he reached similar conclusions by similar arguments.[2] By this time, however, the weight-standard of the Islamic dinar introduced in the currency reform of the Umayyad Caliph 'Abd al-Malik was correctly known to be close to 4.25 g. Arabic sources had also become known which stated that the Islamic silver dirham weighed seven-tenths of the gold dinar, giving a dirham of 2.97 g. Relatively recently it has been noticed that the early dirhams and coin-weights do not support this and that the dirham standard of the initial reform must have been lighter. Nevertheless, there is no doubt that at some later stage a standard of ca. 2.97 g for the dirham was introduced and widely used. The standards in use under the Fatimids for dinars and dirhams were close to these figures, though they may have been slightly lower part of the time.[3]

Confirmation that the Fatimids did use glass coin-weights soon became available with the discovery of the late-tenth-century description of the Islamic world by Muqaddasī. He was a native of Jerusalem and lived through the period when Egypt and Syria were conquered by the Fatimids. In describing the coinage and weights of the Fatimid realm, he informs us that glass coin-weights (*sinaj*) stamped (*maṭbūʿ*) with the name of the caliph were used.[4] The Fatimids were in fact familiar with glass coin-weights before their arrival in Egypt, for

specimens are known which were issued by them in the Maghrib early in the tenth century. It is also worth noting that there appears to be a gap in the official issue of glass weights of any kind in Egypt itself from late in the ninth century until after the arrival of the Fatimid armies in AD 969. It is possible, and Muqaddasī's notice lends some support to this, that the practice of officially issuing glass coin-weights was reintroduced into Egypt by the Fatimids.

Students of the subject have occasionally proposed other explanations for the Fatimid disks. It is true that in the corpus of stamped glass disks now available there are some types, though none so far identified as from the Fatimid period, which the metrological evidence shows not to have been weights.[5] In the 1890s, Casanova, who was certainly mistaken to say that the weights of the disks with the names of the Fatimid caliphs were very variable, argued that they were some kind of talisman or charm.[6] He was led to this conclusion largely it would seem by a description given by the fifteenth-century Egyptian chronicler Maqrīzī of the discovery made in the year 1433/837 among ruins in a settlement in the Delta of a large number of objects made of glass (*zujāj*) with the names of a series of Fatimid caliphs written (*maktūb*) upon them.[7] Maqrīzī's report of the find came from an eye-witness but it is not easy to know quite what was found. However the term used to describe them is read, it is an uncommon word. In the edition of Maqrīzī it appears as *'idādāt*. Among the meanings of *'idād* given in dictionaries is that of amulet, often specified, for instance, in Lane's *Dictionary*, as one tied to the upper arm (*'adud*). Recognizing that the disks lacked suspension holes Casanova inclined to prefer the reading *ghadārāt*, found in a manuscript of Maqrīzī in Paris. For *ghadāra* he gave the meaning 'clay amulet which protects against the evil eye'. This occurs in the dictionaries, usually under *ghadār* rather than *ghadāra*, though some of the Arabic lexicons used by Lane, for instance, again specify that it is attached to the arm. The other difficulty with this of course is that clay is not glass. And the connection with clay is strong: the primary meaning of *ghadār* is a certain type of clay; *ghaddār* and *ghadā'irī* mean 'potter'. Further speculation is possible. *'Idād* may mean armlet, or even bracelet, and glass bracelets were produced in medieval Egypt. Alternatively, *ghadāra* may mean a large bowl or dish, though the etymology implies that such vessels would be of pottery. The one attractive point of Casanova's theory is that except for the disks no other series of glass objects is yet known to bear the Fatimid caliphs' names. But even if the find was of the glass disks, Maqrīzī's description, coming so long after its deposit and offering such difficulties of interpretation, tells us nothing certain about their function.

More recently Jungfleisch and, at much greater length, Balog, though accepting that some of the Fatimid disks were weights, have argued that some of them may have been, or were, token currency, reviving, though only within certain chronological limits, the theory current in the early nineteenth century.[8] Balog maintained that during the reign of al-'Azīz (975–96/365-86) the disks came to be used in this way rather than as weights and that this remained the case for the rest of the Fatimid period and subsequently under the Ayyubids. His

main arguments, based on what he saw as the unexpectedly large number of surviving coin-weights from the later Fatimid period and discrepancies between the denominations of the weights and of the coins, rest on assumptions about survival rates and the manner in which coin-weights were employed which, as Bates has shown, can be countered.[9] The chief points in favour of accepting that the disks are weights would seem to be: the statement of Muqaddasī, the metrological data showing the same pattern of denominations throughout the Fatimid period and the complete lack of any mention of glass money, which would have been a most unusual phenomenon.

Precisely how the weights were used remains to some extent debatable but a high proportion of surviving specimens fall into two groups, one connected to the standard of the gold dinar and one to that of the silver dirham. Beside actual dinar weights those for double dinars and quarter dinars are found. The dirham series, which is much more common, is represented by double dirhams, dirhams, half dirhams, quarter dirhams and one-eighth dirhams. There is also evidence of a denomination weighing ca. 1.70 g, which still needs explanation.

The legends were stamped on the disks with a die, which may be presumed to have been of iron.[10] In some cases, such as plates 48a–c below, a second die impression appears on the reverse. As on Fatimid coins, a plain Kufic script is used in the earlier period and more ornamental ones later. There is some variety in the legends, which may include a date, but for the most part the obverses bear a selection of the names and titles of the Caliphs. The most common reverse legend consists of the Muslim profession of faith, in the form used by the Shī'ītes, among them the Ismā'īlīs: "There is no God but God. Muḥammad is the Prophet of God. 'Alī is the Friend of God." Most are translucent, rather than truly transparent. Green is the most common colour but others, for instance blue, pink and brown, also occur. Specimens are also found, becoming plentiful towards the end of the period, made of glass that is opaque in normal light (see plate 49). Turquoise and white are the most usual colours for these.

The pieces described below are a selection from among the best preserved in the V&A. References here are to Balog, "The Fātimid glass jeton".

## NOTES

1. Castiglioni 1847. Castiglioni also first identified the two other main categories of Islamic glass stamps: larger weights used in ordinary commercial transactions, and vessel-stamps, which were applied to glass measures of capacity. Neither of these types appears to have been in use in the Fatimid period. However, multiple coin-weights made of glass have since become known, some of which are official Fatimid issues. On these last see Jungfleisch 1929, pp. 61–71 and Morton 1985, pp. 20–1.

2. Rogers 1873, pp. 60–88.

3. The evidence requires closer examination on this point. The contemporary testimony of Muqaddasī indicates fractionally lower standards for both dinar and dirham in the later tenth century, with the former standing at ca. 4.19 g. See Bates 1981, pp. 74–5, 90, and, for Muqaddasī, the next note.

4. Muqaddasī 1906, p. 240. The first edition came out in 1877.

5. See Morton 1985, pp. 25–6.

6. Casanova 1893, pp. 353–9. Casanova

used the word *amulette*, but he was aware that an amulet is normally attached in some way to its owner's body and that there was no obvious way of attaching the disks. He stated that he did not mean this. Another point that must have made the amulet theory attractive to him was that he misattributed a group of eighth-century coin-weights issued in the name of "the House of Muḥammad" to the Fatimids, who claimed to be descendants of the Prophet Muḥammad, and thought they were already provided with glass coin-weights. On the types of "the House of Muḥammad" see Morton 1985, p. 82–3.

7.  Maqrīzī 1853, I, p. 181.
8.  Jungfleisch 1952, pp. 359–74; for Paul Balog's views see in particular the introduction to his extremely valuable corpus of the Fatimid pieces, 1971-2, pp. 175–264 and 1973 pp. 121–212, and his subsequent article, 1981 pp. 93–109.
9.  Bates 1981, pp. 63–92.
10. Evidence that the dies used for official weights and other stamps in the eighth century AD were made of iron is given in Matson 1948, pp. 39–43.

## GLASS COIN-WEIGHTS IN THE V&A

### PLATE 48a
*Al-Ḥākim. Green, with surface decay and iridescence; Diameter 2.8 cm; Diameter of die 1.6cm; weight 5.72g (double-dirham standard). Balog, type 119; from the same dies as Balog 119.2. 360/2-1900*

*Obverse*: three-line legend within border of pellets:

*Al-Ḥākim / bi-amr allāh / 'adl*

الحاكم
بامر الله
عدل

The final word *'adl*, meaning justice, appears quite often from the time of the Qur'ān onwards in contexts where equity in commercial dealings is concerned.

*Reverse*: three-line legend within plain circular border, giving the Shī'īte confession of faith:

*Lā ilāh illā allāh / Muḥammad rasūl allāh / 'Alī walī allāh*

لا اله الا الله
محمد رسول الله
علي ولي الله

### PLATE 48b
*Al-Ḥākim and his heir apparent. Green; 1.6cm; die 1.0cm; 1.46g (half-dirham standard). Balog type 149, probably from die of Balog illustration 149.3. 360/12-1900*

*Obverse*: two-line legend:

*Al-Ḥākim / wa walī 'ahduhu*

الحاكم
و وليعهده

*Reverse:* traces of legend, probably the Shī'īte profession of faith, within a dotted circular border.

The heir apparent (*walī 'ahd*) referred to is 'Abd al-Raḥīm b. Ilyās, a distant cousin of the eccentric al-Ḥākim who appointed him heir in 1013/404 and gave him extensive powers. His name is also found on coins following that of the Caliph. At al-Ḥākim's disappearance, however, he was imprisoned by the former's sister who arranged for the succession to pass to her brother's son, who became the Caliph al-Ẓāhir. The glass pieces on which 'Abd al-Raḥīm is mentioned must have been issued between 1013/404 and 1020/411.

**PLATE 48c**

*Al-Ẓāhir. Green; 2.2 cm; die 1.5 cm; 2.57 g (probably intended to be on the dirham standard). Cf. Balog types 175, 195. 360/8-1900*

*Obverse:* plain circular border enclosing three-line legend with pellet above and below:

*Al-Imām al-Ẓāhir / li-i'zāz dīn allāh / Amīr al-Mu'minīn*

الامام الظاهر
لاعزاز دين الله
امير المؤمنين

*Reverse:* traces of legend.

**PLATE 48d**

*Al-Mustanṣir. Blue. 2.3 cm; die 1.6cm; 2.96g (dirham standard). As Balog, type 262 variety 1; probably from the same die as Balog nos 262.6, 262.7. 360/22-1900*

*Obverse:* three-line legend:

*Al-Imām Ma'add Abū / Tamīm al-Mustanṣir bi- / llāh Amīr al-Mu'minīn*

الامام معد ابو
تميم المستنصر با
لله امير المؤمنين

**PLATE 48e**

*Al-Mustanṣir. Green. 1.6 cm; 0.73g (quarter-dirham standard). As Balog, type 283; possibly from the same die as Balog no. 283.1. 5629M-1901*

*Obverse:* two-line legend, with three pellets above and below and a single pellet over the centre of line 2:

*al-Mustanṣir / billāh*

المستنصر
بالله

**PLATE 48f**

*Al-Mustanṣir. Palish blue; 2.5 cm; die 1.7cm; 3.00g (dirham standard). Balog, type 298; from the same dies as Balog nos 298.1-5. 360/10-1900*

*Obverse:* plain outer border enclosing circular legend which continues with two horizontal lines in the central field, itself defined by a plain circular border:

*Al-Imām Ma'add Abū Tamīm al-Mustanṣir billāh / Amīr / al-Mu'minīn*

الامام معد ابو تميم المستنصر بالله
امير
المؤمنين

**PLATE 49**

*Al-'Āḍid. Turquoise, opaque; 1.4 cm; 1.00g (quarter-dinar standard). As Balog, type 425. 5629K-1901*

*Obverse:* four line-legend:

*Al-Imām / al-'Āḍid li-dīn / allāh Amīr / al-Mu'minīn*

الامام
العاضد لدين
الله امير
المؤمنين

Nearly all the quarter-dinar weights, like this one, are produced from dies primarily designed for the dinar and double-dinar denominations and only show part of the legend. To judge by similar pieces the die used here may have had a plain circular border.

# 5: IVORY, WOODWORK AND METALWORK

These categories are less well represented in the V&A collection of Fatimid material and may be dealt with together. This is, however, not just a question of convenience, for ivory and woodwork have much in common. Although there are only three examples to consider, one in each category, each is of considerable importance.

## IVORY

**PLATE 50**

*Hexagonal ivory plaque. Carved in relief with a bird and two hares on a background of interlaced foliage scrolls. Elephant ivory. From Fusṭāṭ, eleventh century. A.53-1921*

*H. 8 cm; W. 9.5 cm*

This hexagonal ivory plaque was probably intended to be inserted on a wooden panel. Four of the six sides retain a lower protruding flange or lip which would have served to secure it beneath the abutting wooden sections, and the manner in which such plaques were used for decorative effect is illustrated by a pair of wooden doors inlaid with ivory in the V&A (886-1884, 886a-1884).

The carving is on two levels: a low relief of interlacing scrolls constituting the background, and a higher relief with the main decorative motifs of two addorsed hares with their heads turned to look at each other and a bird flying over them. The technique of low and high relief is found in Fatimid woodwork carving as well, as seen in the eleventh-century panels reutilized in the Māristān (hospital) of Qalā'ūn at the end of the thirteenth century,[1] and it continues into the Ayyubid and early Mamluk period, as is demonstrated by the carved wooden tiles in the V&A (391–1884) from the *minbar* of the mosque of Ibn Ṭūlūn, of the period of the Sultan Lājīn, 1297–8 (696–7).[2] It is also found in other media, such as stone, as on the V&A marble basin (335-1903)

dated 1277/676, which also has a complex decoration of low and high relief.[3]

The ivory employed for luxury goods and artefacts in the Islamic period seems to be elephant ivory, most probably from East Africa. Walrus ivory could be used for the handles of daggers,[4] and bone for plaques, but so far no Islamic ivory has been identified as made of hippopotamus tusks, despite the recent find in Gao (Mali) of a large cache of hippopotamus ivory presumably destined for the cross-Sahara trade with North Africa.[5] During medieval Islamic times elephant ivory was used for chess pieces, although examples in bone are also known.[6]

Other carved ivory and bone panels have been found in Fustāt and are associated stylistically with Fatimid wood carvings. These represent hunting scenes, isolated animals and human figures, set against a background of scrollwork. Like the plaque under consideration, they were probably either panels for caskets or insets to larger wooden panels and can be dated to the eleventh or twelfth century.[7] Al-Maqrīzī reports that caskets of ivory, both rectangular and round, were mentioned by the Qādī Ibn Zubayr as part of the Fatimid treasury.[8]

The representation of animals such as the hare is very commonly found in Fatimid art of different media.[9] The iconography of the hare turning its head towards the other one will go on until the Mamluk period, as is demonstrated by a fourteenth-century bestiary.[10] In Islamic literature the hare has the symbolic meaning of good luck, fertility and prosperity in general,[11] and it is possible that the representation of it in the visual arts reflects, directly or indirectly, this symbolism. The two addorsed hares are complemented perfectly by the bird whose outstretched wings fill the space between their backward-turned heads. The bird itself has exactly the same pose, resembling closely that on the lustre-painted glass fragment in the V&A (plate 47a). A fragmentary wooden panel with two similar hares on a scroll background (fig.34) datable to the eleventh century is in the Louvre.[12]

Not much of Fatimid ivory carved with imagery has remained.[13] Perhaps the most famous pieces are the six panels carved in ajouré in the Bargello Museum in Florence,[14] with a bevelled cut which gives an impression of volume to the figures. Other comparable panels are two in the Louvre (also carved in ajouré; see fig.35) and four in Berlin.[15] The similarity of these panels to the Fatimid wood ones from the Dār al-Qutbiyya, or Western Fatimid palace[16] (later Māristān of Qalā'ūn), in terms of style, iconography and technique of carving, firmly dates them to the eleventh century. The iconography of all these objects follows the princely

*34.* Wooden fragment (H. 7.2 cm; W. 11.4 cm), Fatimid Egypt, late 10th–early 11th century. Musée du Louvre, Paris: MAO 465. © Photograph RMN; Hervé Lewandowski

*35.* Ivory plaque carved in ajouré. Fatimid Egypt, 11th–12th century. Musée du Louvre, Paris: 6265. © Photograph RMN; Hervé Lewandowski

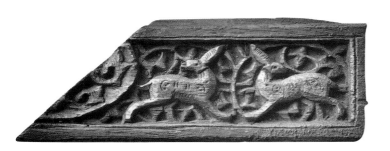

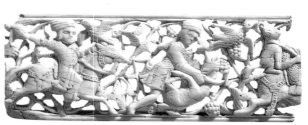

cycle, with scenes of courtly life, servants occupied in their activities and the ruler himself surrounded by attendants, musicians and dancers. This is also found in wood carvings,[17] in the paintings of the ceiling of the Cappella Palatina in Palermo and the Duomo of Cefalù,[18] and on the lustre-painted pottery of the Fatimid period. As already discussed in Chapter 3, the realistic elements in the portrayal of these scenes may be related to the survival of an uninterrupted classical–hellenistic tradition in Fatimid Egypt, on the iconographic repertoire of which they sometimes make direct call.[19]

The technique of incrustation was also practised in Egypt, and a casket of wood with ivory inscrustations in the Cappella Palatina in Palermo has been attributed to Egypt since it is connected in style and technique with a fragmentary wood panel incrusted with ivory found at Edfù.[20] Its date would appear to be the end of the twelfth or beginning of the thirteenth century (Ayyubid period).

A particularly important example of early Fatimid ivory work is found on a rectangular box (fig. 5). This has an ivory inlay on the flat cover in the form of a dedication to al-Muʻizz, the last Fatimid to rule from Ifrīqiya, to which is added the interesting information that it was made in Manṣūriyya, the Fatimid capital, near Qayrawān.[21] The casket can therefore be dated between 953/341 and 972/362. The maker's name is unfortunately almost all obliterated apart from his *nisba* al-Khurāsānī. The sides are decorated with a border of scrollwork painted in green and red, recalling, even if their style is more cursory, the so-called Siculo-Arabic ivories,[22] which are usually dated later. It suggests that the technique of painting on ivory was already known and practised in the Maghreb in the third quarter of the tenth century.

For comparative materials mention may be made of a plaque in Berlin,[23] and a number of wood carvings with similar decoration, of the Fatimid period, discussed by Max Herz-Pasha.[24] Comparison should be also made with the six V&A wooden panels (plates 51 and 52a–e) discussed below, which are closely similar in style.

BIBLIOGRAPHY: Longhurst 1927, I, pl. XXVIII.

# WOODWORK

### PLATES 51 AND 52A–E
*Set of six wooden panels, probably for a door. Fatimid Egypt, eleventh century. 785A–1896, and 785B–F-1896*

*H. 47 cm, W. 21 cm*

*Acquired in Egypt*

*Six panels of carved wood, deeply incised, with interlacing floral scroll-work forming a complex of compartments with, in the centre, the following figural subjects:*

*plate 51:* two hares with opposed heads

*plate 52a:* a seated figure, one leg crossed, the other with raised knee, holding a beaker on his left hand

*plate 52b:* two peacocks with intertwined necks

*plate 52c:* two birds of prey with opposed heads

*plate 52d:* two birds of prey with opposed heads and raised wings

*plate 52e:* two birds of prey with opposed heads. Very similar to plate 52c

The earliest surviving examples of Islamic woodwork date from the seventh century, and production has been continuous down to the present day. Inevitably, representation is uneven for different areas, and it is in Egypt that the

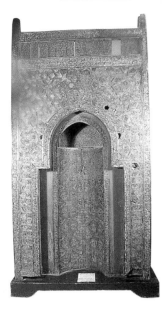

*36.*Wooden *miḥrāb* from the mosque of Sayyida Ruqayya in Cairo, 1154–60/533–40.
Museum of Islamic Art, Cairo: 446

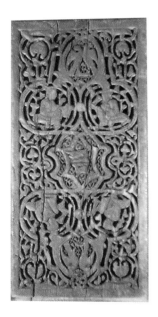

*37.*Wooden panel (H. 61 cm; W. 29 cm) carved in relief, found in the Māristān of Qalā'ūn, Fatimid Egypt, 11th century.
Museum of Islamic Art, Cairo: 441.

fullest historical sequence can be traced, starting from the seventh-century panel fragments[25] which show, like early ivory, a link with the Coptic tradition of carving:[26] the carving is still on one level, and the designs are variations on the trefoil vine leaf with the stems sometimes framing animal figures such as birds and lions.

Fatimid Egypt saw a great flowering of wood carving.[27] Developing out of Coptic and Tulunid styles,[28] Fatimid woodwork is characterized by a more complex texture and a wider iconographic repertoire. Panel designs can also be seen to build upon Abbasid developments,[29] but exploiting further the potential of floreated intersections for the creation of multiple and overlapping fields. The complexity is later intensified in the increasing elaboration of the geometrical and interlace patterns of the two *miḥrābs* from the mosques of Sayyida Nafīsa (1138–45/533–40) and Sayyida Ruqayya (1154–60/533–40; fig.36).[30] The use of figural motifs becomes more frequent, and at the same time more varied. One trend was to integrate a motif within an abstract structure, as in a striking panel including two addorsed horses,[31] the heads of which are still represented realistically while the bodies acquire rather the morphology of a sea-horse, the legs disappearing as the abstract design of the whole increasingly prevails. But this is counterbalanced by the frequent inclusion of genre scenes taken from the princely cycle, some echoing exactly the representational techniques of carving on ivory, as in the eleventh century friezes from the Fatimid palace site in Cairo (reutilized at the end of the thirteenth century in the Māristān, or hospital, of Qalā'ūn).[32] As on lustre-painted pottery, the iconographical repertoire includes the standard scenes of courtly life: hunting, dancers, musicians and servants at work.

Technically there is also a considerable variety of types. Although the very broad and rounded effects produced by bevelling in Abbasid and Tulunid carving[33] are no longer found, bevelling is still used, for example on the panels from the Māristān.[34] Elsewhere, however, in place of the effect of volume achieved by bevelling, a technique already found in Abbasid woodwork (see note 33) may be used, emphasizing abstract floreated designs by a combination of sharper edges with deep incisions. Depth could also be varied, as on ivory, to produce carving on two levels, an example being the Qalā'ūn frieze on which the human figures are raised above the background foliated scroll.[35] There is also, inevitably, considerable variation in finish, but it is important to note the delicacy and refinement of detail that could be achieved in the most finely worked pieces, as shown, for example, by the costumes and animal markings on one of the panels from the Māristān now in the Louvre,[36] comparable to those on ivory panels in the same museum.[37] A further link with ivory carving is provided by the fact that much woodwork must originally have been painted. Although it is long since eroded, evidence for painting is provided by the traces still detectable on some examples, with dark blue for the background and red for the figures.[38]

As in earlier periods, inscriptions are often carved in bands either in isolation, within a background of scrollwork, or on top of the frieze.[39] They have the same function as stone-carved inscriptions, those in mosques thus being Qur'ānic, while others, as with most texts on ceramics and textiles, are benedictory. The parallelism also extends to style, so that the Kufic script may be itself floreated or set against a background of floreated scrolls.

The surviving examples of Fatimid

wood carving are primarily associated with architecture, being friezes, door panels and surface panels around beams. Consequently, much Egyptian woodwork is preserved *in situ*, in Coptic churches, mosques and secular buildings.

Given the parallels with the thematic range and carving techniques of ivory, it may well be that the same craftsmen worked in both media. But evidence is lacking, and, although it is known that the Fatimids controlled the exploitation of acacia in Upper Egypt, the structure and economics of the wood industry is essentially undocumented. Pine, acacia, cypress, box, ebony and teak are only some of the species encountered in Fatimid woodwork, representing both indigenous and imported woods.[40] But despite the fact that Egypt is thought to have been more abundantly wooded during the Fatimid period, with a number of species having been introduced from elsewhere, the bulk of its supply was imported,[41] some no doubt at considerable cost, so that, even if less expensive than the ivory sometimes combined with them, the rarer woods could have formed only part of the luxury market.

The V&A panels are very similar to some of the eleventh-century panels from the Māristān of Qalā'ūn (fig.37), currently in the Museum of Islamic Art in Cairo,[42] in type of carving, composition, subject matter and scroll-work. Similarities are also found with pieces in the Louvre,[43] also dated to the eleventh century (fig.34). Another panel, without figural decoration but with a comparable interlace design, was found in Fusṭāṭ and is datable to the twelfth century.[44]

For further notes on types of carving, iconography and comparative material see text on Ivory.

BIBLIOGRAPHY: Christie 1925, pl. A (where four of the six panels are illustrated).

# METALWORK

## PLATES 53 AND 54
*Metal bucket with handle. Cast, copper alloy (?). Fatimid, eleventh century. M.25-1923*
*H. 15.8 cm, Diam. 17.3 cm*

The bucket has a flat base and a cylindrical body with a slightly projecting rim produced by hammering the inside, which therefore follows the same curving profile as the outside. The rim has a band of incised, reversed Z pattern, while below it, around the body, is a benedictory Arabic inscription incised in Kufic letters. A little below the band with the inscription is a decorative band of incised rhombs. The two lugs have a hole on to which the handle is fixed with pins. The handle has incised decorative lines and a hole in the middle.

A few other Fatimid buckets are extant. Among the published ones, one may mention three in the Keir collection (fig.38),[45] one in the Louvre,[46] and three from the eleventh-century Serçe Limani shipwreck.[47] These vary in size and decoration, but normally have, like the present example, cylindrical walls, a projecting rim and either a flat or a convex base. The handles are semicircular, with a small hole near each end, through which is riveted a swivel pin. The pin fits through the hole in the lug of the bucket, and has a domical head riveted on to its outer end.[48] The form of handle on the Serçe Limani buckets is different, since there is no swivel pin; instead, each end of the handle forms a loop through the hole in the appropriate lug. It has been suggested that there are two distinct traditions of bucket handle in the early Islamic Near East, the one with swivel pins, Egyptian, and the other with looped ends, Syrian.[49]

*38.* Metal bucket (H. 12.5 cm; Diam. 16.7 cm), Fatimid Egypt, 10th–11th century.
Keir Collection, Richmond, England: 24.

*39.* Silver and nielloed casket (H. 7.5cm; L. 12.4 cm; W. 7.9 cm) made for Ṣadaqa ibn Yūsuf, vizier to the Fatimid Caliph al-Mustanṣir, mid-11th century. Real Colegiata de San Isidoro, León.
Photograph © 1993 The Metropolitan Museum of Art, New York.

The function of the hole in the middle of the handle in our piece is explained by one of the three buckets in the Keir collection (fig.38).[50] This is very similar to the V&A one in shape and decoration, and it preserves the ring fitted through the hole in the middle of the handle with a pin, for suspension. The Keir piece has also an inscription in Kufic script, again of a benedictory type.

Very little is known about Fatimid metalwork from Egypt, and surviving and published examples are rare.[51] A rather large vessel and a dish from Egypt belonging to this period are found in the Louvre.[52] A small bucket of the same date was published by Ettinghausen,[53] but its present whereabouts are unknown. Metalwork animal figures of Islamic origin are often attributed to Fatimid Egypt, but many were produced in Persia, Spain and Sicily. An acquamanile with elaborately engraved body in the form of a stag in Munich is generally considered of Fatimid origin,[54] and another Fatimid, eleventh-century stag from Egypt is in the Museo di Capodimonte in Naples.[55] The origin of the Pisa Griffin is still to be ascertained, but in this case a Fatimid attribution seems unlikely.[56]

An important piece which adds to our knowledge of metalwork of the Fatimid period is a silver casket (fig.39) decorated in gilt and nielloed with a fine pattern of spirals covering the entire surface. Around the four sides of the lid runs a nielloed Kufic inscription which states that it was made for the treasury of Ṣadaqa ibn Yūsuf, recently identified as the vizier to the Fatimid Caliph al-Mustanṣir (r. 1036–94/428–487) between 1044/436 and 1047/439.[57] It is also noteworthy for having been signed by its maker, a certain 'Uthmān.

BIBLIOGRAPHY: unpublished.

## NOTES

1. For these panels see Pauty 1931, pls XLVI–LVIII.
2. See Lane-Poole 1886, figs 36–40.
3. Migeon 1927, fig. 84.
4. Ettinghausen 1950, pp. 120 ff.
5. Several Islamic ivory objects in the V&A were examined in June 1994 by me, Olga Krzyszkowska and Timothy Insoll (Department of Archaeology, Cambridge University), who found a hoard of hippo tusks in Gao (Mali). But although a couple of later, Mamluk, plaques proved to be of bone, all the others were of elephant ivory.
6. Contadini 1995.
7. Kubiak and Scanlon 1979, fig. 19; Ḥasan 1937, pl. 56; Dimand 1947, fig. 70.
8. Al-Maqrīzī 1895–1906, I, p. 414.
9. For comparison between different artefacts see Grube 1963.
10. In the copy of Ibn Bakhtīshū''s *Kitāb manāfi' al-ḥayawān* in the Escorial Library, Ar. 898, dated 1354, fol. 31v: see Contadini 1988–9, fig. 12.
11. Daneshvari 1986, pp. 11 ff.
12. Inv. no. MAO 465: Anglade 1988, fig.31.
13. For the material attributed to Fatimid Egypt, apart from archaeological material cited separately, see Kühnel 1971, pp. 68–73, nos 88–101 and pls XCVII–C.
14. Inv. no. 800. Kühnel 1971, pp. 24 and 70–1, no. 90A–F and pl. XCIX. For a comprehensive bibliography on the six panels and colour photographs see Grube 1993, no. 63.
15. For those in the Louvre see Migeon 1927, fig. 148, also Louvre 1989, no. 180, and for a colour picture Bernus-Taylor pl. on p. 27; for those in Berlin, Staatliche Museen für Islamische Kunst, see Kühnel 1971, pp. 68–9, no. 88, pls XCVII–XCVIII; also Hayward 1976, p. 154, no. 151.
16. Pauty 1931, pls XLIV, XLVI–LIX; also, for a panel now in the Louvre, inv. no. 4062, Anglade 1988, fig. 32.
17. As in a panel in the Louvre, inv. no. 4062, datable to the eleventh century: see Anglade 1988, fig. 32.
18. The Cappella ceiling was probably finished together with the Cappella in 1143. The paintings on the Cefalù ceiling are datable to the same date by comparison. For the Cappella paintings see Monneret de Villard 1950; Grube 1994; for colour reproductions

see Gabrieli and Scerrato 1985, pls 40–96 (Cappella) and pls 238–42 (Cefalù). For the Cefalù paintings see Gelfer-Jørgensen 1986.

19. See Chapter 3, p. 7 and note 3.

20. Now in the Islamic Art Museum in Cairo, inv. no. 3180. For both casket and Edfù fragment see Monneret de Villard 1938, pls I–V and pl. XXVI. For a colour reproduction of the casket see Gabrieli and Scerrato 1985, pl. 159.

21. The box was found at Carrion de los Condes in Palencia, and is now in the Museo Arqueológico in Madrid: Ferrandis 1935–40, no. 9; Kühnel 1971, no. 20, pl. VIII; Hayward 1976, p. 151, no. 145. For the inscription see *Répertoire*, V, 89, no. 1811.

22. Cott 1939; Pinder-Wilson 1973.

23. Kühnel 1925, fig. 168, p. 199.

24. Herz-Pasha 1912–13, pp. 169 ff.

25. Pauty 1931, pl. II.

26. See examples in Labib 1956.

27. Lamm 1936, pp. 90–1.

28. See Pauty 1930.

29. As in a panel in Damascus, National Museum, Syria, ninth or tenth century: Hayward 1976, no. 432.

30. Migeon 1927, I, figs 122–4.

31. Pauty 1931, p. 47; Hayward 1976, no. 443.

32. Pauty 1931, pls XLVI–LVIII; Lamm 1936; Marçais 1957.

33. As in examples from Samarra and Tulunid Egypt: see the panel in the British Museum, Hayward 1976, no. 431, and that in Cairo, Museum of Islamic Art, Pauty 1931, pp. 26–7, respectively. See also Ettinghausen 1952.

34. Pauty 1931, p. 44.

35. Hayward 1976, no. 442.

36. Inv. no. 4062: Anglade 1988, fig. 32.

37. Inv. nos 6265 and 6266: Anglade 1988, figs 32c and d.

38. See for example panel in Hayward 1976, no. 442.

39. Van Berchem 1891, XVII, pp. 411–95; XVIII, pp. 46–86.

40. See for example the pieces examined in the Louvre: Anglade 1988, Introduction, pp. 4–5.

41. Mayer 1958, p. 13.

42. Especially inv. nos 441 and 554: Pauty 1931, pls XLVI–LVIII. For photographs of the door see Creswell 1952, I, Pl. 39. See also Anglade 1988, pp. 60–1, figs 32a–b; Lane-Poole 1886, fig. 48, and Hayward 1976, p. 285, fig. 442.

43. Anglade 1988, figs 34–40.

44. The piece is in Seattle Art Museum, no. 56.Is 13,2: Hayward 1976, p. 287, no. 447.

45. Fehérvári 1976, nos 24, 25, 26, pl. 8b, c, d.

46. Inv. no. 6022: see Allan 1976, pl. 6.

47. A drawing of one of the three is published in Bass and van Doorninck 1978, fig. 5, but the three of them will be published in James Allan's article in G.F. Bass, *Serçe Limani*, forthcoming.

48. The form with swivel pins is known from precious objects, in silver and glass: see a glass example from the fifth or sixth century in the treasury of San Marco, Venice (121): Hahnloser 1971, no. 13.

49. For this suggestion and a discussion on bucket handles in general see James Allan's article in G.F. Bass, *Serçe Limani*, forthcoming.

50. Fehérvári 1976, no. 24, pl. 8b.

51. Among them is a bowl decorated with incised scrolls and Kufic inscriptions, attributed by Grube 1965, pl. XXXIII, to Egypt, second half of the tenth or first half of the eleventh century, in the Metropolitan Museum of Art in New York. However, the attribution to Egypt is controversial.

52. Inv. no. MAO 17 and AA 275 respectively: Allan 1976, pls 7 and 8.

53. Ettinghausen 1943, p. 205, fig. 5 on p. 200.

54. Bayerisches Nationalmuseum: Munich 1912, pl. 155; Migeon 1927, fig. 183.

55. Scerrato 1966, pl. 31.

56. The griffin has been attributed to southern Italy, Fatimid Egypt, Persia and Spain: for the latest discussion with review of the literature see Contadini 1993.

57. The casket is in León, Real Colegiata de San Isidoro: Carboni 1993, no. 47. For the vizier Ṣadaqa ibn Yūsuf see al-Imad 1990, pp. 165 and 180–1.

# BIBLIOGRAPHY

Introduction

Amari, M., 1933 – 8  *Storia dei Musulmani di Sicilia*, 2nd ed., Catania.

Arberry, A.J., 1967  *The Koran Illuminated*, Dublin.

Ashtor, E., 1978  *Studies on the Levantine Trade in the Middle Ages*, Variorum, London.

Assad, S.A., 1974  *The Reign of al-Ḥākim bi Amr Allāh (386/996–411/1021): A Political Study*, Beirut.

Barnes, R., 1990  "Indian Trade Cloth in Egypt: The Newberry Collection", in *Textiles in Trade*, Washington.

Bellafiori, G., 1978  *La Zisa di Palermo*, Palermo.

Berti, G. and Tongiorgi, L., 1981  *I bacini ceramici medievali delle chiese di Pisa*, Rome.

Beshir, B.K., 1978  "The Fatimid Military Organisation", *Der Islam*, LV, pp. 37–56.

Bianquis, T., 1972  "La prise du pouvoir par les Fatimides in Egypte", *Annales Islamologiques*, XI, pp. 49–108.

Bianquis, T., 1986–9  *Damas et la Syrie sous la domination fatimide (359–486/969–1076)*, 2 vols, Damascus.

Bierman, I., 1997  *Writing Signs: The Fatimid Public Text*, Berkeley.

Bloom, J., 1983  "The Mosque of al-Ḥākim in Cairo", *Muqarnas*, I, pp. 15–36.

Bloom, J., 1985  "The Origins of Fatimid Art", *Muqarnas*, III, pp. 20–38.

Bloom, J., 1989  "The Blue Koran: An Early Fatimid Kufic Manuscript from the Maghrib", in F. Déroche (ed.), *Les manuscrits du Moyen-Orient: essais de codicologie et paléographie*, Istanbul and Paris, pp. 95–9.

Brett, M., 1969  "Ifrīqiya as a Market for Saharan Trade from the Tenth to the Twelfth century A.D.", *Journal of African History*, X, pp. 343–64.

Brett, M., 1980  *The Moors: Islam in the West*, London.

Brett, M., 1983  "Islam and Trade in the Bilad al-Sudan, Tenth–Eleventh Century A.D.", *Journal of African History*, XXIV, pp. 431–40.

Brett, M., 1984  "The Way of the Peasant", *Bulletin of the School of Oriental and African Studies*, XLVII, pp. 44–56.

Brett, M., 1987  "Islam in North Africa", in P. Clarke *et al.* (eds), *The World's Religions*, London.

Brett, M., 1994  "The Mim, the 'Ayn, and the Making of Ismā'īlism", *Bulletin of the School of Oriental and African Studies*, LVII, 1, pp. 25–39.

Brett, M., 1996  "The Realm of the Imām: The Fatimids in the Tenth Century", *Bulletin of the School of Oriental and African Studies*, LIX, 3, pp. 431–49.

Bryer, D., 1975–6  "The Origin of the Druze Religion", *Der Islam*, LII, pp. 47–84, 239–62; LIII, pp. 5–27.

Bussagli, M., 1963  *Central Asian Painting*, Geneva.

Cahen, C., 1947  "Un traité d'armurerie composé pour Saladin", *Bulletin des Etudes Orientales*, XII, pp. 103–63.

Cahen, C., 1953 "L'évolution de l'iqtaʿ du IXe au XIIIe siècle", *Annales: Économies, Sociétés, Civilisations*, VIII, pp. 25–52.

Cahen, C., 1972a "Les marchands étrangers au Caire sous les Fatimides et les Ayyubides", *Colloque internationale sur l'histoire du Caire*, Cairo, pp. 97–101.

Cahen, C., 1972b "L'administration financière de l'armée fatimide, d'après al-Makhzumi", *Journal of the Economic and Social History of the Orient*, XV, pp. 163–82.

Canard, M., 1951 "Le cérémonial fâtimite et le cérémonial byzantin: essai de comparaison", *Byzantion*, XXI, pp. 355–420.

Canard, M., 1955 "Notes sur les Arméniens à l'époque fatimite", *Annales de l'Institut des Etudes Orientales*, Algiers, XIII, pp. 143–57.

Canard, M., 1956 "Quelques notes relatives à la Sicile sous les premiers califes fatimites", in *Studi medievali in onore di A. De Stefano*, Palermo, pp. 569–76.

Canard, M., "Fāṭimids" in *Encyclopaedia of Islam*, new edition, Leiden and London, II, 1965, pp. 850–62.

Canard, M., 1973a "La procession du Nouvel An chez les Fâtimides", in M. Canard, *Miscellanea orientalia*, Variorum, London.

Canard, M., 1973b "L'Impérialisme des Fatimides et leur propagande", in M. Canard, *Miscellanea orientalia*, Variorum, London.

Canard, M., 1973c "Une lettre du calife fatimite al-Hafiz à Roger II de Sicile", in M. Canard, *Miscellanea orientalia*, Variorum, London.

Contadini, A., 1988–9 "The *Kitāb Manāfiʿ al-Ḥayawān* in the Escorial Library", *Islamic Art*, III, pp. 33–57.

Contadini, A., 1993 "La Spagna dal II/VIII al VII/XIII Secolo", in G. Curatola (ed.), *Eredità dell'Islam - Arte Islamica in Italia*, Cinisello Balsamo, pp. 105–32.

Contadini, A., 1994 "The Ibn Buhtīshūʿ Bestiary Tradition: The Text and its Sources", *Medicina nei Secoli – Arte e Scienza*, VI, 2, pp. 349–64.

Creswell, K.A.C., 1952 *The Muslim Architecture of Egypt*, 2 vols, Oxford.

Crone, P. and Hinds, M., 1986 *God's Caliph: Religious Authority in the First Centuries of Islam*, Cambridge.

Curatola, G. (ed.), 1993 *Eredità dell'Islam – Arte Islamica in Italia*, Cinisello Balsamo.

Dachraoui, F., 1961 "Contribution à l'histoire des Fatimides en Ifriqiya", *Arabica*, VIII, pp. 189–203.

Dachraoui, F., 1981 *Le Califat fatimide au Maghreb: histoire politique et institutions*, Tunis.

Daftary, F., 1990 *The Ismaʿilis: Their History and Doctrines*, Cambridge.

Daghfous, R., 1977 "Aspects de la situation économique de l'Egypte au milieu du Ve siècle/milieu du XIe siècle", *Les Cahiers de Tunisie*, XXV, pp. 23–50.

Dodge, B., 1959 "Al-Ismāʿīlīyyah and the Origins of the Fatimids", *The Muslim World*, XLIX, pp. 296–305.

Dodge, B., 1960 "The Fatimid Hierarchy and Exegesis", *The Muslim World*, 1960.

Ehrenkreutz, A.S., 1972 "Saladin's Coup d'Etat in Egypt", in S.A. Hanna (ed.), *Medieval and Middle Eastern Studies in Honor of Aziz Suryal Atiya*, Leiden.

Elisséeff, N., 1967 *Nur al-Din: un grand prince musulman de Syrie au temps des Croisades (511–569H/1118–1174)*, Damascus.

Ettinghausen, R., 1942 "Painting in the Fatimid Period: A Reconstruction", *Ars Islamica*, IX, pp. 112–24.

Ettinghausen, R., 1952 "The 'Bevelled Style' in the Post-Samarra Period", in G.C. Miles (ed.), *Archaeologica Orientalia in Memoriam Ernst Herzfeld*, Locust Valley, NY.

Ettinghausen, R. and Grabar, O., 1987 *The Art and Architecture of Islam 650–1250*, Harmondsworth.

Ferrandis, J., 1935–40 *Marfiles árabes de Occidente*, Madrid.

Forsyth, J., 1977 *The Byzantine–Arab Chronicle (938–1034) of Yahya b. Saʿid al-Antaki*, 2 vols, Ann Arbor and London.

Gabrieli, F. and Scerrato, U., 1985 *Gli Arabi in Italia*, Milan (1st ed. 1979).

Gelfer-Jørgensen, M., 1986 *Medieval Islamic Symbolism and the Paintings in the Cefalù Cathedral*, Leiden.

De Goeje, M.J., 1886 *Mémoire sur les Carmathes du Bahrain et les Fatimides*, Leiden.

Goitein, S.D., 1950 "Mediterranean Trade in the Eleventh Century: Some Facts and Problems", in M.A. Cook (ed.), *Studies in the Economic History of the Middle East*, London.

Goitein, S.D., 1963 "Letters and Documents on the India Trade in Mediaeval Times", *Islamic Culture*, XXXVII, pp. 188–205.

Goitein, S.D., 1967–88 *A Mediterranean Society*, 5 vols: I, 1967 (Economic Foundations); II, 1971 (The Community); III, 1978 (The Family); IV, 1983 (Daily Life); V, 1988 (The Individual); VI, 1993 (Cumulative Indices), Los Angeles and London.

Golvin, L., 1957 *Le Maghrib central à l'époque des Zirides*, Paris.

Golvin, L., 1965 *Recherches archéologiques à la Qala des Banu Hammad*, Paris.

Gray, B., 1938 "A Fatimid Drawing", *The British Museum Quarterly*, XII, 1, 1938, pp. 91–6.

Grube, E.J., 1963 "Three Miniatures from Fustat in the Metropolitan Museum of Art in New York", *Ars Orientalis*, V, pp. 89–95.

Grube, E.J., 1968 *The Classical Style in Islamic Painting*, Lugano, 1968.

Grube, E.J., 1976 "Fostat Fragments" and "Pre-Mongol and Mamluk Painting", in B.W. Robinson (ed.), *The Keir Collection: Islamic Painting and the Arts of the Book*, London, pp. 25–128.

Grube, E.J., 1985 "A Drawing of Wrestlers in the Cairo Museum of Islamic Art", *Quaderni di Studi Arabi*, III, pp. 89–106.

Grube, E.J., 1987 "A Coloured Drawing of the Fatimid Period in the Keir Collection", *Rivista degli Studi Orientali*, LIX, pp. 147–74.

Grube, E.J., 1994 "La pittura islamica nella Sicilia normanna del XII secolo", in *La Pittura in Italia. L'Altomedioevo*, Milan, pp. 416–31.

Guest, R., 1912 "The Delta in the Middle Ages", *Journal of the Royal Asiatic Society*, pp. 941–80.

Halm, H., 1978 *Kosmologie und Heilslehre der frühen Isma'iliya*, Wiesbaden.

Halm, H., 1991 *Das Reich des Mahdi: der Aufstieg der Fatimiden*, Munich.

Hamdānī, H.F., 1931 *The Life and Times of Queen Saiyidah Arwā the Ṣulaiḥid of the Yemen*, London.

Hamdānī, A., 1956a "Evolution of the Organisational Structure of the Fatimid Da'wah", *Arabian Studies*, III, pp. 85–114.

Hamdānī, A.H., 1956b *The Beginnings of the Isma'ili da'wa in Northern India*, Cairo.

Hamdānī, A., 1974 "Byzantine–Fatimid Relations before the Battle of Manzikert", *Byzantine Studies*, I, pp. 169–79.

Ḥasan, H.I., 1958 *Ta'rīkh al-dawla al-fāṭimiyya*, Cairo.

Hayward, 1976 *The Arts of Islam*, catalogue of the exhibition held at the Hayward Gallery, 8 April–4 July, London.

Hillenbrand, R., 1994 *Islamic Architecture*, Edinburgh.

Hodgson, M.G.S., 1955 *The Order of Assassins*, The Hague.

Holt, P.M., 1986 *The Age of the Crusades: The Near East from the Eleventh Century to 1517*, London and New York.

Ibn Ḥawqal, 1938 *Ṣūrat al-arḍ*, Leiden.

Ibn al-Ṭaḥḥān, 1990 *Ḥāwī al-funūn wa-salwat al-maḥzūn*, facsimile edition ed. E. Neubauer, Frankfurt am Main.

Idris, H.R., 1962 *La Berbérie orientale sous les Zirides*, Paris.

Ivanow, V.A., 1939 "The Organisation of the Fatimid Propaganda", *Journal of the Bombay Branch of the Royal Asiatic Society*.

Ivanow, V.A., 1942 *Isma'ili Tradition concerning the Rise of the Fatimids*, London.

Al-Jawdharī, A.'A.M.al-'A., 1954 *Sīrat al-ustādh Jawdhar*, ed. M.K. Ḥusayn and M.'A.H. Sha'ira, Cairo.

Johns, J., 1995  "Re normanni e califfi fatimiti: nuove prospettive su vecchi materiali", in *Giornata di Studio del Nuovo sulla Sicilia Musulmana*, Rome, 3 maggio 1993, *Accademia Nazionale dei Lincei-Fondazione Leone Caetani*, XXVI, pp. 3–50.

Kahle-Bonn, P., 1935  "Die Schätze der Fatimiden", *Zeitschrift der Deutschen Morgenländischen Gesellschaft*, pp. 329–62.

Kubiak, W.B., 1987  *Al-Fustat: Its Foundation and Early Urban Development*, Cairo.

Kühnel, E., 1971  *Die Islamischen Elfenbeinskulpturen*, VIII–XIII Jahrhundert, 2 vols, Berlin.

Lamm, C.J., 1937  *Cotton in Medieval Textiles in the Near East*, Paris.

Lane-Poole, S., 1901  *A History of Egypt in the Middle Ages*, London.

Lane-Poole, S., 1902  *The Story of Cairo*, London.

Lev, Y., 1979  "The Fatimid Conquest of Egypt, Military Political and Social Aspects", *Israel Oriental Studies*, IX, pp. 315–28.

Lev, Y., 1980  "The Fatimid Army, A.H. 358–427/968–1036 C.E. Military and Social Aspects", *Asian and African Studies*, XIV, pp. 165–92.

Lev, Y., 1981  "Fatimid Policy towards Damascus (358/968–386/996) – Military, Political and Social Aspects", *Jerusalem Studies in Arabic and Islam*, III, pp. 165–83.

Lev, Y., 1984  "The Fatimid Navy, Byzantium and the Mediterranean Sea, 909–1036 C.E./297–427 A.H.", *Byzantion*, LIV, pp. 220–52.

Lev, Y., 1991  *State and Society in Fatimid Egypt*, Leiden, 1991.

Levy, R., 1957  *The Social Structure of Islam*, Cambridge.

Lewis, A.R., 1951  *Naval Power and Trade in the Mediterranean, AD 500–1100*, Princeton.

Lewis, B., 1949–50  "The Fatimids and the Route to India", *Revue de la Faculté des Sciences Economiques*, University of Istanbul, XI, pp. 50–4.

Lewis, B., 1967  *The Assassins*, London.

Lewis, B., 1972  "An Interpretation of Fatimid History", *Colloque internationale sur l'histoire du Caire*, Cairo, 1972, pp. 287–95.

Lézine, A., 1965  *Mahdiya: recherches d'archéologie islamique*, Paris.

Lombard, M., 1975  *The Golden Age of Islam*, Amsterdam and London.

Lombard, M., 1978  *Les textiles dans le monde musulman, VIIe–XIIe siècle*, Paris, The Hague, New York.

Lyons, M.C. and Jackson, D., 1981  *Saladin: The Politics of the Holy War*, Cambridge.

Madelung, G.,  "Ismā'īlīyya" in *Encyclopaedia of Islam*, new edition, Leiden and London 1978, IV, pp. 198–206.

Madelung, W., 1977  "Aspects of Isma'ili Theology: The Prophetic Chain and the God beyond Being", in S.H. Nasr (ed.), *Isma'ili Contributions to Islamic Culture*, Tehran.

Madelung, W., 1985  *Religious Schools and Sects in Medieval Islam*, London.

Mann, J., 1920–2  *The Jews in Egypt and Palestine under the Fatimid Caliphs*, 2 vols, Oxford.

Al-Maqrīzī, A.I.'A., 1853  *Al-mawā'iẓ wa'l-i'tibār bi-dhikr al-khiṭaṭ wa'l-āthār*, 2 vols, Cairo.

Al-Maqrīzī, A.I.'A., 1895  *Description topographique et historique de l'Egypte*, trans. U. Bouriant, Paris.

Al-Maqrīzī, A.I.'A., 1967–73  *Itti'āẓ al-ḥunafā' bi-akhbār al-a'imma al-fāṭimiyyīn al-khulafā'*, 3 vols, Cairo.

Marçais, G., 1946  *La Berbérie musulmane et l'Orient au Moyen Âge*, Paris.

Marçais, G., 1954  *L'architecture musulmane d'Occident*, Paris.

Marçais, G. and Poinssot, L., 1952  *Objects Kairouanais*, 2 vols, Tunis.

Marzouk, M.A.A., 1957  "The Earliest Fatimid Tiraz (Tiraz al-Mansuriyya)", *Bulletin of the Faculty of Arts Alexandria University*, XI, pp. 37-56.

May, B., 1975  *Die Religionspolitik der Ägyptischen Fatimiden, 969–1171*, Hamburg.

Meinecke-Berg, V., 1991  "Materialien zu fatimidischen Holzdekorationen in Kairo I:

Holzdecken aus dem fatimidischen Westpalast in Kairo", *Mitteilungen des Deutschen Archäologischen Instituts, Abteilung Kairo*, XLVII, pp. 227–33.

Mekky, M.A., 1972 "Un aspect des relations entre l'Egypte Fatimide et l'Espagne musulmane au cours du XIème siècle de notre ère, d'après de noveaux documents manuscrits", *Colloque internationale sur l'histoire du Caire*, Cairo, pp. 323–4.

Monneret de Villard, U., 1930 *La necropoli musulmana di Aswan*, Cairo.

Monneret de Villard, U., 1941 "Un codice arabo-spagnolo con miniature", *La Bibliofilia*, XLIII, pp. 209–23.

Monneret de Villard, U., 1950 *Le pitture musulmane al soffitto della Cappella Palatina in Palermo*, Rome.

Morimoto, K., 1981 *The Fiscal Administration of Egypt in the Early Islamic Period*, Kyoto.

Al-Muqaddasī, A.ʻA.A.M.b.A., 1994 *Aḥsan al-taqāsīm fī maʻrifat al-aqālīm*, trans. and ed. B.A. Collins and M.H. al-Tai, Reading.

Nāṣir-i Khusraw, 1881 *Sefer nameh*, ed. C. Schefer, Paris (reprinted by Philo Press, Amsterdam, 1970).

O'Leary, De Lacy, 1923 *A Short History of the Fatimid Caliphate*, London and New York.

Ostrogorsky, G., 1956 *History of the Byzantine State*, Oxford.

Parry, V.J. and Yapp, M.E. (eds), 1975 *War, Technology and Society in the Middle East*, Oxford.

Philon, H., 1980 *Early Islamic Ceramics*, London.

Poliak, A.N., 1936 "La féodalité islamique", *Revue des Etudes Islamiques*, X, pp. 247–65.

Rabie, H., 1972 *The Financial System of Egypt, A.H. 564–741/A.D. 1169–1341*, London.

Raghib, Y., 1987 "Un oratoire fatimide au sommet du Muqattam", *Studia Islamica*, LXV, pp. 51 ff.

*Répertoire* Combe, E., Sauvaget, J. and Wiet, G., *Répertoire chronologique d'épigraphie arabe*, 17 vols, Cairo, 1931–82.

Runciman, S., 1951–4 *A History of the Crusades*, 3 vols: see especially I, *The First Crusade*, II, *The Kingdom of Jerusalem*, Cambridge.

Salibi, K.S., 1977 *Syria under Islam*, Delmar, NY.

Sato, T., 1972 "Irrigation in Rural Egypt from the 12th to the 14th Centuries – Especially in Case of the Irrigation in Fayyum Province", *Orient*, VIII, pp. 81–92.

Sayyid, A.F., 1992 *Al-dawla al-fāṭimiyya fī miṣr/Les Fatimides en Egypte*, Cairo.

Setton, K.M. (ed.), 1955 *A History of the Crusades*, I, Philadelphia.

Smail, R.C., 1956 *Crusading Warfare (1097–1193)*, Cambridge.

Stanley, T., 1996 *The Qur'an and Calligraphy*, Bernard Quaritch Catalogue 1213, London.

Stern, S.M., 1950 "An Embassy of the Byzantine Emperor to the Fatimid Caliph al-Muʻizz", *Byzantion*, XX, pp. 239–58.

Stern, S.M., 1972 "Cairo as the Centre of the Ismaʻili Movement", *Colloque internationale sur l'histoire du Caire*, Cairo, pp. 437–50.

Stern, S.M., 1983 *Studies in Early Ismaʻilism*, Jerusalem and Leiden.

Talbi, M., 1966 *L'Emirat aghlabide*, Paris.

Udovitch, A.L. (ed.), 1981 *The Islamic Middle East, 700–1900: Studies in Economic and Social History*, Princeton.

Van Ess, J., 1977 *Chiliastiche Erwartungen und die Versuchung der Göttlichkeit: Der Kalif al-Hakim (386–411 H)*, Heidelberg.

Vanacker, C., 1973 "Géographie économique de l'Afrique du Nord selon les auteurs arabes du IXe siècle au milieu du XIIe siècle", *Annales: Économies, Sociétés, Civilisations* XXVIII, pp. 659–80.

Vatikiotis, P.J., 1954 "A reconstruction of the Fatimid theory of the state: The apocalyptic nature of the state", *Islamic Culture*, XXVIII, pp. 399-409.

Vatikiotis, P.J., 1955 "Al-Hakim bi-Amrillah: The God-King Idea Realized", *Islamic Culture*, XXIX, pp. 1–18.

Vatikiotis, P.J., 1957a *The Fatimid Theory of State*, Lahore.

Vatikiotis, P.J., 1957b "The Rise of the Extremist Sects and the Dissolution of the Fatimid Empire in Egypt", *Islamic Culture*, XXXI, pp. 17–26.

Ventrone, G., 1974 "La problematica della ceramica islamica del Nord Africa", *Atti del VII Convegno Internazionale della ceramica*, Albisola, pp. 85–102.

Walker, P.E., 1993 "The Ismaili Da'wa in the Reign of the Fatimid Caliph Al-Ḥākim", *Journal of the American Research Institue in Cairo*, XXX, pp. 161–82.

Wiet, G., 1937 "L'Egypte arabe", in G. Hanotaux (ed.), *Histoire de la nation égyptienne*, IV, Paris.

Wiet, G., 1963 "Recherches sur les bibliothèques égyptiennes aux Xe et XIe siècles", *Cahiers de Civilisation Médiéval*, VI, pp. 1–11.

Williams, C., 1983 "The Cult of 'Alid Saints in the Fatimid Monuments of Cairo. Part 1: The Mosque of al-Aqmar", *Muqarnas*, I, pp. 37–52.

Wüstenfeld, F., 1881 *Geschichte der Fatimiden-Chalifen*, Göttingen.

Yusuf, M.D., 1985 *Economic Survey of Syria during the Tenth and Eleventh Centuries*, Berlin.

Zakkar, S., 1971 *The Emirate of Aleppo, 1004–1094*, Beirut.

Zbiss, S.M., 1956 "Mahdiyya et Sabra Mansouriya: nouveaux documents d'art fatimite et d'Occident", *Journal Asiatique*, CCXLIV, pp. 79–93.

CHAPTER 1

Al-Akfānī, 1908 *Al-machriq*, ed. by the Fathers of the University of St Joseph, Beirut.

Anglade, E., 1988 *Catalogue des boiseries de la section islamique – Musée du Louvre*, Paris.

Aristotle, 1490 *De Lapidibus*, ed. Antonius Zarotus, Milan.

Ashtor, E., "Makāyil", *Encyclopaedia of Islam*, new edition, Leiden and London, VI, 1991 pp. 117–21.

Atil, E., 1975 *Art of the Arab World*, Freer Gallery of Art, Smithsonian Institution, Washington.

Atil, E. (ed.), 1990 *Islamic Art and Patronage: Treasures from Kuwait*, New York.

Babelon, E., 1902 *Histoire de la gravure sur gemmes*, Paris.

Beckwith, J., 1960 *Victoria and Albert Museum – Caskets from Cordoba*, London.

Berlin, 1989 *Europa und der Orient 800–1900*, catalogue of the exhibition, Munich.

al-Bīrūnī, A.R.M., 1936 *Kitāb al-jamāhir fī ma'rifat al-jawāhir*, Hyderabad.

Bond, M., 1997 "Desert Melting Pots", *New Scientist*, CLIII, 11 January, pp. 34–6.

Brend, B., 1991 *Islamic Art*, London.

British Museum, 1984 *The Treasury of San Marco, Venice*, catalogue of the exhibition held at the British Museum, Milan.

Buckley, W., 1935 "Two Glass Vessels from Persia", *The Burlington Magazine*, LXVII, pp. 66–71.

Charleston, R.J., 1942 "A Group of Near Eastern Glasses", *The Burlington Magazine*, LXXXI, pp. 212–18.

Christie, A.H., 1942 "Two Rock-crystal Carvings of the Fatimid Period", *Ars Islamica*, IX, pp. 166–8.

Clayton, M., 1985 *The Collector's Dictionary of the Silver and Gold of Great Britain and North America*, Antique Collectors' Club.

Contadini, A., 1995a "Islamic Ivory Chess Pieces, Draughts and Dice in the Ashmolean Museum", *Oxford Studies in Islamic Art*, X, part 1, Oxford, pp. 111–54.

Contadini, A., 1995b "Ewer," in T. Phillips (ed.), *Africa – The Art of a Continent*, catalogue of the exhibition, London, cat. no 7.50.

Erdmann, K., 1940 "Islamische Bergkristallarbeiten", *Jahrbuch der Preussischen Kunstsammlungen*, LXI, pp. 125–46.

Erdmann, K., 1942 "Die Bergkristall-Arbeiten der Islamischen Abteilung", *Berliner Museen – Berichte aus den Preussischen Kunstsammlungen*, LXIII, 1, pp. 7–10.

Erdmann, K., 1951 "'Fatimid' Rock Crystals", *Oriental Art*, III, 4, pp. 142–6.

Erdmann, K., 1953a "The 'Sacred Blood' of Weissenau", *The Burlington Magazine*, XCV, pp. 299–303.

Erdmann, K., 1953b "Die Fatimidischen Bergkristallkannen", *Wandlungen Christlicher Kunst im Mittelalter*, pp. 189–205.

Erdmann, K., 1959 "Neue islamische Bergkristalle", *Ars Orientalis*, III, pp. 200–5.

Erdmann, K., 1971 "Opere islamiche", in H.R. Hahnloser (ed.), *Il Tesoro di S. Marco: il tesoro e il museo*, II, Florence, pp. 100–27.

Ettinghausen, R., 1952 "The 'Bevelled Style' in the Post-Samarra Period", in G.C. Miles (ed.), *Archaeologica Orientalia in Memoriam Ernst Herzfeld*, Locust Valley, NY, 1952, pp. 72–83, plates IX–XVI.

Ettinghausen, R. and Grabar, O., 1987 *The Art and Architecture of Islam 650–1250*, Harmondsworth.

Evans, J., 1970 *A History of Jewellery 1100–1870*, London (1st ed. 1953).

Falke, O. von, 1930 "Gotisch oder Fatimidisch?" *Pantheon*, V, pp. 120–9.

Faltermeier, K., 1987 "Why Does Rock Crystal Explode?", in J Black (ed.), *Recent Advances in the Conservation and Analysis of Artifacts*, University of London, Jubilee Conference at the Institute of Archaeology, London, pp. 365–6.

Fukai, S., 1977 *Persian Glass*, New York and Tokyo (1st Japanese ed. 1973).

Gabrieli, F. and Scerrato, U., 1985 *Gli Arabi in Italia*, Milan (1st ed. 1979).

Ghirshmann, R., 1954 *Iran from the Earliest Times to the Islamic Conquest*, Harmondsworth.

Glanville, P., 1990 *Silver in Tudor and Early Stuart England*, V&A, London.

Grabar, A., 1971 "Opere bizantine", in H.R. Hahnloser (ed.), *Il Tesoro di S. Marco: il tesoro e il museo*, II, Florence, pp. 14–34.

Grube, E., 1993 "Il Periodo Fatimide in Egitto dal 297/909 al 567/1171", in G. Curatola (ed.), *Eredità dell' Islam: Arte Islamica in Italia*, Cinisello Balsamo.

Guidi, I., 1899 "Di un vaso arabo posseduto dal signor Marchese Alfieri di Sostegno, senatore del Regno d'Italia", *Actes du Onzième Congrès International des Orientalistes, Paris 1897*, Paris, pp. 39–43.

Hahnloser, H.R., 1955 *Scola et Artes Cristellariorum de Veneciis*, Comptes-rendus du XVIII Congrès d'Histoire de l'Art, Venice, 1955.

Hahnloser, H.R. (ed.), 1971 *Il Tesoro di S. Marco: il tesoro e il museo*, II, Florence.

Hájek, L., 1960 *Indische Miniaturen vom Hof der Mogulkaiser*, Prague.

Hall, C., 1993 *Gems and Precious Stones*, London.

Harada, J., 1932 *English Catalogue of Treasures in the Imperial Repository Shosoin*, Tokyo.

Hauser, W. and Wilkinson. C.K., 1942 "The Museum's Excavations at Nishapur", *Bulletin of the Metropolitan Museum of Art*, XXXVII, New York.

Hayward, 1976 *The Arts of Islam*, catalogue of the exhibition held at the Hayward Gallery, London, 8 April–4 July 1976, London.

Herrmann, G.; *et al.* 1996 "The International Merv Project – Preliminary Report on the Fourth Season (1995)", *Iran*, XXXIV, pp. 1–22.

Honey, W.B., 1946 *Glass*, V&A, London.

Jackson, C.J., 1911 *An Illustrated History of English Plate*, 2 vols, London.

Kahle-Bonn, P., 1935 "Die Schätze der Fatimiden", *Zeitschrift der Deutschen Morgenländischen Gesellschaft*, pp. 329–62.

Kahle-Bonn, P., 1936 "Bergkristall, Glas und Glasflüsse nach dem Steinbuch von el-Beruni", *Zeitschrift der Deutschen Morgenländischen Gesellschaft*, XC, pp. 322–56.

Kühnel, E., 1925 *Islamische Kleinkunst*, Berlin.

Kühnel, E., 1962 *Die Kunst des Islam*, in Springer (ed.), *Handbuch der Kunstgeschichte*, VI, Stuttgart.

Kunz, G.F., 1886 "The Occurrence and Manipulation of Rock Crystal", *Scientific American*, LV, 14 August, pp. 103–4 (Trans. NY Acad. Sciences, 30 May).

Kunz, G.F., 1971 *The Curious Lore of Precious Stones*, New York (1st ed. 1913).

Lamm, C.J., 1928 *Das Glas von Samarra*, Berlin.

Lamm, C. J., 1929–30 *Mittelalterliche Gläser und Steinschnittarbeiten aus dem Nahen Osten*, 2 vols, Berlin.

Lightbown, R.W., 1968 "An Islamic Crystal Mounted as a Pendant in the West", *Bulletin of the Victoria and Albert Museum*, IV, pp. 50–8.

Lightbown, R.W., 1992 *Medieval European Jewellery*, V&A, London.

Lipinsky, A., 1960–4 "La Chiesa Metropolitana di Capua e il suo Tesoro", *Archivio Storico di Terra e di Lavoro*, Caserta, III, pp. 341–435.

Longhurst, M.H., 1926 "Some Crystals of the Fatimid Period", *Burlington Magazine*, XLVIII, pp. 149–55.

Longhurst, M.H., 1927 *Catalogue of Carvings in Ivory*, 2 vols, V&A, London.

Michel, H.V., 1960 *Cristal de Roche et Cristalliers*, Académie Royale de Belgique, Classe des Beaux-Arts, XI, 3.

Migeon, G., 1907 *Manuel d'art musulman: arts plastiques et industriels*, 2 vols, Paris.

Migeon, G., 1922 *L'Orient Musulman – Musée du Louvre*, Paris.

Migeon, G., 1927 *Manuel d'art Musulman: arts plastiques et industriels*, 2 vols, Paris.

Montesquiou-Fezensac, B. de, 1973–7 *Le trésor de Saint-Denis*, 3 vols, Paris.

Munich, 1912 Sarre, F. and Martin, F.R. (eds), *Die Ausstellung von Meisterwerken Muhammedanischer Kunst in München 1910*, 3 vols, Munich.

Nāṣir-i Khusraw, 1881 *Sefer nameh*, ed. C. Schefer, Paris (reprinted by Philo Press, Amsterdam, 1970).

Oliver, P., 1961 "Islamic Relief Cut Glass: A Suggested Chronology", *Journal of Glass Studies*, III, 1961, pp. 8–29.

Oliver Harper, P., 1978 *The Royal Hunter – Art of the Sasanian Empire*, New York.

Paris, 1991 *Le trésor de Saint-Denis*, Musée du Louvre, Paris.

Pasini, A., 1885–6 *Il Tesoro di San Marco in Venezia*, Venice.

Pinder-Wilson, R.H., 1954 "Some Rock-crystals of the Islamic Period", *British Museum Quarterly*, XIX, pp. 84–7.

Pinder-Wilson, R.H., 1988 "Rock Crystal", in B.W. Robinson (ed.), *Islamic Art in the Keir Collection*, London, pp. 287–309.

Pinder-Wilson, R.H., 1991 "The Islamic Lands and China", in H. Tait, *Five Thousand Years of Glass*, London, pp. 112–43.

Pinder-Wilson, R.H. and Scanlon, G.T., 1973 "Glass Finds from Fustat: 1964–71", *Journal of Glass Studies*, XV, pp. 12–30.

Pinder-Wilson, R.H. and Scanlon, G.T., 1987 "Glass Finds from Fustat: 1972–1980", *Journal of Glass Studies*, XXIX, pp. 60–71.

Pliny, C.S., 1962 *Naturalis Historia Liber*, with translations by D.E. Eichholz, London and Cambridge, MA.

Qaddumi, G.H., 1990 *A medieval Islamic book of gifts and treasures*, trans. and comm. on the "Kitāb al-Hadāya wa' l-Tuḥaf", PhD, Harvard.

Qazwīnī, 1848 *'Ajā'ib al-makhlūqāt wa gharā'ib al-mawjūdāt*, ed. F. Wüstenfeld, Göttingen.

Riant, M. le Comte, 1875 "Des dépouilles religieuses enlevées à Constantinople au XIIIe siècle par les Latins", *Mémoires de la Société Nationale des Antiquaires de France*, XXXVI.

Riant, M. le Comte, 1885 "La part de l'évêque de Bethléem dans le butin de Constantinople en 1204", *Mémoires de la Société Nationale des Antiquaires de France*, XLVI, pp. 225–37.

Rice, D.S., 1955 *The Unique Ibn Al-Bawwāb Manuscript in The Chester Beatty Library*, Dublin.

Rice, D.S., 1956 "A Datable Islamic Rock Crystal", *Oriental Art*, New Series, II, pp. 85–93.

Safar, F., 1945 *Wasit: The Sixth Season's Excavations*, Institut français d'Archéologie orientale, a publication of the Government of Iraq, Directorate General of Antiquities, Cairo.

Schmidt, R., 1912 "Die Hedwigsgläser und die verwandten fatimidischen Glas und Kristall-Schnittarbeiten", *Jahrbuch des Schlesischen Museums für Kunstgewerbe und Altertum*, VI, pp. 53–78.

Shalem, A., 1996 *Islam Christianized*, (Ars Faciendi vol. 7), Frankfurt am Main.

Solinus, Caius Julius, 1587 *Collectanea Rerum Memorabilium*, trans. A. Golding (The Excellent and Pleasant Worke of Julius Solinus), London.

Sotheby's, 1928 *Islamic Art*, Sotheby's, London, 7 November.

Sotheby's, 1985 *Islamic Art*, Sotheby's, Geneva, 25 June.

*SPA* Pope. A.U., *A Survey of Persian Art*, 6 vols, Oxford, 1938-9.

Streck, M., "al-Sūs" in *Encyclopaedia of Islam*, new edition, Leiden and London, IX, 1997, pp. 898–901.

Strohmer, E. von, 1949 "Burgundian Jars of Rock-Crystal", *Phoenix*, IV, 1, January, pp. 11–19.

Al-Ṣūlī, A.B.M. ibn Y., 1935 *Akhbār ar-rāḍī wa'l-muttaḳī from the Kitāb al-awrāḳ*, ed. J.Heyworth Dunne, London.

Theophilus Presbyter, 1961 *De Diversis Artibus*, trans. C.R. Dodwell, London.

Tait, H. (ed.), 1991 *Five Thousand Years of Glass*, London.

Tatton-Brown, V. 1991 "The Roman Empire", in H. Tait, *Five Thousand Years of Glass*, London, pp. 62–97.

al-Tīfāshī, A. ibn Y., 1977 *Azhar al-afkār fī jawāhir al-aḥjār*, ed. M.Y. Ḥasan and M.B. Khafājī, Cairo.

Tokyo, 1909 *Toyei Shuko*, Tokyo.

V&A, 1921 *Review of the Principal Acquisitions During the Year 1920*, London.

V&A, 1929 *Review of the Principal Acquisitions During the Year 1928*, London.

Watts, W.W., 1924 *Old English Silver*, London.

Wentzel, H., 1972 "Das byzantinische Erbe der ottonischen Kaiser – Hypothesen über den Brautschatz der Theophano", *Aachener Kunstblätter des Museumsvereins*, XLIII, pp. 11–96.

Whitehouse, D., 1985 "Transparent Mystery (The Corning Ewer)", *Connoisseur*, CCXV, December, pp. 130–1.

## CHAPTER 2

'Abbās, M.S.W., 1995 "New Ṭirāz from Fayyūm during the Islamic period", in *Bulletin of Islamic and Archaeological Studies*, 5.

Adams, N.K., 1986 "Textiles at Qasr Ibrim: An Introductory Quantitative Study", *Wissenschaftliche Zeitschrift der Humbold Universität zu Berlin, Geisteswissenschaftliche Reihe*, XXX, pp. 21–6.

d'Agnel, A., 1904 "Le trésor de l'église d'Apt", *Bulletin Archéologique*, pp. 329–35.

Ashtor, E., 1969 *Histoire des prix et des salaires dans l'orient mediéval*, Paris.

Ashtor, E., 1976 *A Social and Economic History of the Near East in the Middle Ages*, Los Angeles.

Ashtor, E., 1980 "Gli Ebrei nel commercio mediterraneo nell'alto medioevo (sec. X–XI)", in *Gli Ebrei nell'alto medioevo: settimane di studio del Centro italiano di studi sull'alto medioevo XXVI (Spoleto 1978)*, Spoleto, pp. 401–64.

Al-Azraqī 1857–61 *Die Chroniken der Stadt Mekka*, ed. F. Wüstenfeld, Leipzig.

Baker, P.L., 1995 *Islamic Textiles*, London.

Beg, M.A.J., "Al-Khāṣṣa wa'l-ʿĀmma" in *Encyclopaedia of Islam*, new edition, IV, Leiden and London, pp. 1100-1102.

Berchem, M. van, 1910 *Meisterwerke Muhammadanischer Kunst*, Munich.

Bierman, I.A., 1980 *Art and Politics: The Impact of Fatimid Uses of Tiraz Fabrics*, Ph.D. thesis, Department of Near East Languages and Civilisation, University of Chicago, June (typescript).

Britton, N.P., 1938 *A Study of Some Early Islamic Textiles in The Museum of Fine Arts Boston*, Boston.

Britton, N.P., 1942 "Pre-Mameluke Tiraz in the Newberry Collection", *Ars Islamica*, IX, pp. 158–66.

Cahen, C., 1964 "Un texte inédit relatif au Tiraz Egyptien", *Arts Asiatiques*, XI, pp. 165–8.

Cairo, 1969, *Islamic Art in Egypt 969-1517*, catalogue of the exhibition, Cairo.

Capitani D'Arzago, A. de, 1941 *Antichi Tessuti della Basilica Ambrosiana*, Biblioteca de "L'Arte", Nuova Serie, I, Milan, 1941.

Combe, E., 1947 "Une institution de l'état Musulman: le Dâr al-Tirâz, atelier de tissage", *Revue des Conférences Françaises en Orient*, XI, 2, February, pp. 85–92.

Constable, O.R., 1994 *Trade and Traders in Muslim Spain: The Commercial Realignment of the Iberia Peninsula, 900–1500*, Cambridge.

Contadini, A., 1995 "Textile with embroidered calligraphic band," in T. Phillips (ed.), *Africa – The Art of a Continent*, catalogue of the exhibition, London, cat. no. 7.51.

Cornu, G., 1992 *Tissus islamiques de la collection Pfister*, Biblioteca Apostolica Vaticana, Rome.

Crowfoot, E.G., 1977 "The Clothing of a Fourteenth-Century Nubian Bishop", in V. Gervers (ed.), *Studies in Textile History in Memory of Harold B. Burnham*, Toronto, pp. 43–51.

Crowfoot, E.G., forthcoming *The Cathedral Burials and Their Textiles (Qasr Ibrim Excavations)*, Egypt Exploration Society.

David-Weill, J., 1970 "Un tissu toulounide à décor animalier et caractères coufiques", *Objets*, IV–V, pp. 33–4.

Day, F.E., 1952 "The Tiraz Silk of Marwan", in G.C. Miles (ed.), *Archaeologica Orientalia in Memoriam Ernst Herzfeld*, Locust Valley, NY, pp. 39–61.

Dimand, M.S., 1931 "Coptic and Egypto-Arabic Textiles", *Bulletin of the Metropolitan Museum of Art New York*, XXVII, pp. 92–6.

Elsberg, H.A. and Guest, R., 1936 "The Veil of St Anne", *The Burlington Magazine*, LXVIII, pp. 140–5.

Errera, I., 1907 *Catalogue d'étoffes anciennes et modernes*, Bruxelles, Musées Royaux des Arts Décoratifs, Brussels.

Ettinghausen, R., 1962 *Arab Painting*, Lausanne.

Ettinghausen, R., 1974 "Arabic Epigraphy: Communication or Symbolic Affirmation", in D.K. Kouymjian (ed.), *Near Eastern Numismatics, Iconography, Epigraphy and History – Studies in Honour of George C. Miles*, American University of Beirut, pp. 297–311.

Falke, O. von, 1913 *Kunstgeschichte der Seidenweberei*, 2 vols, Berlin.

Flury, S., 1936 "Le décor épigraphique des monuments fatimides du Caire", *Syria*, XVII, pp. 365–76.

Frantz-Murphy, G., 1981 "A New Interpretation of the Economic History of Medieval Egypt – The Role of the Textile Industry 254–567/868–1171", *Journal of the Economic and Social History of the Orient*, XXIV, 3, pp. 274–97.

Gayraud, R.P., 1986 "Istabl ʿAntar (Fostat) 1985: rapport de fouilles", *Annales Islamologiques*, XXII, pp. 1–26.

Glidden, H.W. and Thompson, D., 1988 "'Tiraz' Fabrics in the Byzantine Collection,

Dumbarton Oaks. Part One: 'Tiraz' from Egypt", *Bulletin of the Asia Institute*, II, n.s., pp. 119–39.

Goitein, S.D., 1967–88   *A Mediterranean Society*, 5 vols: I, 1967 (Economic Foundations); II, 1971 (The Community); III, 1978 (The Family); IV, 1983 (Daily Life); V, 1988 (The Individual) VI, 1993 (Cumulative Indices), Los Angeles and London.

Goitein, S.D., 1973  *Letters of Medieval Jewish Traders*, Princeton.

Golombek, L. and Gervers, V., 1977  "Tiraz Fabrics in the Royal Ontario Museum", in V. Gervers (ed.), *Studies in Textile History in Memory of Harold B. Burnham*, Toronto, pp. 82–125.

Grabar, A., 1966  *Byzantium: Byzantine Art in the Middle Ages*, London.

Granada and New York, 1992  *Al-Andalus: The Art of Islamic Spain*, ed. J.D. Dodds, New York.

Grohmann, A. "Ṭirāz"a  in *Encyclopaedia of Islam*, Leiden and London, 1913–34, IV, pp. 785–93.

Grohmann, A. "Ṭirāz"b  in *Encyclopaedia of Islam*, new edition, supplement, Leiden and London, 1980–, pp. 248–50.

Grube, E.J., 1962  "Studies in the Survival and Continuity of pre-Muslim Tradition in Egyptian Islamic Art", *Journal of the American Research Center in Egypt*, I, Cairo, pp. 75–97.

Guest, A.R., 1906   "Notice of Some Arabic Inscriptions on Textiles at the South Kensington Museum", *Journal of the Royal Asiatic Society*, pp. 387–99.

Guest, A.R., 1918  "Further Arabic Inscriptions on Textiles", *Journal of the Royal Asiatic Society*, pp. 263–5.

Guest, A.R., 1923  "Further Arabic Inscriptions on Textiles (II)", *Journal of the Royal Asiatic Society*, pp. 405–8.

Guest, A.R., 1930  "Further Arabic Inscriptions on Textiles (III)", *Journal of the Royal Asiatic Society*, pp. 761–6.

Guest, A.R., 1931  "Further Arabic Inscriptions on Textiles (IV)", *Journal of the Royal Asiatic Society*, pp. 129–34.

Guest, A.R. and Kendrick, A.F., 1932   "The Earliest Dated Islamic Textiles", *The Burlington Magazine*, LX, pp. 185–91.

Hayward, 1976  *The Arts of Islam*, catalogue of the exhibition held at the Hayward Gallery, 8 April–4 July, London.

Hourani, G.F., 1995  *Arab Seafaring*, revised and expanded by J. Carswell, Princeton (1st ed. 1951).

Ibn 'Abdūn, 1934  *Ḥisba*, ed. E. Levi-Provençal, *Journal Asiatique*, CCXXIV.

Ibn Khaldūn, 1862–8  *Prolégomènes historiques*, ed. M. de Slane, Paris.

al-Imad, L.S., 1990  *The Fatimid Vizierate 969–1172*, Berlin.

Karabacek, J. von, 1883  *Die Theodor Graf'schen Funde in Ägypten*, Vienna.

Kendrick, A.F., 1924  *Catalogue of Muhammadan Textiles of the Medieval Period*, Victoria and Albert Museum, London.

Kreutz, B.M., 1976  "Ships, Shipping, and the Implications of Change in the Early Mediterranean", *Viator*, 7, pp. 79–109.

Kühnel, E., 1927  *Islamische Stoffe aus ägyptischen Gräbern in der islamischen Kunstabteilung und in der Stoffsammlung des Schlossmuseums*, Berlin.

Kühnel, E., 1938 "La tradition copte dans les tissus musulmans", *Bulletin de la Société d'Archéologie Copte*, IV, pp. 79–89.

Kühnel, E. and Bellinger, L., 1952  *The Textile Museum: Catalogue of Dated Tiraz Fabrics: Umayyad, Abbasid, Fatimid*, The Textile Museum, Washington.

Lamm, C.J., 1937  *Cotton in Medieval Textiles in the Near East*, Paris.

Lane-Poole, A., 1863–93  *An Arabic–English Lexicon*, 8 parts, London.

Lev, Y., 1991  *State and Society in Fatimid Egypt*, Leiden.

Mann, J., 1920–2  *The Jews in Egypt and Palestine under the Fatimid Caliphs*, 2 vols, Oxford University Press (in Hebrew).

Al-Maqrīzī, A. ibn 'A., 1853  *Al-mawā'iẓ wa'l-i'tibār fī dikhr al-khiṭaṭ wa'l-āthār*, 2 vols, Cairo (Bulaq).

Al-Maqrīzī, A. ibn 'A., 1900–20  *Khiṭaṭ, description topographique et histoire de l'Egypte*, trans. U. Bouriant and P. Casanova, Paris.

Marçais, G. and Wiet, G., 1934  "Le 'Voile de St. Anne' d'Apt", *Académie des Inscriptions et Belle-Lettres, Monuments et Mémoires Fondation Piot*, XXIV, pp. 177–94.

Marzouk, M.A.A., 1943  "The Evolution of Inscriptions on Fatimid Textiles", *Ars Islamica*, X, pp. 164–6.

Marzouk, M.A.A., 1948–9  "Alexandria as a Textile Centre 331 B.C.–1517 A.D.", *Bulletin de la Société d'Archéologie Copte*, XIII, pp. 111–35.

Marzouk, M.A.A., 1955  "Four Dated Tiraz Fabrics of the Fatimid Khalif az-Zahir", *Kunst des Orients*, II, pp. 45–55.

Marzouk, M.A.A., 1957  "The Earliest Fatimid Textile (Tiraz al-Mansuriya)", *Bulletin of the Faculty of Arts Alexandria University*, XI, pp. 37–56.

Marzouk, M.A.A., 1965  "The Tiraz Institutions in Medieval Egypt", *Studies in Islamic Art and Architecture in Honour of Professor K.A.C. Creswell*, Cairo, pp. 157–62.

Monneret de Villard, U., 1940  "Una iscrizione marwanide su stoffa del secolo XI nella Basilica di Sant'Ambrogio a Milano", *Oriente Moderno*, XX, 10, ottobre, pp. 504–6.

Monneret de Villard, U., 1946  "La tessitura palermitana sotto i Normanni e i suoi rapporti con l'arte bizantina", *Miscellanea Giovanni Mercati*, III (Letteratura e Storia Bizantina), Città del Vaticano, pp. 1–26.

Al-Muqaddasī 1994  *Aḥsan al-taqāsīm fī ma'rifat al-aqālīm*, trans. and ed. B.A. Collins and M.H. al-Tai, Reading.

Nāṣir-i Khusraw, 1881  *Sefer nameh*, ed. C. Schefer, Paris (reprinted by Philo Press, Amsterdam, 1970).

Paris, Musée des Gobelins, 1934  *Exposition des tapis et tapisseries d'orient de haute époque*, Musée des Gobelins, Paris.

Paris, Grand Palais, 1977  *L'Islam dans les collections nationales*, Paris.

Pérez-Higuera, T., 1994  *Objetos e Imagenes de Al-Andalus*, Madrid.

Pfister, R., 1938  *Les toiles imprimées de Fostat et l'Hindoustan*, Paris.

Pfister, R., 1939  "The Indian Art of Calico Printing in the Middle Ages: Characteristics and Influences", *Indian Art and Letters*, London, XIII, 22, pp. 22–33.

Al-Qalqashandī, A. ibn 'A., 1913–19  *Ṣubḥ al-a'shā*, 10 vols, Cairo.

*Répertoire*  Combe, E., Sauvaget, J. and Wiet, G., *Répertoire chronologique d'épigraphie arabe*, 17 vols, Cairo 1931–82.

Rice, D.S., 1955  *The Unique Ibn Al-Bawwāb Manuscript in the Chester Beatty Library*, Dublin.

Rogers, C. (ed.), 1983  *Early Islamic Textiles*, Brighton.

Serjeant, R.B., 1972  *Islamic Textiles: Materials for a History up to the Mongol Conquest*, Beirut (reprint of articles in Ars Islamica, IX, 1942, pp. 54–92; X, 1943, pp. 71–104; XI–XII, 1946, pp. 98–145; XIII–XIV, 1948, pp. 75–117; and XV–XVI, 1951, pp. 29–86).

Steingass, F., 1930  *A Comprehensive Persian–English Dictionary*, London (1st ed. 1892).

Stillman, N.A.,  "Khil'a", in *Encyclopaedia of Islam*, new edition, Leiden and London, 1986, V, pp. 6–7.

Stillman, Y.K., 1972  *Female Attire of Medieval Egypt: According to the Trousseau Lists and Cognate Material from the Cairo Geniza*, Ph.D. dissertation, University of Pennsylvania, Philadelphia.

Talbot Rice, T., 1969  "Some Reflections on the Subject of Arm Bands", in O. Aslanapa and R. Naumann (eds), *Forschungen zur Kunst Asiens, In Memoriam Kurt Erdmann*, Istanbul, pp. 262–77.

Thompson, D., 1965 "A Fatimid Textile of Coptic Tradition with Arabic Inscription", *Journal of the American Research Center in Egypt*, IV, pp. 145–50.

Thompson, D., 1971 *Coptic Textiles in the Brooklyn Museum*, New York.

Volbach, W.F. and Kühnel, E., 1926 *Late Antique-Coptic and Islamic Textiles of Egypt*, London.

Weibel, A.C., 1952 *Two Thousand Years of Textiles: The Figured Textiles of Europe and the Near East*, New York.

Wensinck, A. J., "Miṣr" in *Encyclopaedia of Islam*, new edition, Leiden and London, 1993, VII, pp. 146–7.

Wiet, G., "Dabīq" in *Encyclopaedia of Islam*, new edition, Leiden and London, 1960, II, pp. 72–3.

Wiet, G., 1900–30 *Corpus Inscriptionum Arabicarum*, Cairo (Institut Française d'Archéologie Orientale).

Wiet, G., 1935 "Les tissus et tapisseries de l'Égypte musulmane", *Revue de l'Art Ancien et Moderne*, LXVIII, pp. 68–9.

Al-Yaʿqūbī, 1892 *Kitāb al-buldān*, ed. M.J. de Goeje, Leiden.

## CHAPTER 3

Abu-Lughod, J.L., 1971 *Cairo*, Princeton.

Allan, J.W., 1971 *Medieval Middle Eastern Pottery*, Ashmolean Museum, Oxford.

Allan, J.W., 1973 "Abu'l-Qasim's Treatise on Ceramics", *Iran*, XI, pp. 111–20.

Atil, E., 1981 *Renaissance of Islam: Art of the Mamluks*, Washington.

Bahgat, A.B., 1914 "Les fouilles de Foustat, découverte d'un four de potier arabe du XIVe siècle", *Bulletin de L'Institut Egyptien*, 5e série, VIII, pp. 233–46.

Bahgat, A.B. and Massoul, F., 1930 *La Céramique musulmane de l'Égypte*, Cairo.

Ballardini, G., 1928 "Note sull'origine della ceramica orientale a lustro e a riflesso metallico", *Nuova Antologia*, August.

Ballardini, G., 1964 *L'eredità artistica dell'antico mondo romano: lineamenti di una "storia civile" della ceramica romana*, Rome.

al-Bāsha, Ḥ.M., 1956 "Ṭabaq min al-khazaf bi-ism 'Ghaban' mawlā al-Ḥākim bi-amr Allāh", *Majallat Kulliyyat al-ādāb (Bulletin of the Faculty of Arts, Cairo University)*, XVIII, 1, pp. 71–85, figs 1–6.

Berti, G. and Tongiorgi, L., 1981 *I bacini ceramici medievali delle chiese di Pisa*, Rome.

Berti, G. and Tongiorgi, L., 1986 "Ceramiche importate dalla Spagna nell'area pisana dal XII al XV secolo", *Segundo Coloquio Internacional de Ceramica Medieval en el Mediterraneo Occidental – Toledo, 1981*, Madrid, pp. 315–46.

Blake, H. and Aguzzi, F., 1990 "Eleventh Century Islamic Pottery at Pavia, North Italy: The Torre Civica Bacini", with analyses by S. Sfrecola, *The Accordia Research Papers*, I, pp. 95–152.

Butler, A.J., 1926 *Islamic Pottery – A Study Mainly Historical*, London.

Cairo, 1969 *Islamic Art in Egypt 969-1517*, catalogue of the exhibition, Cairo.

Caiger-Smith, A., 1973 *Tin-Glaze Pottery*, London.

Caiger-Smith, A., 1985 *Lustre Pottery*, London.

Centlivres-Demont, M., 1971 *Une communauté de potiers en Iran*, Wiesbaden.

Clairmont, C.W., 1977 *Benaki Museum – Catalogue of Ancient and Islamic Glass*, Athens.

Contadini, A., 1995 "Bowl", in T. Phillips (ed.), *Africa – The Art of a Continent*, catalogue of the exhibition, London, cat. no. 7.53.

Crowe, Y., 1975–7 "Early Islamic Pottery and China", *Transactions of the Oriental Ceramic Society*, XLI, pp. 263–75.

Ettinghausen, R., 1942 "An Early Glass Making Centre", *Records of the Museum of Historic Art*, I, 2, Princeton, pp. 4–7.

Ettinghausen, R., 1956 "Early Realism in Islamic Art", *Studi orientalistici in onore di Giorgio Levi Della Vida*, I, Rome, pp. 250–73.

Ettinghausen, R. and Grabar, O., 1987 *The Art and Architecture of Islam 650–1250*, Harmondsworth.

Fehérvári, G., 1963 "Two Early 'Abbasid Lustre Bowls and their Influence of Central Asia", *Oriental Art*, NS IX, pp. 79–88.

Fehérvári, G., 1985 *La ceramica islamica*, Milan.

Frierman, J.D., Asaro, F. and Michel H.V., 1980 "The Provenance of Early Islamic Lustre Wares", *Ars Orientalis*, XII, pp. 111–26.

Gayraud, R.P., 1995 "Istabl 'Antar (Fostat) 1994: rapport de fouilles", *Annales Islamologiques*, XXIX, pp. 2–24.

Goitein, S.D., 1967–88 *A Mediterranean Society*, 5 vols: I, 1967 (Economic Foundations); II, 1971 (The Community); III, 1978 (The Family); IV, 1983 (Daily Life); V, 1988 (The Individual);VI, 1993(Cumulative Indices), Los Angeles and London.

Golvin, L., Thiriot, J. and Zakariya, M., 1982 *Les potiers actuels de Fustat*, Institut Français d'Archéologie Orientale du Caire, Cairo.

Grabar, O., 1972 "Imperial and Urban Art in Islam: The Subject Matter of Fatimid Art", *Colloque Internationale sur l'Histoire du Caire*, 1969, Cairo, pp. 173–89.

Gray, B., 1975–7 "The Export of Chinese Porcelain to the Islamic World", *Transactions of the Oriental Ceramic Society*, LXI.

Grube, E.J., 1962 "Studies in the Survival and Continuity of Pre-Muslim Traditions in Egyptian-Islamic Art", *Journal of the American Research Center in Egypt*, I, pp. 75–102.

Grube, E.J., 1965 "The Art of Islamic Pottery", *The Metropolitan Museum of Art Bulletin*, NS XXIII, pp. 198–228.

Grube, E.J., 1976 *Islamic Pottery of the Eighth to the Fifteenth Century in the Keir Collection*, London.

Grube, E.J., 1984 "Realism or Formalism: Notes on Some Fatimid Lustre-painted Ceramic Vessels", *Studi in onore di Francesco Gabrieli nel suo ottantesimo compleanno*, Rome, pp. 423–32.

Gyllensvärd, B., 1973–5 "Recent Finds of Chinese Ceramics at Fustat", *Bulletin of the Museum of Far Eastern Antiquities*, Stockholm, XLV, XLVII.

Ḥasan, Z.M., 1933 *Les Tulunides: étude de l'Egypte Musulmane à la fin du IXe siècle, 868–905*, Paris.

Hayes, J.R. (ed.), 1992 *The Genius of Arab Civilization – Source of Renaissance*, New York and London.

Hillenbrand, R., 1995 "Images of Authority on Kashan Lustreware", *Oxford Studies in Islamic Art*, X, part 1, Oxford, pp. 167–98.

Hobson, R.L., 1932 *A Guide to the Islamic Pottery of the Near East*, London.

Jenkins, M., 1968 "Muslim: An Early Fatimid Ceramist", *Bulletin of the Metropolitan Museum of Art*, N.S. XXVI, New York, pp. 359–69.

Jenkins, M., 1988 "Sa'd: Content and Context", in P. Soucek (ed.), *Content and Context of Visual Arts in the Islamic World*, Pennsylvania and London, pp. 67–75.

Jenkins, M., 1997, Evans, H.C. and Wixon, W.D. (eds), *The Glory of Byzantium: Art and Culture of the Middle Byzantine Era A.D. 843–1261*, New York.

Kelekian, D.K., 1910 *The Kelekian Collection of Persian and Analogous Potteries 1885–1910*, Paris.

Kingery, W.D. and Vandiver, P.B., 1986 *Ceramic Masterpieces: Art, Structure, Technology*, New York.

Kubiak, W. and Scanlon, G.T., 1973 "Fustat Expedition: Preliminary Report 1966," *Journal of the American Research Center in Egypt*, X, pp. 11–25.

Kühnel, E., 1925 *Islamische Kleinkunst*, Berlin.

Kühnel, E., 1934 "Die Abbasidischen Lustrefayencen", *Ars Islamica*, I, pp. 149–59.

Lamm, C.J., 1941 *Oriental Glass of Medieval Date found in Sweden and the Early History of Lustre-Painting*, Stockholm.

Lane, A., 1937–8 "The Early Sgraffito Ware of the Near East", *Transactions of the Oriental Ceramic Society*, XV, pp. 33–54.

Lane, A., 1947 *Early Islamic Pottery*, London.

Leroy, J., 1974 *Les manuscrits coptes et coptes–arabes illustrés*, Paris.

Lightbown, R. and Caiger-Smith, A., 1980 *I Tre Libri dell'Arte del Vasaio: The Three Books of the Potter's Art by Cipriano Piccolpasso*, a facsimile of the manuscript in the Victoria and Albert Museum, trans. and introduced by R. Lightbown and A. Caiger-Smith, 2 vols, London.

Marçais, G., 1913 *Les poteries et faiences de la Qal'a des Beni Hammad*, Constantine.

Marçais, G., 1928 *Les faiences à reflets métalliques de la Grande Mosquée de Kairouan*, Paris.

Mason, R.B. and Keall, E.J., 1988 "Provenance of Local Ceramic Industry and the Characterization of Imports: Petrography of Pottery From Medieval Yemen", *Antiquity*, LXII, September, pp. 452–63.

Mason, R.B. and Keall, E.J., 1990 "Petrography of Islamic Pottery from Fustat", *Journal of the American Research Center in Egypt*, XXVII, pp. 165–84.

Matson, F.R., 1973 "Technological Studies of Egyptian Pottery, Ancient and Modern", in A. Bishay (ed.), *Recent Advances in Science and Technology of Materials*, III, New York, pp. 129–39.

Michel, H.V., Frierman, J.D. and Asaro, F., 1976 "Chemical Composition Patterns of Ceramic Wares from Fustat, Egypt", *Archaeometry*, XVIII, pp. 85–92.

Migeon, G., 1927 *Manuel d'art Musulman: arts plastiques et industriels*, 2 vols, Paris.

Munich, 1912 F. Sarre and F.R. Martin (eds), *Die Ausstellung von Meisterwerken Muhammedanischer Kunst in München 1910*, 3 vols, Munich.

Nāṣir-i Khusraw, 1881 *Sefer nameh*, ed. C. Schefer, Paris (reprinted by Philo Press, Amsterdam 1970).

Naumann, R., 1971 "Brennofen für Glasurkeramik", *Istanbuler Mitteilungen*, XXI, pp. 185–7.

Naumann, R., 1976 *Takht-i Suleiman*, Ausstellungskataloge der Prähistorischen Staatssammlung, Munich.

Olmer, P., 1932 *Les filtres des gargoulettes*, Catalogue Générale du Musée Arabe du Caire, Cairo.

Paris, 1996 *La médicine au temps des califes*, catalogue of the exhibition at the Institut du Monde Arabe, Paris, 18 November 1996–2 March 1997, Paris.

Philon, H., 1980 *Early Islamic Ceramics*, London.

Pinder-Wilson, R., 1959 "An Early Fatimid Bowl Decorated in Lustre", in R. Ettinghausen (ed.), *Aus der Welt der islamischen Kunst: Festschrift fur Ernst Kühnel*, Berlin, pp. 139–43.

Pinder-Wilson, R. and Scanlon, G.T., 1973 "Glass Finds from Fustat 1964–1971", *Journal of Glass Studies*, XV, pp. 12–30.

Porter, V., 1981 *Medieval Syrian Pottery*, Oxford, Ashmolean Museum.

Porter, V., 1995 *Islamic Tiles*, London.

Porter, V. and Watson, O., 1987 "'Tell Minis' Wares", in J. Allan and C. Roberts (eds), *Syria and Iran: Three Studies in Medieval Ceramics*, Oxford Studies in Islamic Art, Oxford, pp. 175–248.

Riis, P.J. and Poulsen, V.H., 1957 *Hama, fouilles et recherches, 1931–1938*, IV, 2, Copenhagen, pp. 136–41 and 152–6.

Rodziewicz, M., 1976 *Alexandrie I: la céramique romaine tardive d'Alexandrie*, Warsaw.

Rodziewicz, M., 1983 "Egyptian Glazed Pottery of the 8th to the 9th Centuries", *Bulletin de la Société d'Archéologie Copte*, XXV, pp. 73–5.

al-Ṣadr, Ḥ., 1960 *Madīnat al-fakhār* (Town of the Potteries), Cairo (Arabic text).

Sarre, F., 1925 *Die Keramik von Samarra*, Berlin.

Scanlon, G.T., 1965 "Preliminary Report: Excavations at Fusṭāṭ 1964", *Journal of the*

*American Research Center in Egypt*, IV, pp. 7–30.

Scanlon, G.T., 1966 "Fusṭāṭ Expedition: Preliminary Report 1965. Part I", *Journal of the American Research Center in Egypt*, V, pp. 83–112.

Scanlon, G.T., 1967 "Fusṭāṭ Expedition: Preliminary Report 1965. Part II", *Journal of the American Research Center in Egypt*, VI, pp. 65–86.

Scanlon, G.T., 1970a "Kasr al-Wizz", *Journal of Egyptian Archaeology*, LVI, pp. 29–57.

Scanlon, G.T., 1970b "Egypt and China: Trade and Imitation", in D.S. Richards (ed.), *Islam and the Trade of Asia*, Oxford and Philadelphia, pp. 81–96.

Scanlon, G.T., 1974a "Fusṭāṭ Expedition: Preliminary Report 1968, Part I", *Journal of the American Research Center in Egypt*, XI, pp. 81–91.

Scanlon, G.T., 1974b "The Pits of Fusṭāṭ: Problems of Chronology", *Journal of Egyptian Archaeology*, LX, pp. 60–78.

Scanlon, G.T., 1984 "Fusṭāṭ Expedition: Preliminary Report 1978", *Journal of the American Research Center in Egypt*, XXI, pp. 1–38.

Sinclair, K., 1990 "Potters of Fusṭāṭ (Cairo: Gordon Sinclair's Photographic Trip to Egypt)", *Ceramics Review*, CXXIV, July/August, pp. 6–7.

*SPA* Pope, A.U., *A Survey of Persian Art*, 6 vols, Oxford, 1938-9.

Ventrone, G., 1974 "La problematica della ceramica islamica del Nord Africa", *Atti del VII Convegno Internazionale della ceramica*, Albisola, pp. 85–102.

Watson, O., 1976 "Persian Lustre-painted Pottery: The Rayy and Kashan Styles", *Transaction of the Oriental Ceramic Society*, XL, pp. 1–19.

Watson, O., 1985 *Persian Lustre Ware*, London.

Whitcomb, D., 1989 "Coptic Glazed Ceramics from the Excavations at Aqaba, Jordan", *Journal of the American Research Center in Egypt*, XXVI, pp. 167–82.

Whitcomb, D.S. and Johnson, J.H., 1979 *Quseir al-Qadim 1978*, American Research Center in Egypt, Princeton.

Whitcomb, D.S. and Johnson, J.H., 1982 *Quseir al-Qadim 1980*, American Research Center in Egypt Reports, VII, Malibu, CA.

Whitehouse, D., 1971 "Excavations at Siraf: Fourth Interim Report", *Iran*, IX, pp. 1–17.

Whitehouse, D., 1972 "Excavations at Siraf: Fifth Interim Report", *Iran*, X, pp. 63–87.

Whitehouse, D., 1974 "Excavations at Siraf: Sixth Interim Report", *Iran*, XII, pp. 1–30.

Wulff, H.E., 1966 *The Traditional Crafts of Persia*, Cambridge, MA.

Yūsuf, 'A. al-R., 1958 "Ṭabaq 'Ghaban' wa'l-khazaf al-fāṭimī al-mubakkir", *Majallat Kulliyyat al-ādāb (Bulletin of the Faculty of Arts, Cairo University)*, XVIII, 1, May, pp. 87–106, figs 1–50.

Yūsuf, 'A. al-R., 1962 "Khazzāfūn min al-'aṣr al-fāṭimī wa asālībuhum al-fanniyya (Fatimid Potters and their Styles)", *Majallat Kulliyyat al-ādāb (Bulletin of the Faculty of Arts, Cairo University)*, XX, pp. 173–279.

## CHAPTER 4

Allan, J. and Henderson, J., 1995 "Investigations into Marvered Glass: I and II", in J. Allan (ed.), *Oxford Studies in Islamic Art*, X, part 1, Oxford, pp. 1–50.

Ashton, A.L.B., 1932 "Three New Glass Vessels Painted in Lustre", *Burlington Magazine*, LX, pp. 293–4.

Bahgat, A.B. and Massoul, F., 1930 *La Céramique musulmane de l'Égypte*, Cairo.

Balog, P., 1971-2 and 1973 "The Fatimid glass jeton", *Annali, Istituto Italiano di Numismatica*, XVII-XIX, pp.175-264 and XX, pp.121-212.

Balog, P., 1981 "Fāṭimid glass jetons: token currency or coin weights?", *Journal of the Economic and Social History of the Orient*, XXIV, pp.93-109.

Bass, G.F., 1984 "The Nature of the Serçe Limani Glass", *Journal of Glass Studies*, XXVI, pp. 64–9.

Bass, G.F., 1996 *Shipwrecks in the Bodrum Museum of Underwater Archaeology*, Ankara (chapter on Serçe Limani pp. 37–53).

Bass, G.F. and van Doorninck, F.H., 1978 "An 11th Century Shipwreck at Serçe Liman, Turkey", *The International Journal of Nautical Archaeology and Underwater Exploration*, VII, 2, pp. 119–32.

Bass, G.F. *et al.*, 1988 *The Glass Wreck: An 11th-century Merchantman*, INA Newsletter, XV, 3, September.

Bates, M.L., 1981 "The Function of Fāṭimid and Ayyūbid glass weights", *Journal of the Economic and Social History of the Orient*, XXIV, pp.74-5.

Brill, R.H., 1970 "Chemical Studies of Islamic Lustre Glass", in R. Berger (ed.), *Scientific Methods in Medieval Archaeology*, UCLA, pp. 351–77.

British Museum, 1984 *The Treasury of San Marco, Venice*, catalogue of the exhibition, Milan.

Brooks, J.A., 1975 *Glass*, Maidenhead (1st ed. New York, 1973).

Casanova, P., 1893 "Catalogue des pièces de verre des époques byzantine et arabe de la collection Fouquet", *Mémoires publiées par les membres de la Mission Archéologique Française au Caire*, VI, III, pp.353-9.

Castiglioni, C.O., 1847 *Dell'uso cui erano destinato i vetri con epigrafi cufiche, e della origine, estensione e durato di esso*, Milan.

Castillo Galdeano, F., Martínez Madrid, R. and Acién Almansa, M., 1987 "Urbanismo e industria in Bayyana, Pechina (Almería)", *II Congreso de Arqueologia Medieval Española, Madrid 1987*, Madrid, II, pp. 539–48.

Charleston, R.J., 1990 *Masterpieces of Glass: A World History from the Corning Museum of Glass*, New York (1st ed. 1980).

Clairmont, C.W., 1977 *Benaki Museum – Catalogue of Ancient and Islamic Glass*, Athens, 1977.

Contadini, A., 1995 "Islamic Ivory Chess Pieces, Draughts and Dice in the Ashmolean Museum", *Oxford Studies in Islamic Art*, X, part 1, Oxford, pp. 111–54.

Cressier, P., 1993 "Humildes joyas: pulseras de vidrio en una casa Andalusí de Senés (Almería)", *Revista del Centro de Estudios Históricos de Granada y de Reino*, second series, VII, Granada, pp. 67–84.

Erdmann, K., 1971 "Opere islamiche", in H.R. Hahnloser (ed.), *Il Tesoro di San Marco: il tesoro e il museo*, II, Florence, pp. 100–27.

Ettinghausen, R., 1962 *Arab Painting*, Lausanne.

Fehérvári, G., 1976 *Islamic Metalwork of the Eighth to the Fifteenth Century in the Keir Collection*, London.

Folsach, K. von, 1990 *Islamic Art: The David Collection*, Copenhagen.

Gómez-Moreno, M., 1951 *El arte español hasta los Almohades – arte Mozárabe*, Ars Hispaniae, III, Madrid.

Gray, B., 1972 "Thoughts on the Origin of 'Hedwig' Glasses", *Colloque International sur l'Histoire du Caire*, Cairo, pp. 191–4.

Hahnloser, H.R. (ed.), 1971 *Il Tesoro di San Marco: il tesoro e il museo*, II, Florence.

Hauser, W. and Wilkinson, C.K., 1942 "The Museum's Excavations at Nishapur", *Bulletin of the Metropolitan Musuem of Art*, XXXVII, New York.

Hayward, 1976 *The Arts of Islam*, catalogue of the exhibition held at the Hayward Gallery, 8 July–4 August, London.

Honey, W.B., 1946 *Glass*, Victoria and Albert Museum, London.

Jenkins, M., 1986 *Islamic Glass: A Brief History*, The Metropolitan Museum of Art Bulletin, XLIV, Fall.

Jungfleisch, M., 1929 'Poids fatimites en verre polychrome', *Bulletin de l'Institut d'É-gypte*, pp.61-71

Kohlhausen, H., 1967 "Al-Zujāja al-Fāṭimiyya: Ka's Hedwig", *Fikr wa-Fann*, IX, pp. 20–2.

Kröger, J., 1984 *Glas: Berlin Staatliche Museen Preussischer Kulturbesitz – Museen für Islamische Kunst*, Mainz.

Kröger, J., 1995 *Nishapur: Glass of the Early Islamic Period*, Metropolitan Museum of Art, New York.

Kühnel, E., 1925 *Islamische Kleinkunst*, Berlin.

Lamm, C.J., 1928 *Das Glas von Samarra*, Berlin.

Lamm, C.J., 1929–30 *Mittelalterliche Gläser und Steinschnittarbeiten aus dem Nahen Osten*, 2 vols, Berlin.

Lamm, C.J., 1935 *Glass from Iran – The National Museum, Stockholm*, Uppsala.

Lamm, C.J., 1941 *Oriental Glass of Medieval Date found in Sweden and the Early History of Lustre Painting*, Stockholm.

Lane, A., 1938 "Mediaeval Finds at Al-Mina in North Syria", *Archaeologia*, LXXXVII.

Liefkes, R. (ed.), 1997 *Glass*, Victoria and Albert Museum, London.

Matson, F.R., 1948 "The Manufacture of eighth-century Egyptian glass weights and stamps", in G.C.Miles, *Early Arabic Glass Weights and Stamps*, New York, pp.39-43.

Al-Maqrīzī, A. ibn ʿA., 1853 *Al-mawāʿiẓ waʾl-iʿtibār fī dikhr al-khiṭaṭ waʾl-āthār*, 2 vols, Cairo (Bulaq).

Morton, A.H., 1985 *A Catalogue of Early Islamic Glass Stamps in the British Museum*, London.

Muqaddasī, 1906 *Aḥsan al-taqāsīm fī maʿrifat al-aqālīm*, ed. M.J. De Goeje, Leyden (first edition 1877).

Navarro Palazón, J. and García Avilés, A., 1989 "Aproximación a la cultura material de Madinat Mursiya", *Murcia Musulmana*, Murcia, pp. 253-356.

Pérez Higuera, T., 1994 *Objetos e Imagenes de Al-Andalus*, Madrid.

Philon, H., 1980 *Early Islamic Ceramics*, London.

Pinder-Wilson, R., 1976 "Glass", in *The Arts of Islam*, catalogue of the exhibition held at the Hayward Gallery, 8 July–4 August, London, pp. 131–46.

Pinder-Wilson, R., 1991 "The Islamic Lands and China", in H. Tait (ed.), *Five Thousand Years of Glass*, London, pp. 112–43.

Pinder-Wilson, R. and Scanlon, G., 1973 "Glass Finds from Fusṭāṭ 1964–1971", *Journal of Glass Studies*, XV, pp. 12–30.

Rogers, E.T., "Glass as a material for standard coin weights", *Numismatic Chronicle*, New Series, XII, pp.60-88

Rogers, J.M., 1994 Review of *Eredità dell'Islam – Arte Islamica in Italia*, in *The Burlington Magazine*, February, pp. 136–8.

Scanlon, G., 1965 "Preliminary Report: Excavations at Fusṭāṭ, 1964", *Journal of the American Research Center in Egypt*, IV, pp. 7–30.

Scanlon, G., 1966 "Fusṭāṭ Expedition: Preliminary Report 1965, Part I", *Journal of the American Research Center in Egypt*, V, pp. 83–112.

Scanlon, G., 1967 "Fusṭāṭ Expedition: Preliminary Report, 1965, Part II", *Journal of the American Research Center in Egypt*, VI, pp. 65–86.

Scanlon, G., 1974 "Fusṭāṭ Expedition: Preliminary report 1968, Part I", *Journal of the American Research Center in Egypt* XI, pp. 81–91.

Scanlon, G., 1981 "Fusṭāṭ Expedition: Preliminary Report, 1972, Part I", *Journal of the American Research Center in Egypt*, XVIII, pp. 57–84.

Shalem, A., 1993-5 "New Evidence for the History of the Turquoise Glass Bowl in the Treasury of San Marco", in *Persica*, XV, pp.91-4.

*SPA* Pope, A. U., *A Survey of Persian Art*, 6 vols, Oxford, 1938-9.

Tait, H. (ed.), 1991 *Five Thousand Years of Glass*, London.

Tatton-Brown, V., 1991 "The Roman Empire", in H. Tait (ed.), *Five Thousand Years of Glass*, London, pp. 62–97.

Tatton-Brown, V. and Andrews, C., 1991 "Before the Invention of Glassblowing", in H. Tait (ed.), *Five Thousand Years of Glass*, London, pp. 21–61.

Al-ʿUsh, M.A.-F., 1971 "Incised Islamic Glass", *Archaeology*, XXIV, 3, June, pp. 200–3.

Whitehouse, D., 1968 "Excavations at Siraf: First Interim Report", *Iran*, VI, pp. 1–22.

Yūsuf, ʿA. al-R., 1972 "Etude sur le verre égyptien", *Colloque International sur l'Histoire du Caire*, Cairo, pp. 467–8.

CHAPTER 5

Allan, J., 1976 Review article of Fehérvári, G., *Islamic Metalwork of the Eighth to the Fifteenth Century in the Keir Collection*, *Oriental Art*, XXII, 3, pp. 299–302.

Anglade, E., 1988 *Catalogue des boiseries de la section islamique – Musée du Louvre*, Paris.

Bass, G.F. and van Doorninck, F.H., 1978 "An 11th Century Shipwreck at Serçe Liman, Turkey", *The International Journal of Nautical Archaeology and Underwater Exploration*, VII, 2, pp. 119–32.

Berchem, M. van, 1891 "Notes d'archéologie arabe: monuments et inscriptions fatimites", *Journal Asiatique*, 8ème série, XVII and XVIII.

Bernus-Taylor, M., 1993 *Les Arts de l'islam - Musée du Louvre*, Paris.

Carboni, S., 1993 "Casket", in *The Art of Medieval Spain, a.d. 500–1200*, The Metropolitan Museum of Art, New York, no. 47.

Christie, A.H., 1925 "Fatimid Wood-carvings in the Victoria and Albert Museum", *Burlington Magazine*, XLVI, pp. 184–7.

Contadini, A., 1988–9 "The *Kitāb Manāfi' al-Ḥayawān* in the Escorial Library", *Islamic Art*, III, pp. 33–57.

Contadini, A., 1993 "Il grifone di Pisa", in G. Curatola (ed.), *Eredità dell'Islam - Arte Islamica in Italia*, Cinsello Balsamo, no. 43.

Contadini, A., 1995 "Islamic Ivory Chess Pieces, Draughts and Dice in the Ashmolean Museum", *Oxford Studies in Islamic Art*, X, part 1, Oxford, pp. 111–54.

Cott, P.B., 1939 *Siculo-Arabic Ivories*, Princeton.

Creswell, K.A.C., 1952 *The Muslim Architecture of Egypt*, 2 vols, Oxford.

Curatola, G. (ed.), 1993 *Eredità dell'Islam - Arte Islamica in Italia*, Cinisello Balsamo.

Daneshvari, A., 1986 *Symbolism in Warqa wa Gulshah*, Oxford Studies in Islamic Art, II, Oxford.

Dimand, M.S., 1947 *A Handbook of Muhammadan Art*, New York, 1947.

Ettinghausen, R., 1943 "The Bobrinski 'Kettle', Patron and Style of Islamic Bronze", *Gazette des Beaux-Arts*, XXIV, pp. 193–208.

Ettinghausen, R., 1950 *The Unicorn*, Washington.

Ettinghausen, R., 1952 "The 'Bevelled Style' in the Post-Samarra Period", in G.C. Miles (ed.), *Archeologica Orientalia in Memoriam Ernst Herzfeld*, Locust Valley, NY, pp. 72–83.

Fehérvári, G., 1976 *Islamic Metalwork of the Eighth to the Fifteenth Century in the Keir Collection*, London.

Ferrandis, J., 1935–40 *Marfiles árabes de Occidente*, Madrid.

Gabrieli, F. and Scerrato, U., 1985 *Gli Arabi in Italia*, Milan (1st ed. 1979).

Gelfer-Jørgensen, M., 1986 *Medieval Islamic Symbolism and the Paintings in the Cefalù Cathedral*, Leiden.

Grube, E.J., 1963 "Three Miniatures from Fustat in the Metropolitan Museum of Art in New York", *Ars Orientalis*, V, pp. 89–95.

Grube, E.J., 1965 "A Bronze Bowl from Egypt", *Journal of the American Research Center in Egypt*, IV, pp. 141–3.

Grube, E.J., 1993 "Sei placchette d'avorio", in G. Curatola (ed.), *Eredità dell'Islam – Arte Islamica in Italia*, Cinsello Balsamo, no. 63.

Grube, E.J., 1994 "La pittura islamica nella Sicilia normanna del XII secolo", in *La Pittura in Italia. L'Altomedioevo*, Milan, pp. 416-31.

Hahnloser, H.R. (ed.), 1971 *Il Tesoro di S. Marco: il tesoro e il museo*, II, Florence.

Ḥasan, Z.M., 1937 *Kūnuz al-fāṭimiyyīn*, Cairo.

Hayward, 1976 *The Arts of Islam*, catalogue of the exhibition held at the Hayward Gallery, 8 April–4 July, London.

Herz-Pasha, M., 1912–13 "Boiseries fatimites aux sculptures figurales", *Orientalisches Archiv*, III, pp. 169–74.

al-Imad, L.S., 1990 *The Fatimid Vizierate: 969–1172*, Islamkundliche Untersuchungen, 133, Berlin.

Kubiak, W. and Scanlon, G.T., 1979 "Fusṭāṭ Expedition: Preliminary Report 1971, Part I", *Journal of the American Research Center in Egypt*, XVI, pp. 103–24.

Kühnel, E., 1925 *Islamische Kleinkunst*, Berlin.

Kühnel, E., 1971 *Die islamischen Elfenbeinskulpturen, VIII.–XIII. Jahrhundert*, 2 vols, Berlin.

Labib, P., 1956 *The Coptic Museum at Old Cairo*, Cairo.

Lamm, C.J., 1936 "Fatimid Woodwork, its Style and Chronology", *Bulletin de l'Institut d'Egypte*, XVIII, Cairo, pp. 59–91.

Lane-Poole, S., 1886 *The Art of the Saracens in Egypt*, London.

Longhurst, M., 1927 *Catalogue of Carvings in Ivory*, Victoria and Albert Museum, 2 vols, London.

Louvre, 1989 *Arabesques et jardins de paradis*, Musée du Louvre, Paris.

Al-Maqrīzī, A. ibn 'A., 1895–1906 *Khiṭaṭ, Description topographique et historique de l'Egypte*, trans. U.M. Bouriant and M.P. Casanova, Paris, 3 vols.

Marçais, G., 1957 "Les figures d'hommes et des bêtes dans les bois sculptés d'époque fatimide, conservés au musée arabe du Caire: étude d'iconographie musulmane", *Mélanges Maspero*, III, Algiers, pp. 241–57.

Mayer, L.A., 1958 *Islamic Woodcarvers and their Works*, Geneva.

Migeon, G., 1927 *Manuel d'Art Musulman: arts plastiques et industriels*, 2 vols, Paris.

Monneret de Villard, U., 1938 *La Cassetta incrostata della Cappella Palatina di Palermo*, Rome.

Monneret de Villard, U., 1950 *Le pitture Musulmane al soffitto della Cappella Palatina in Palermo*, Rome.

Munich, 1912 Sarre, F. and Martin, F.R. (eds), *Die Ausstellung von Meisterwerken Muhammedanischer Kunst in München, 1910*, 3 vols, Munich.

Pauty, E., 1930 *Bois sculptés d'églises coptes, époque fatimide*, Cairo.

Pauty, E., 1931 *Les bois sculptés jusqu'à l'époque ayyoubite*, Catalogue Générale du Musée Arabe du Caire, Cairo.

Pinder-Wilson, R., 1973 "The Reliquary of St Petroc and the Ivories of Norman Sicily", *Archaeologia*, CIV, pp. 261–305.

*Répertoire* Combe, E., Sauvaget, J. and Wiet, G., *Répertoire chronologique d'épigraphie arabe*, 17 vols, Cairo, 1931–82.

Scerrato, U., 1966 *Metalli Islamici*, Milan.

# INDEX